CITIZEN WOMAN

© Prestel Verlag, Munich · London · New York 2020
A member of Verlagsgruppe Random House GmbH
Neumarkter Strasse 28 · 81673 Munich

Prestel Publishing Ltd.
14-17 Wells Street
London W1T 3PD

Prestel Publishing
900 Broadway, Suite 603
New York, NY 10003

Library of Congress Cataloging-in-Publication Data

Names: Gerhard, Jane F., editor. | Tucker, Dan (Book producer), editor.
Title: Citizen woman : an illustrated history of the women's movement /
 [edited by] Jane Gerhard, Dan Tucker.
Description: London ; New York, NY : Prestel, [2020] | Includes index.
Identifiers: LCCN 2019038099 | ISBN 9783791385303
Subjects: LCSH: Women's rights--History. | Women's rights--Pictorial works.
 | Feminism--History. | Feminism--Pictorial works.
Classification: LCC HQ1236 .C487 2019 | DDC 305.4209--dc23
LC record available at https://lccn.loc.gov/2019038099

A CIP catalogue record for this book is available from the British Library.

Editorial direction: Holly La Due
Design and layout: MGMT. design
Production management: Anjali Pala
Photo research: Julia DeVarti
Copyediting: Meghan Drury
Proofreading: Monica Parcell
Index: Marilyn Bliss

Verlagsgruppe Random House FSC® N001967
Printed on the FSC®-certified paper

Printed in Slovakia
ISBN 978-3-7913-8530-3
www.prestel.com

AN ILLUSTRATED HISTORY
OF THE WOMEN'S MOVEMENT

CITIZEN WOMAN

JANE GERHARD AND DAN TUCKER

PRESTEL

MUNICH LONDON NEW YORK

Contents

THE Woman Citizen

THE WOMAN'S JOURNAL FOUNDED 1870

TEN CENTS A COPY

DECEMBER 4, 1920

SUFFRAGE WON—FORWARD, MARCH!

The triumphant cover of the December 4, 1920 issue of *The Woman Citizen*, celebrating the August 26 ratification of the Nineteenth Amendment to the United States Constitution, granting women the right to vote.

Women's history is the primary tool for women's emancipation.

Gerda Lerner

One is not born, but rather becomes, a woman.

Simone de Beauvoir
The Second Sex

Introduction

The right to vote is one that most of us take for granted. Many of us exercise it only occasionally, and we feel that we're performing a civic virtue when we do so. Today, this is as true for women in most of the world as it is for men. But this was not always so. Having a say in the way we are governed, however small, seems to us such a basic human right that even though we know there was a long-ago struggle to achieve suffrage for women—exactly a century ago for the United States, and approximately that span for many European nations, Australia, and New Zealand—it seems to us now that women's suffrage (from the Latin *suffragium*, "to support") was inevitable.

The pages of this book will show you otherwise. The transnational women's suffrage movement was full of dynamic and committed individuals who faced opposition from entrenched powers that used every means at their disposal to defeat them. Unlike us, looking back on their achievements today, suffragists had no idea whether or not they would succeed. Even the most optimistic among them had to take success as an article of faith; many early suffragists didn't live long enough to cast their first ballot.

Individual suffrage movements varied tremendously by culture, geography, and religion, yet they shared information and ideas to a degree that is surprising in a world where instantaneous communication was unknown. Suffrage organizations were beset by internal rifts, conflicting agendas, and uncertainty about tactics. Members committed terrible acts of betrayal caused by racial prejudice, class conflict, and religious differences. Yet they also achieved stunning feats of political organization and brilliant and audacious acts of civil disobedience. They showed mastery of the art of public discourse and public relations, and an uncanny knack for pulling the few levers of power that were available to them. Many went to extraordinary lengths to work for social justice, demonstrating remarkable ingenuity and drive to fight for rights and protections for those less fortunate than themselves.

Still, interesting as these stories may be, why should we bother to look back now?

In the age of Twitter feminism, it's more important than ever that feminists understand their history. In order to be convincing, and to understand and digest the views of others, there is no substitute for being well informed. As we've learned from the seemingly sudden emergence of the so-called alt-right, there are signifiers hidden in plain sight. Today, white supremacists rarely don the white robes of the KKK; subtler cues of attire and other personal choices communicate solidarity to fellow members. Awareness of our history helps us recognize these signposts.

Moreover, the sad but oddly reassuring truth is that the arguments and tactics of those who have fought against the emancipation of women have varied little over time. To be an effective feminist, it's important to recognize and understand these strategies, and to see how they have been neutralized and defeated in cases where feminists have triumphed. In the words of the Austrian-American historian Gerda Lerner, one of the pioneers in the field of women's studies, "Women's history is the primary tool for women's emancipation."

Even more importantly, the events of the first decades of the twenty-first century have been stomach-churning illustrations of the fact that history is not linear, and that progress is not a one-way street. Women today face persecution around the world, in overtly oppressive regimes, war-torn nations, and in the wealthiest countries: acts of physical and sexual violence; intimidation; workplace harassment and unequal pay; and restrictions on women's bodies and reproduction. Even in 2020, there is no place on the planet where

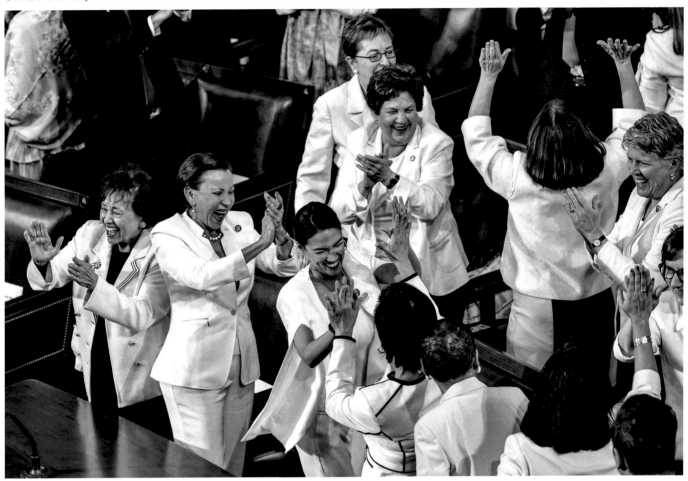

Democratic congresswomen wore all white to President Donald Trump's State of the Union address on February 5, 2019, as a nod to the suffrage movement. As Representative Brenda Lawrence of Michigan stated, "Today we stand together wearing white in solidarity with the women of the suffrage movement who refused to take no for an answer." Wearing "suffragette white" first became a sartorial statement in the early twentieth century, as participants sought to create a recognizable public image. Purple, white, and yellow were the official colors of the suffrage movement, representing loyalty, purity, and hope. White dresses provided a visual contrast during parades and were also a defense against stereotypes that portrayed suffragists as overly masculine. Here, congresswomen respond to President Trump's acknowledgment of increasing numbers of women serving in Congress and participating in the workforce.

women are exempt from acts of violence simply for being women. An understanding of the conditions that brought us here is vital to improving them. Recognizing and appreciating the methods that women have used to bring about change allows us to implement and adapt the most effective approaches, and to draw on their strength and effectiveness as bedrocks of inspiration and faith.

One need only look to new laws regarding abortion and birth control in the United States and the worldwide effects of the global gag rule (a U.S. policy of revoking aid to any overseas health organization that provides information, referrals, or services for abortion, see p. 78) to understand that women are facing a new and powerful set of challenges. According to data from the World Economic Forum, women across the globe in 2018 had on average less than 70 percent of the access to economic, educational, and political opportunities that men did. In countries that are experiencing war, where women are especially vulnerable, women have about half the access to these opportunities that men do. Even in countries where women have opportunities for education that are close to equal to those of men, their economic opportunities and political empowerment lag well behind. In Iceland, the top-ranked country for gender parity, women still are at a 15 percent overall disadvantage in spite of their nearly equal access to educational opportunities.

Women's fight to gain the right to vote is genuinely compelling and inspiring, but it is only a part of a much larger story—that of women's quest for full and equal citizenship. Our modern understanding of what it means to be a citizen is based on the twin ideas of equality and political power requiring the consent of the governed. Oppressed and marginalized groups have struggled to redefine and expand the concept of citizenship ever since Enlightenment thinkers introduced these ideas in the eighteenth century.

This book traces the themes that define citizenship for women, and it attempts to do so, somewhat quixotically, on a global basis. Perhaps for this reason, we've chosen to let pictures do a great deal of the storytelling for us. We did this not only for the dynamism and emotional impact that photographs, paintings, and other works of art bring to the subject, but because they also convey particularities of culture, dress, appearance, and other subtleties that enrich the story in ways that would otherwise take many pages of description. You are able to see at a glance the vast spectrum of circumstances in which women find themselves.

Additionally, the images afford us the opportunity to dig deeper by providing information specific to a time and place, and allow us to illustrate how the particular situation depicted in a photograph sheds light on a universal truth or an experience that is shared across vast expanses of time and geography. We've tried to convey this in extended captions.

The purpose is not to offer a comprehensive history of the women's movement in every country in the world, which would be impossible for a team of

scholars given a lifetime. Rather, the goal is to trace the issues that deeply affect the ways that women can exist in the world, and to highlight instances when women have fought to assert their claims to equal rights with men—not to become men, as some anti-feminists have argued rather sophistically, but to be able to live with the same autonomy and opportunities that men do.

The story of women achieving political rights is the subject of "To Have a Voice." The right to vote—to have a say in how society is governed—is perhaps the first and most essential tool for achieving the other changes vital to women's interests.

Birth control and abortion have been employed since ancient times to give women a degree of control over their lives by allowing them to choose when they will begin a family and the number of children they will have. "The Right to Choose" depicts the different ways in which these practices have been medicalized, demonized, and even criminalized, and how feminists have sought to ensure that women have both access to knowledge about birth control and abortion and the option to control their bodies.

Marriage and economic rights have always been a critical issue for women. "Out of the Doll's House" looks at the evolution of marriage, and examines the significance of a woman's right to choose a spouse and file for divorce, to own and trade property, and to represent herself in business and social transactions. Those rights, essential to the ability of women to live as equals of men before the law, have come about only after great struggle. In many areas of the world,

they are still subject to challenge. We look at the intersection of poverty and religion, and the way that the practices of child marriage and honor killings impact women.

"We Can Do It" delves into the lives of women as workers, whether in unremunerated jobs within the family home, or as maids, industrial workers, or business executives. The assumption that a good woman should live under the financial aegis and protection of a man has far outlived the reality in which that may have been possible for most people. As single-earner families have become increasingly rare, and situations where at least one parent must hold down multiple jobs have become the norm, feminists have worked to achieve equal opportunity to get jobs, receive equal pay for doing them, and work in environments free of harassment. Advocates for the rights of women have proposed childcare programs that are accessible and affordable, forging close ties between the labor and feminist movements.

Throughout modern history, women have been subject to control by male standards of beauty. Feminist artists and art critics are the heroes of "Eye of the Beholder," as they have identified, challenged, and redefined depictions of women, and shown how beauty ideals have been used to manipulate them. In recent years, these feminists have begun to establish new norms of beauty and sexual attractiveness, ones that incorporate and resonate with women of color, transgender women, and other historically underrepresented groups. Activists have

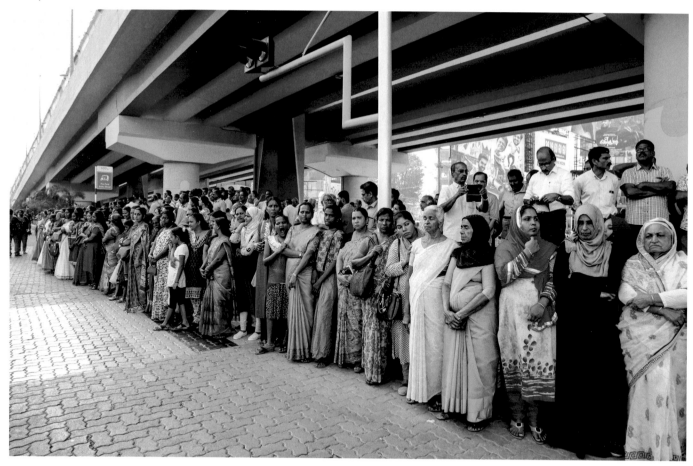

Women in Kerala, southern India, gathered to form a human chain deemed a "women's wall" on January 1, 2019. The human chain covered a total of 385 miles, and the government estimated that there were between three and a half and five million participants. Organized by the Left Democratic Front, the event was created to spread awareness about gender equality and to protest a ban that prohibited women of menstruating age from entering the Sabarimala Temple, an important Hindu religious site. India's Supreme Court lifted this ban in September 2018, but several women were stopped outside by crowds of men. In Hinduism, menstruating women are viewed as impure and advised not to enter temples, but women have generally been allowed to visit Hindu religious sites while not menstruating. The massive turnout for the "women's wall" on New Year's Day inspired hope for the fight for gender equality in India.

also worked to stop body modification practices—such as female genital mutilation—seen in certain cultures to embody ideals of purity, and therefore, feminine beauty.

From its inception, the women's movement has contained contradictions that are easily traced to economic status, race, ethnicity, gender, and sexual orientation. The issues that arise from these differences, with the tensions and conflicting agendas that they inevitably raise, are explored in "The Expanding Circle of Citizenship." The first-wave suffrage movements tended to be organized and populated by women in the upper half of the economic spectrum, and they sometimes worked to the exclusion or even the detriment of women of color, working women, and lesbian and transgender women. But in recent decades, feminists have broadened their focus, recognizing that the oppression of one group has ramifications for all. The goal of feminists now is to expand the circle of citizenship, bringing once-marginalized groups under the umbrella of rights and protections to be enjoyed by all citizens in the fullest sense of the word.

So why look back at the history of the women's movement? If you take the view from thirty thousand feet, it's possible to see the discrete streams and individual cultural eddies that flow together and unite to form the great tidal movements on the planet. Informed activism by individuals and groups of individuals—even the

simple refusal to accept things the way they "have always been"—is what has succeeded in pushing the rights of full citizenship for women from the fringes to mainstream acceptability. In the words of the anthropologist Margaret Mead, "Never doubt that a small group of thoughtful, committed citizens can change the world. Indeed, it's the only thing that ever has."

When the long struggle for the enfranchisement of women is over, those who read the history of the movement will wonder at the blindness that led the Government of the day to obstinately resist so simple and obvious a measure of justice.

Emmeline Pankhurst,
British suffragette

To Have a Voice

Perhaps the most surprising thing to modern readers about women's struggle for the right to vote is how widely and virulently disparaged suffrage was right up until it became the law. But over many decades in virtually every corner of the globe, it did become the law, first in New Zealand (1893) and Australia (1902), then in much of Scandinavia (1913–1915). The United Kingdom followed suit in 1918, as did Austria, Canada, Germany, Hungary, Latvia, Lithuania, and Poland. Full suffrage arrived in Russia with the Revolution in 1917, a fact that American suffragists used to taunt "Kaiser" Woodrow Wilson to goad him into supporting "woman suffrage," as it was then called. Congress finally passed the Nineteenth Amendment to the U.S. Constitution, guaranteeing women the right to vote, in June 1919, It was ratified, in a true nail-biter, in August 1920.

United States, 1917

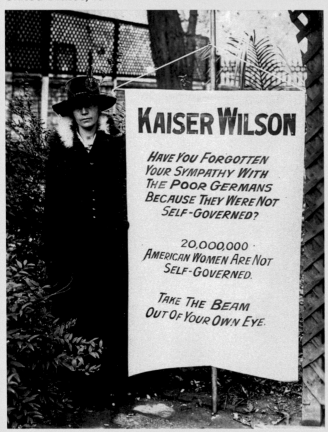

United States, 1913

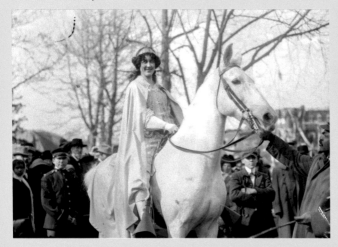

LEFT After years of meetings with President Woodrow Wilson that had failed to produce results, Alice Paul and the National Woman's Party (NWP) decided to "mak[e] it impossible for the President to enter or leave the White House without encountering a sentinel bearing some device pleading the suffrage cause," according to an article published in the *Washington Post* on January 10, 1917. This photograph, taken later in 1917, shows Virginia Arnold, a school-teacher from North Carolina who also served as executive secretary of the NWP. Arnold holds a banner needling Wilson for intervening on behalf of democratic principles in Germany but ignoring the same problem at home. The provocations by Paul's group eventually led to violence and arrests (see p. 28–29).

LEFT, BELOW Inez Milholland Boissevain (1886–1916), wearing a white cape, sits astride a white horse at the National American Woman Suffrage Association parade in Washington, D.C. on March 3, 1913. The Brooklyn-born Milholland was a labor and children's rights attorney and served as a journalist and corre-spondent during World War I. Known for her ability to electrify crowds as much as for her progressive views, Milholland went on a nationwide speaking tour for the National Woman's Party in 1916 in spite of ill health. Milholland collapsed at the podium while delivering a suffrage speech in Los Angeles in the fall of 1916 and died several weeks later on November 25, 1916. Her death was front-page news, a shock to the nation and her fellow suffragists. She became a martyr and an icon of the suffrage movement.

RIGHT (United Kingdom, 1914) Police arrest Emmeline Pankhurst (1858–1928) on May 21, 1914 outside of Buckingham Palace, where she had organized a march to present a petition to King George V. Pankhurst was arrested another twelve times within the span of a year, serving a total of thirty days in prison. In response to increased militancy by Pankhurst's Women's Social and Political Union (WSPU) during this period, the British government pursued a catch-and-release policy known as the "Cat and Mouse Act," releasing suffrage prisoners after they were weakened from hunger strikes and re-arresting them after they had regained their strength. Pankhurst died several weeks before Parliament passed the Representation of the People Act in 1928, which extended suffrage to all women over twenty-one, but she had lived to celebrate the 1918 version of the Act, which had granted suffrage to women over thirty.

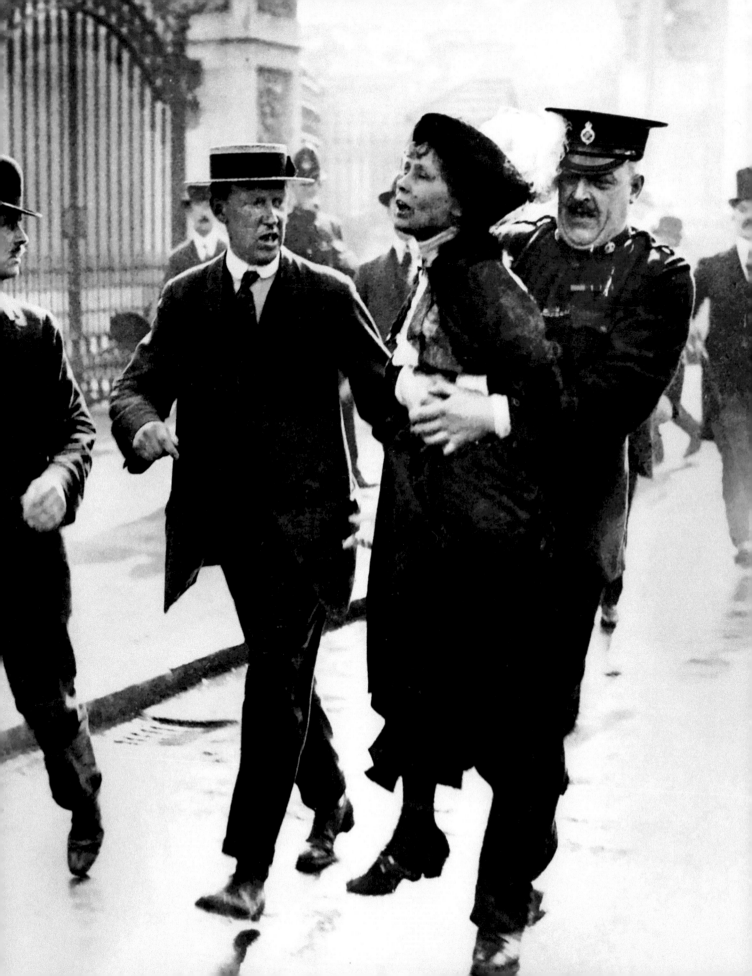

How could something that today seems so self-evidently a basic right have once been so controversial? This question is particularly vexing when applied to modern-era democracies, which were founded on notions of natural rights and an opposition to tyranny. The vast majority of newspaper coverage of the 1848 Seneca Falls Convention, widely viewed as the origin of the American woman's movement, was brutally negative. Why did champions of liberty presume, across all strata of society, that these principles did not apply to half the population?

At the time of the American Revolution in the late eighteenth century, the idea of self-government, of authority originating with "the people"—let alone with women—was not yet a widely accepted idea. Moreover, the very thought of women as individuals, separate from their families, was so far removed from the laws and customs of the day as to have seemed a fantasy. European states operated under a system known as coverture (literally "covered" in French), in which women had no legal status. As "femes covert," or married women, English, and later American, women could not own property, make contracts, testify against their husbands in court, or engage in any legal transactions. Wives also took the surnames of their husbands, and were subject to their rule. Unmarried or widowed women faced uncertain, often precarious, status (see p. 122). European nations exported this system throughout the world through colonization and trade, including to their North American colonies. Nevertheless, in

the New World, many Native American societies, matrilineal in organization, viewed the status of women differently. They traced descent through the maternal line and consequently granted women more power in "public" or "political" life. Women had a meaningful voice in tribal councils (though male elders generally controlled these councils). The women of the Pawnee and Omaha of Nebraska, for example, had both property rights and the ability to initiate divorce. Still, in most of the world, including the Anglo colonies of America, women shared status as legal nonentities, with no formal political voice.

Mary Wollstonecraft had already broached the idea of granting women rights equal to those of men in *A Vindication of the Rights of Woman* (1792), and her proposal had largely been ridiculed. The idea of allowing women a voice in government seemed more radical yet, if not unnatural, in the new American Republic. Under the rules and unspoken customs of coverture, women's lives were properly confined to the domestic sphere of homemaking and child-rearing; though they were often important contributors to the family economy, women's authority generally ended where the making of important decisions began. The idea that women could participate in the public sphere demeaned their femininity and womanhood, the argument went, foreshadowing a refrain that echoes to this day.

Indeed, more than 150 years later, the argument that women have no place in the rough-and-tumble world of politics still had salience. Phyllis Schlafly

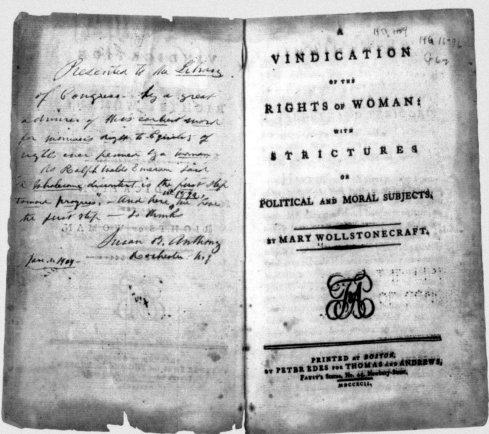

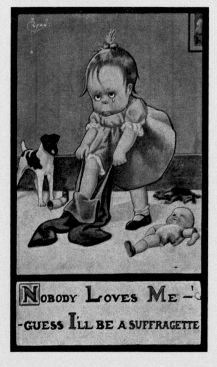

ABOVE Susan B. Anthony donated her personal copy of the first American edition of Mary Wollstonecraft's *A Vindication of the Rights of Woman* (1792) to the Library of Congress in 1904. Wollstonecraft's work, widely ridiculed in its day for its radical stance, anticipated the woman suffrage movement by fifty years, and the feminist movement by considerably more. Anthony's inscription reads "Presented to the Library of Congress by a great admirer of this earliest word for woman's right to Equality of Rights ever penned by a woman. As Ralph Waldo Emerson said 'a Wholesome discontent is the first step toward progress.'—And here, in 1892 [sic], we have the first step—to think."

RIGHT This anti-suffrage cartoon from 1911 upholds the stereotype that only undesirable women were interested in women's rights, further suggesting, by depicting a suffragist as a willful toddler, that their concerns are silly and immature. The girl is wearing a pink dress and putting on a pair of pants, implying that she intends to leave the feminine ideal behind. Cartoons like this one often indicated that suffragettes would no longer take care of their families or perform their household duties if they gained political rights.

and her supporters at the Eagle Forum, for instance, fired the opening salvo in their campaign to defeat the Equal Rights Amendment at the 1977 National Women's Conference in Houston by arousing fears that the codification of equal standing for women would result in the elimination of women's ability to be full-time homemakers and mothers. By treating women like men before the law, would there be an erosion of moral standards, an end of femininity as Americans knew it? Women would be forced into combat in the military, Schlafly warned, and her centuries-old rationales apparently resonated. ERA opponents perpetuated the stereotype of the angry woman activist humorlessly forcing her views on a population that only needed protection from feminists themselves, not from unfair laws or working conditions. As anti-suffragists had once argued, "real" women, as opposed to aggressive and frustrated suffragists, were in no need of a vote that would debase them by bringing the corrupting influence of politics into their pure domestic worlds.

It took time for American women to begin to chip away at these cultural assumptions about femininity, as well as the tenets of English common law depriving them of the full legal status of adult citizens. The question finally arose at a fateful afternoon tea attended by Elizabeth Cady Stanton in Seneca Falls, New York: why don't women enjoy *all* of the rights and privileges won in the American Revolution when they, too, had shared in the risks?

Women would not gain the vote by polite request. It was the unrelenting efforts of activists, writers, artists, theorists, labor organizers, and rank-and-file women (and some men) that shifted the very ground on which the debate was held. Women like Stanton, Susan B. Anthony, Sojourner Truth, Ida B. Wells, Carrie Chapman Catt, Mary Church Terrell, Alice Paul, Lucy Burns, Emmeline and Christabel Pankhurst, and too many others to name, shifted cultural assumptions and political discourse. It is possible that women would still be excluded from government today had it not been for these visionary and unrelenting efforts to challenge the common assumption that women were too physically weak and emotional (at the expense of being rational) to be allowed to have a voice in government. It took clear-eyed, forward-thinking, persistent, and sometimes cantankerous individuals to envision a nation in which half of its population would not be denied the privileges of citizenship.

In the Declaration of Independence, Thomas Jefferson posited that "all men are created equal" under natural law emanating from the Creator (not from monarchs), each entitled to "life, liberty, and the pursuit of happiness." At the Seneca Falls Convention of 1848, Elizabeth Cady Stanton "sampled" Jefferson's words in her own document, purposely echoing his revolutionary rhetoric, but applying it to women. In her "Declaration of Sentiments," Stanton declared simply: "all men *and women* are created equal," placing women on par with men under natural law—as citizens of the nation. Substituting Jefferson's list of colonists'

United States, 1902

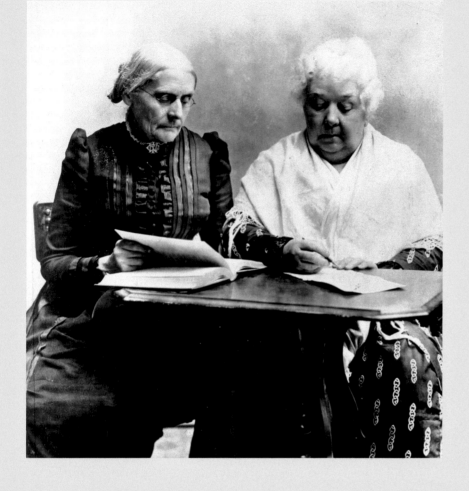

United States, 1870–1880

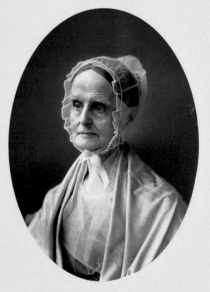

ABOVE, LEFT Susan B. Anthony (*left*) and Elizabeth Cady Stanton shown in a photograph taken three years before Stanton's death in 1902. The two close allies and friends had been at the vanguard of the fight for women's suffrage since meeting in 1851. To honor Stanton's eighty-seventh birthday, Anthony published a letter to her in *Pearson's Magazine*: "We little dreamed when we began this contest, optimistic with the hope and buoyancy of youth, that half a century later we would be compelled to leave the finish of the battle to another generation of women. But our hearts are filled with joy to know that they enter upon this task equipped with a college education, with business experience, with the fully admitted right to speak in public—all of which were denied to women fifty years ago. They have practically one point to gain—the suffrage; we had all." Stanton died two weeks before her birthday, never having seen the letter.

ABOVE, RIGHT Lucretia Mott (1793–1880) was a women's rights activist, abolitionist, and orator. She was raised a Quaker, which helped inform her anti-slavery views. After meeting at the World Anti-Slavery Convention, Lucretia Mott and Elizabeth Cady Stanton began a long collaboration and friendship. In 1848, they organized the first women's rights convention, the Seneca Falls Convention, in Seneca Falls, New York. Despite her opposition to electoral politics, which she viewed as corrupt, Mott signed the Seneca Falls Declaration of Sentiments in support of woman suffrage. Mott also helped found the American Equal Rights Association and after the Civil War, she became the first president. Though she later resigned from the association, Mott continued to play a role in the woman suffrage movement throughout her life.

United States, 1864

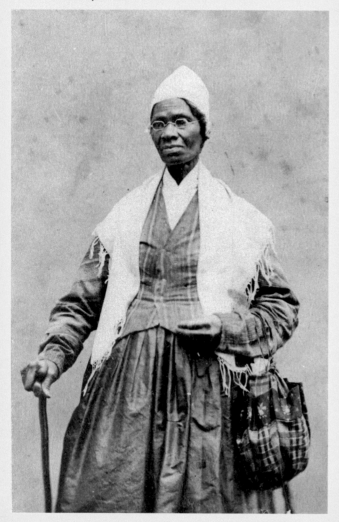

United States, 1848

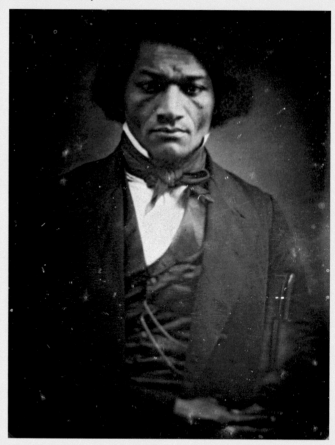

ABOVE, LEFT Prominent abolitionist and women's rights activist Sojourner Truth (born Isabella Baumfree, c. 1797–1883) escaped from slavery in 1826 with her young daughter. She became the first black woman to win a lawsuit against a white man when she fought to regain custody of her son. After converting to Methodism in 1843, she changed her name to Sojourner Truth and began traveling as a preacher and abolitionist speaker, saying, "The Spirit calls me, and I must go." In 1851, Truth delivered a speech now known as "Ain't I a Woman?" at the Ohio Women's Rights Convention, demanding equal human rights for women and black people in the United States.

ABOVE, RIGHT The renowned American abolitionist Frederick Douglass (born Frederick Augustus Washington Bailey, c. 1818–1895), was a vocal and dedicated ally of the woman suffrage movement. Born into slavery, Douglass escaped before he was twenty. His eloquence and impassioned speeches on the horrors of slavery won him a sizable following as a speaker. His moral authority carried tremendous weight at the 1848 Seneca Falls Convention, but his relationship with the suffrage leaders Elizabeth Cady Stanton and Susan B. Anthony suffered in the 1860s over his support for the Fourteenth and Fifteenth Amendments, which extended the rights of citizenship to black men, but not women of any color. Nonetheless, Douglass was seated next to Anthony at a women's convention in Washington, D.C. when he was stricken with the heart attack that was to end his life.

grievances against King George, Stanton enumerated grievances of woman against man: "He has compelled her to submit to laws, in the formation of which she had no voice," she boldly asserted, rejecting the Enlightenment notion that women lacked the capacity to exercise judgment in political affairs. But her ninth resolution to the Declaration of Sentiments was, for the times, the boldest assertion of them all: "Resolved, that it is the duty of the women of this country to secure to themselves their sacred right to the elective franchise." She demanded that women be allowed to vote at a time when it was virtually unthinkable. So shocking was her demand, that among her supporters only the abolitionist giant Frederick Douglass stood up at the convention and endorsed her controversial resolution, believing that *universal adult* suffrage, for black people *and* women, was a worthy goal of the new Republic.

In 1851, Stanton met the woman abolitionist who was to become her steadfast friend and partner in the fight for suffrage for more than fifty years—Susan B. Anthony. The two women very quickly became a formidable team: Stanton had already established herself as a visionary and writer, while Anthony was an unparalleled organizer and a master tactician. In Stanton's words, "I forged the thunderbolts, and she fired them." But these women were very different people with different aims for the woman suffrage movement. Where Stanton was a solidly middle-class Presbyterian, married with seven children, Anthony, who never married, was raised a Quaker in a Massachusetts mill town. As

a consequence of their different situations, Stanton's focus for woman suffrage was to give women like herself control over decisions affecting their daily lives and status as mothers and wives. Anthony, who had to be economically self-reliant, became one of the few in this pioneer generation of suffragists to sympathize with the needs of growing numbers of female factory workers and wage earners. But regardless of their reasons for becoming activists, Stanton and Anthony shared the belief that the vote was the lynchpin of women's fight for autonomy.

If Stanton's Declaration of Sentiments was the shot fired across the bow in 1848, the battle that came to be known as the American suffrage movement was a halting and tortured affair. It took another seventy-two years for American women to gain the right to vote at the federal level. There was the small matter of the U.S. Civil War, which thwarted any forward advance; early suffrage leaders were split on whether or not to postpone their pursuit of the vote to focus on the abolition of slavery first, though eventually that is exactly what they did. For this reason, the woman suffrage movement shares much of its DNA with the great abolitionist movement of the nineteenth century. Both movements were predicated on the notion that an oppressed people were entitled to be "citizens," with their full complement of rights and obligations. For suffrage leaders like Lucretia Mott and Elizabeth Cady Stanton, the fight to rid African Americans of the bonds of slavery caused them to think of their own sort of bondage

as "kept women," who also lacked the legal status to have a voice in shaping American life.

But, foreshadowing future dynamics and conflict in the women's movement, tension emerged over strategy. Should the goal of the vote for women remain front and center, or should the goal be to seek an expansion of natural rights for black men first, and then hope that women would claim theirs next? Eventually, suffrage leaders like Stanton and Anthony took umbrage when the Fourteenth Amendment to the Constitution (1868) extended equal protection under the law to African Americans but guaranteed the right to vote in elections only to *male* inhabitants of the states—the only time the word "male" appears in the U.S. Constitution. When the Fifteenth Amendment passed, granting more citizenship rights to black men but not to women, Stanton and Anthony grew disillusioned. In a tactical turn that ultimately became a blot on the early movement, they turned to rhetoric that disparaged the full rights of citizenship for black people, even after having fought for their emancipation. The exclusionary tactics of the early movement continued into the twentieth century, much to the detriment of black women who wanted to join the suffrage ranks—and to the movement itself. In 1913, when the African American suffragist and anti-lynching activist Ida Wells traveled to Washington to join the suffrage march, the organizers asked her to take a place in the rear of the procession with other black people rather than with her native Illinois delegation.

The Fifteenth Amendment had the practical effect of driving a wedge into the suffrage movement. Lucy Stone and Julia Ward Howe, who supported the amendment, formed the American Woman Suffrage Association (AWSA), which pursued a conservative course of local and state-by-state campaigns for suffrage. These campaigns operated on the basis that women were not equal to men, but they were domestic beings and men's moral superiors, who could temporarily sacrifice their goals and wait for black men to receive the rights of citizenship before them. Stanton and Anthony, meanwhile, took the more radical path of pressing for constitutional acknowledgement that men and women were equal under the law, while insisting that obtaining the vote for women shouldn't wait. Whereas the AWSA included both men and women in its ranks (with men occupying the leadership roles), Stanton and Anthony's National Women's Suffrage Association (NWSA) was made up of women only, and was thus a "separatist" organization. Their suffrage colleague Matilda Joslyn Gage also splintered off to form the Woman's National Liberal Union (WNLU), the most radical of the organizations formed by the pioneer generation of suffragists. These organizations remained rivals until 1890, when the NWSA and AWSA merged to form the National American Woman Suffrage Association (NAWSA), which Stanton led until her retirement in 1892. Despite the merge, it was already clear that the suffrage movement was far from monolithic. American women's fight for the vote was not based

on a singular ideology, nor did women want to vote for a singular reason. And those differences became glaring in the twentieth century.

It was no accident that Stanton had organized the Seneca Falls Convention in 1848, for it had coincided with a rash of popular challenges to aristocratic rule across Europe. Revolutionaries in France upended the monarchy after centuries of rule, only to be replaced themselves in an unending cycle of regimes representing competing economic and class interests. Democratizing forces challenged the established order in Vienna, Prague, Budapest, Berlin, and other European capitals. Elizabeth Cady Stanton had undoubtedly been seized by the democratic spirit of the times.

The seeds of radical politicization were thus also being sown in the mill towns of New England, such as Lowell, Massachusetts, where most of the workers, young farm women, had arrived from significant distances for the promise of a steady wage. In keeping with the mores of the times, women workers were not expected or allowed to live independently, so they lived in shared rooms in boarding houses or in dorm-like housing provided by ownership. But hours were long, conditions were poor, and wages, which were never generous, declined over time (see p. 133). There was much grist for these workers' ire, and what better forum for airing their views than the ad hoc meetings that organically sprouted in the common areas of company housing? For the first time, women were getting a collective sense of themselves as wage earners with a common set of interests.

Whether these textile workers knew it or not, more well-to-do, socially conservative American women were also getting politicized at much the same time, though in the name of their morally superior domesticity. Many left the confines of their homes for the first time to volunteer to help orphans, the mentally ill, the wayward, and the poor. And though they insisted that it was their duty as apolitical mothers to do this work of benevolence, eventually many came to insist that they needed more rights as citizens to bring about the social reforms they sought. Members of the Woman's Christian Temperance Union (WCTU), led by Frances Willard, became some of the most effective suffrage advocates of the nineteenth century—all as a means to end public drunkenness and to assert their female morality in the public sphere. Seeing alcohol consumption as a catalyst of domestic violence and a drain on family finances, temperance women hoped eventually to use the vote to bring about a ban on the sale and consumption of alcohol, and consequently to end many incidents of female destitution. The WCTU became the largest women's organization in the United States advocating for women's suffrage as a means to achieving their social and moral ends.

By the turn of the twentieth century, some reform-minded women had gone to college, learned the social science of poverty, and supported suffrage as a tool in their professional social work. Young,

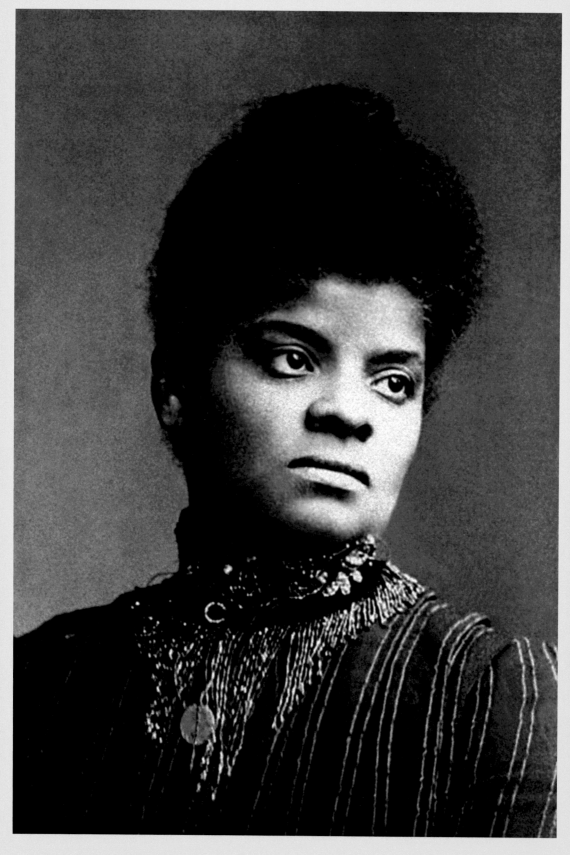

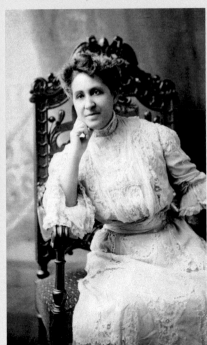

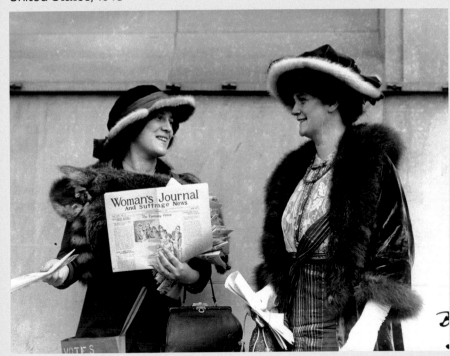

LEFT Ida B. Wells-Barnett (1862–1931) was born into slavery in the Deep South, a year before President Lincoln issued the of the Emancipation Proclamation. Her parents became active in Reconstruction-era politics, but they died in a yellow fever epidemic when Ida was sixteen, leaving her to care for her younger brothers and sister. She took a job as a teacher in order to support them, becoming politically active when lynch mobs murdered several of her friends. Wells-Barnett became a muckraking journalist, investigating and exposing the motivation of lynch mobs that murdered with the purpose of eliminating business competition and intimidating black citizens. She was forced to flee the South for Chicago as a result of her reporting. In addition to her activism in support of NAWSA, Wells-Barnett founded what may have been the first black woman suffrage group, Chicago's Alpha Suffrage Club.

ABOVE, LEFT Born to parents who had risen from slavery to middle-class life in Memphis, Mary Church Terrell (1863–1954), was already active in the woman suffrage movement when the 1892 lynching of her friend Thomas Moss, a black business owner who dared to compete with white businessmen, increased the urgency of her activism and focused it on the needs of black women. An active member of the National American Woman Suffrage Association (NAWSA) since her years as a student at Oberlin College in the early 1880s, Terrell became a co-founder and first president of the National Association of Colored Women (NACW) in 1896. Her co-founders included Harriet Tubman, Frances E.W. Harper, and Ida B. Wells-Barnett. Terrell focused the organization's agenda on job training, wage equity, and childcare. Her autobiography, *A Colored Woman in a White World*, was published in 1940.

ABOVE, RIGHT Margaret Foley distributes copies of the *Woman's Journal and Suffrage News*, the suffrage newspaper edited by Julia Ward Howe, Lucy Stone, and others from 1870 until 1917, on a Boston street. Howe and Stone had formed the American Woman Suffrage Association (AWSA) in 1869 after splitting with the National Woman Suffrage Association (NWSA), the group founded and run by Elizabeth Cady Stanton and Susan B. Anthony, over NWSA's opposition to the Fifteenth Amendment granting the vote to black men. After the groups reconciled and merged in 1890 to form the National American Woman Suffrage Association (NAWSA), Howe and Stone continued to publish the *Woman's Journal* under the auspices of NAWSA. Foley, a fixture in Boston's suffrage movement, was known for interrupting speakers at political rallies with confrontational questions about suffrage. She became known as the "grand heckler."

educated women like Jane Addams, for instance, responded to widespread poverty, especially among immigrant groups, by starting "settlement" houses, where recent immigrants could live at minimal cost and receive training to be assimilated into American life. In addition to providing services for immigrants, these organizations became venues of political engagement. Like the Lowell workers, middle-class settlement and clubwomen learned how to found and grow institutions and use the power of the press to advance their mission. Be it through labor activism or social reform, nineteenth-century women cultivated the skills of organizers, learning how to draft bylaws for organizations, to run meetings and report on them, to manage finances, assign tasks, and hold those assigned accountable. They learned to write and publish newsletters, create and promote effective petitions, and to acquit themselves in court if circumstances called for it. In essence, they were becoming polit-icized, even before they officially had the vote. The skills and lessons they learned put them in good stead for the suffrage fight of the twentieth century.

Indeed, with the new century in the United States, there was a clear passing of the torch between the suffrage pioneers of Stanton and Anthony's generation and younger suffragists, armed with new skills and ideas and ready to lead the modern movement. Alice Stone Blackwell and Harriot Stanton Blatch, the daughters of feuding suffrage pioneers Lucy Stone and Elizabeth Cady Stanton,

had been the ones who pressed their mothers to reconcile in 1890, but it was clear that the NAWSA needed an even greater infusion of youth in the new century. In 1900, Anthony's successor as the head of the NAWSA was the much younger Carrie Chapman Catt, who assumed leadership until 1905, and then again in 1915. Anna Howard Shaw was NAWSA president in the association's much less eventful intervening years.

Following a less ideological, more pragmatic game plan of a modern organization, the NAWSA pursued a state-by-state strategy, running what today would be called a "ground campaign" of local rallies, speeches, and publicity to promote adoption of city, county, and statewide suffrage laws. Leaders reasoned that with every state granting women the vote, the attainment of suffrage on a federal level would become easier to achieve. Under Shaw's leadership, however, and with the advent of World War I, progress had slowed to a crawl in winning suffrage in individual states. Only once Catt resumed her role as NAWSA president did the organization seek the more sweeping federal suffrage amendment preferred by younger NAWSA women who congregated in its Congressional Union. And thus while she didn't originate the idea, Catt eventually coined the federal strategy her "Winning Plan."

Alice Paul was one of the college-educated women of this younger generation, which ultimately broke away from the NAWSA to start the more radical National Woman's Party (NWP). The women

United States, 1914–1920

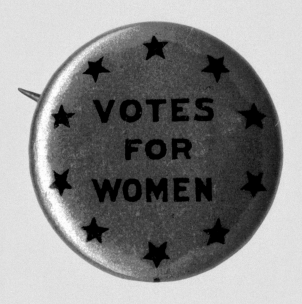

United States, 1865

A PETITION

FOR

UNIVERSAL SUFFRAGE.

To the Senate and House of Representatives:

The undersigned, Women of the United States, respectfully ask an amendment of the Constitution that shall prohibit the several States from disfranchising any of their citizens on the ground of sex.

In making our demand for Suffrage, we would call your attention to the fact that we represent fifteen million people—one half the entire population of the country—intelligent, virtuous, native-born American citizens; and yet stand outside the pale of political recognition.

The Constitution classes us as " free people," and counts us *whole* persons in the basis of representation; and yet are we governed without our consent, compelled to pay taxes without appeal, and punished for violations of law without choice of judge or juror.

The experience of all ages, the Declarations of the Fathers, the Statute Laws of our own day, and the fearful revolution through which we have just passed, all prove the uncertain tenure of life, liberty and property so long as the ballot—the only weapon of self-protection—is not in the hand of every citizen.

Therefore, as you are now amending the Constitution, and, in harmony with advancing civilization, placing new safeguards round the individual rights of four millions of emancipated slaves, we ask that you extend the right of Suffrage to Woman—the only remaining class of disfranchised citizens—and thus fulfil your Constitutional obligation " to Guarantee to every State in the Union a Republican form of Government."

As all partial application of Republican principles must ever breed a complicated legislation as well as a discontented people, we would pray your Honorable Body, in order to simplify the machinery of government and ensure domestic tranquillity, that you legislate hereafter for persons, citizens, tax-payers, and not for class or caste.

For justice and equality your petitioners will ever pray.

NAMES.	RESIDENCE.
Elizabeth Stanton,	New York
Susan B. Anthony	Rochester — N.Y.
Antoinette Brown Blackwell	New York
Lucy Stone	Newark N. Jersey
Joanna S. Morse	48 Livingston. Brooklyn
Ernestine L Rose	New York
Harriet E Eaton	6. West 14th Street N.Y
Catharine C Wilkeson	83 Clinton Place New York
Elizabeth R Tilton	48 Livingston St Brooklyn
Mary Fowler Gilbert	295 W. 19" St New York
May L Gilbert	New York
M. Griffith	New York.

ABOVE, LEFT This button is one of many badges and buttons that suffrage organizations made for supporters to wear in the early twentieth century. While some were created for a particular campaign, others such as this one, were more generic. The button pictured here is part of the collection of the New-York Historical Society. The stars around the edges represent the ten states where women had full suffrage when the button was made: Wyoming (1869); Colorado (1893); Utah (1896); Idaho (1896); Washington (1910); California (1911); Kansas, Oregon, and Arizona (1912); and Montana (1914).

ABOVE, RIGHT Responding to the passage of the Fifteenth Amendment, American suffrage leaders petitioned Congress for a constitutional amendment that would prohibit "the several States from disfranchising any of their citizens on the ground of sex." The signatures of Elizabeth Cady Stanton, Susan B. Anthony, and Lucy Stone are clearly visible. "Therefore, as you are now amending the Constitution, and, in harmony with advancing civilization, placing new safeguards round the individual rights of four millions of emancipated slaves, we ask that you extend the right of Suffrage to Woman— the only remaining class of disfranchised citizens—and thus fulfill your Constitutional obligation 'to Guarantee to every State in the Union a Republican form of Government.'"

United States, 1909

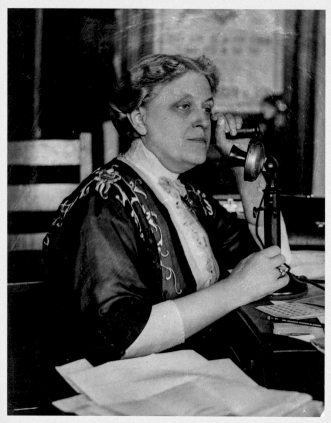

United States, circa 1880

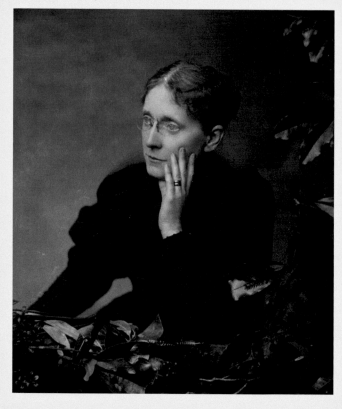

ABOVE, LEFT Wisconsin-born Carrie Chapman Catt (1859–1947) replaced the aging Susan B. Anthony as president of NAWSA in 1900, having joined the suffrage movement in Iowa, her adopted home, in the late 1880s, only to resign in 1904 to care for her ailing husband. When Catt was elected president for a second time in 1915, she unveiled her "Winning Plan," adding the pursuit of a federal amendment to NAWSA's state-by-state strategy. Catt was known to pander to the prejudices of the day, citing woman suffrage as a means of maintaining white supremacy. After her husband's death in 1905, Catt dedicated much of her time to promoting equal-suffrage rights worldwide with the International Alliance of Women (IAW), which eventually incorporated suffrage associations in thirty-two nations.

ABOVE, RIGHT Frances Willard (1839–1898) assumed leadership of the Woman's Christian Temperance Union (WCTU) in 1879, and quickly grew it into the most successful vehicle for the political mobilization of middle-class white women of its day. With its potent combination of moral crusading and pragmatic advocacy for improvements to the lot of women at home and in the workplace, WCTU membership of 150,000 easily dwarfed that of the National American Woman Suffrage Association (NAWSA), the leading suffrage organization in the U.S., which only had 13,000 members. Willard saw suffrage as a means to achieving a higher end—that of a secure, sober, and morally upright society in which women were not subject to the threat of violence nor the corrupting influence of men and alcohol.

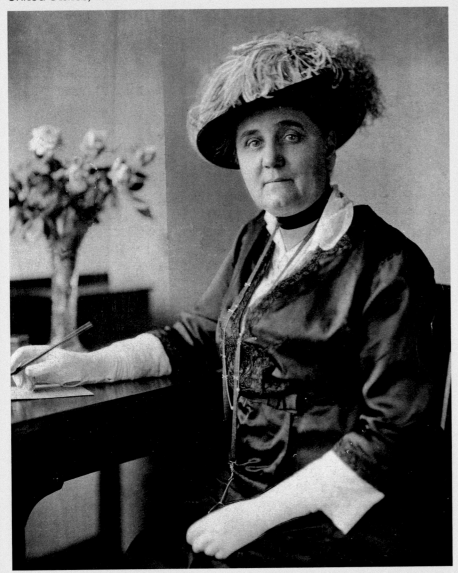

ABOVE, LEFT Jane Addams (1860-1935) and Ellen Gates Starr observed the success of the Toynbee Hall settlement house in London, and decided to do something similar in Chicago. Addams was among the most prominent reformers of the Progressive Era, helping to improve the lives of women. Addams, a lifelong pacifist, believed in the capacity of citizens to build democratic social relationships within and across lines of class, ethnicity, race, and gender—central to her work with immigrants and to her early and consistent support of the woman suffrage movement. She was elected to the vice-presidency of NAWSA in 1911, and was awarded the Nobel Peace Prize in 1931.

ABOVE, RIGHT When Jane Addams and Ellen Gates Starr founded Hull House in 1889—the first settlement house in the United States— the goal was for educated women to share knowledge and experience with recent immigrants and the impoverished in their Chicago neighborhood to help alleviate poverty and improve lives. The Hull House team provided vital services to thousands of people each week, including a kindergarten and day care for working mothers; job training; English language, cooking, and other classes for immigrants eager to assimilate.

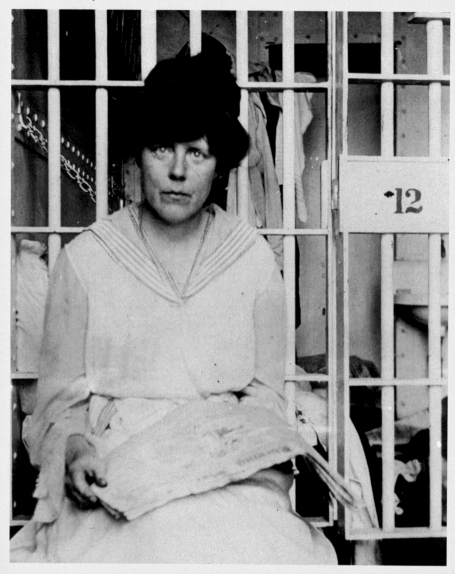

ABOVE While pursuing graduate studies in linguistics at Oxford, Brooklyn-born Lucy Burns (1879-1966) became involved in the movement for women's suffrage led by Emmeline and Christabel Pankhurst, learning firsthand their militant methods. Burns met her future friend and ally, Alice Paul, a fellow American, in a London police station after being arrested while participating in a Women's Social and Political Union (WSPU) protest. On her return to the United States in 1912, Burns organized multiple suffrage campaigns in the western U.S., edited *The Suffragist* (the weekly journal of the National Woman's Party), and later helped lead the "Silent Sentinel" picketers in front of the White House in 1917. Burns was imprisoned six times for her troubles, and like Alice Paul, endured multiple episodes of solitary confinement and force-feeding. Burns retired from public life after the ratification of the Nineteenth Amendment, working with the Catholic Church until her death.

RIGHT (United States, 1920) Born to a Quaker family in New Jersey, Alice Paul (1885-1977) found her way into the circle of Emmeline Pankhurst and the Women's Social and Political Union (WSPU) after moving to England in 1907. Like Lucy Burns, she learned the tactics of civil disobedience from Pankhurst, and experienced her first force-feeding while in an English jail. Paul returned to the United States in 1910 and brought Pankhurst's tactics with her. Burns joined her two years later. Here, Paul toasts the suffrage flag after ratification—she had sewn a star on it each time another state voted for suffrage. After the Nineteenth Amendment was passed, Paul drafted the Equal Rights Amendment and dedicated the rest of her life to its passage.

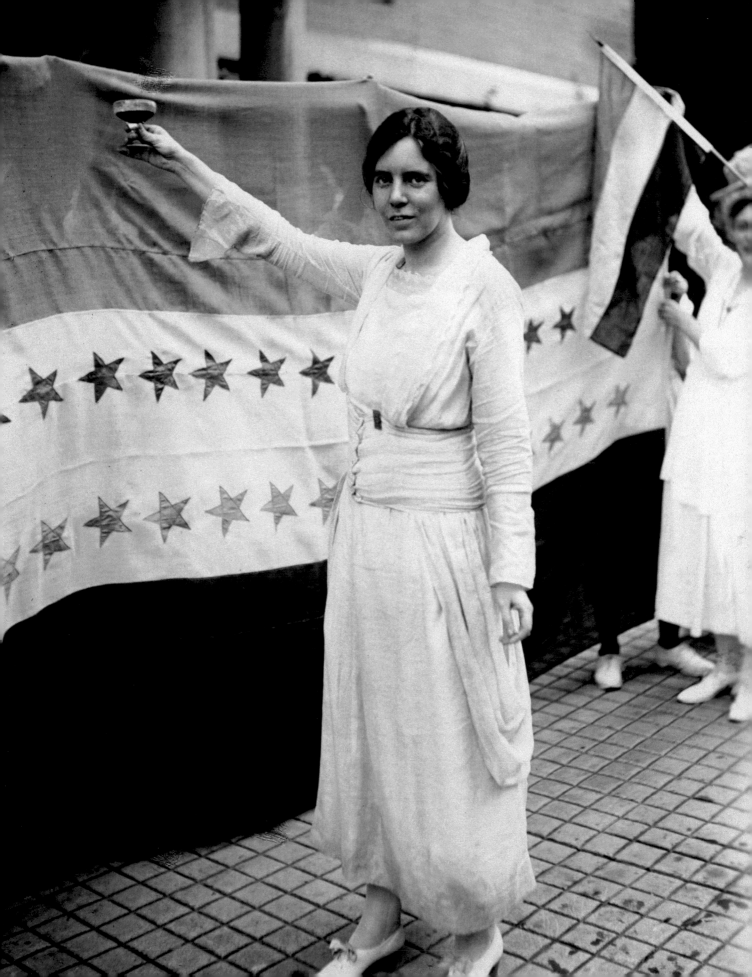

who joined the NWP generally wanted the vote for different reasons than the social reformers and temperance advocates of their mothers' generation. Paul was born in New Jersey, but had her formal schooling in Birmingham, U.K., where she had fallen in with a group of radical "suffragettes" led by Emmeline and Christabel Pankhurst and their Women's Social and Political Union (WSPU). Unlike earlier generations of American suffragists who argued for the vote on the grounds that women were the moral superiors of men and thus fundamentally *different* from male citizens, the Pankhursts, Paul, and soon Paul's second-in-command Lucy Burns, shared the more radical notion that women deserved the vote based on a fundamental sameness of the sexes: both men and women were born with inherent natural rights, which thus should make them equal under the law.

Like their British counterparts, NWP women resorted to less ladylike tactics, understanding that their provocations would garner attention in the press. There was the time, for instance, when they trolled newly elected President Woodrow Wilson, first with a suffrage parade that upstaged his inauguration in 1913, and then, in the face of his stubborn refusals and foot-dragging, with the daily placement of "Silent Sentinels"—white-clad picketers—outside the White House gates. Paul and her supporters were arrested for "obstructing traffic," and imprisoned. Undaunted, the women went on well-publicized hunger strikes, and were force-fed for their efforts, which only served to gain additional public sympathy and visibility for their cause.

NWP women appeared to have far less propriety than their NAWSA foremothers; indeed, the popular press often referred to their brash talk and tactics unflatteringly as "suffrage noise." And yet Paul's aggressive tactics and mastery of the art of controlling press coverage arguably gave organized suffrage its final impetus. It turned out that the two-pronged approach of the NAWSA and NWP was the winning combination needed to see suffrage finally passed on the federal level in the United States NAWSA's decades-long strategy of chipping away at suffrage in carefully chosen localities had yielded powerful political and communications networks in each state—quite useful, it turned out, to gain the support of state legislatures to ratify the amendment.

By early summer in 1920, the total number of states willing to ratify was 35, one short of what was needed for the amendment to pass. Ratification of the Nineteenth Amendment ultimately hinged on one state, Tennessee, and the vote of a single 24-year-old state legislator named Harry Burn, an anti-suffragist who came around and voted "yes" in the final moments. Burn carried a letter from his mother, Febb Ensminger Burn, onto the floor of the legislature. "Hurrah and vote for suffrage," the college-educated mother had urged her son. "I knew that a mother's advice is always safest for a boy to follow," he said, "and my mother wanted me to vote for ratification." A modern woman's influence in the

United States, 1917

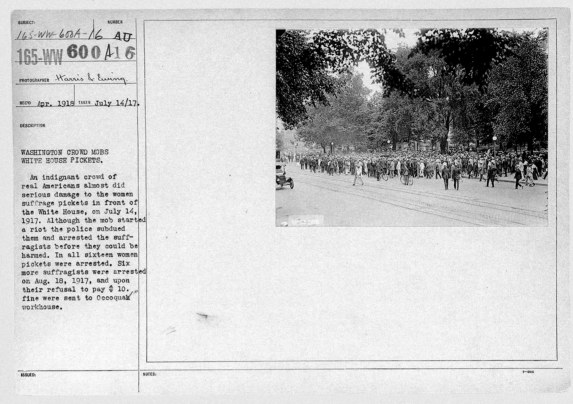

United States, 1917

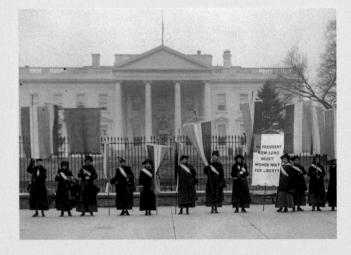

ABOVE The caption on this archive card for a 1917 photograph
tells as much of a tale as the photograph itself. The image shows
the unruly crowds that the NWP's Silent Sentinel protestors faced
by the summer of 1917, about six months after they began picketing
the White House. Protestors had begun carrying signs denouncing
"Kaiser" Wilson, and many members of the public took exception,
as the United States had just entered the war against Germany earlier
in the year. The caption reveals the clear bias of the photographer,
not unusual for the media of the day.

RIGHT In early 1917, the National Woman's Party (NWP) began
posting "Silent Sentinels" outside the White House to protest the
government's inaction regarding women's suffrage. Provoking the
new president, Woodrow Wilson, at his residence, turned a political
confrontation into a personal one. Tensions escalated to the point
where protestors were roughed up by onlookers, then arrested and
sent to Occoquan Workhouse, a notoriously inhumane detention
center in nearby Virginia. There they were brutally force-fed after
going on hunger strikes. The NWP made sure that the press coverage
was extensive. In January 1918, Wilson came out in support of
a suffrage amendment.

NEXT SPREAD (United States, 1917) Suffrage protesters from the
National Woman's Party bring their pickets to the steps of the United
States Capitol building in Washington, D.C.

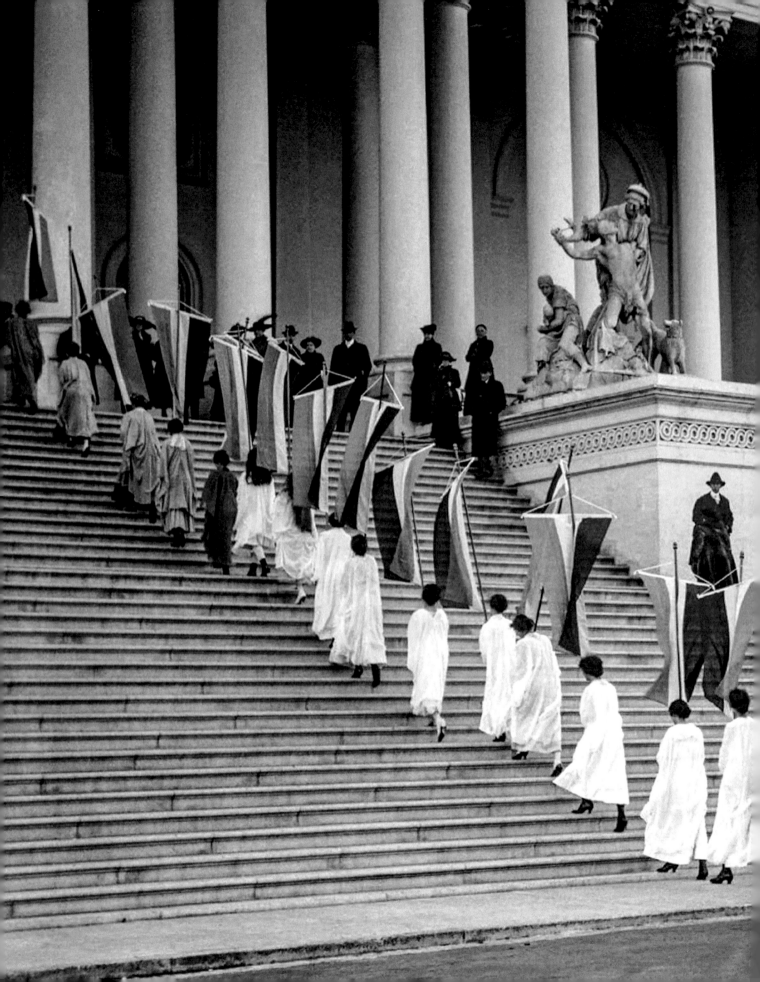

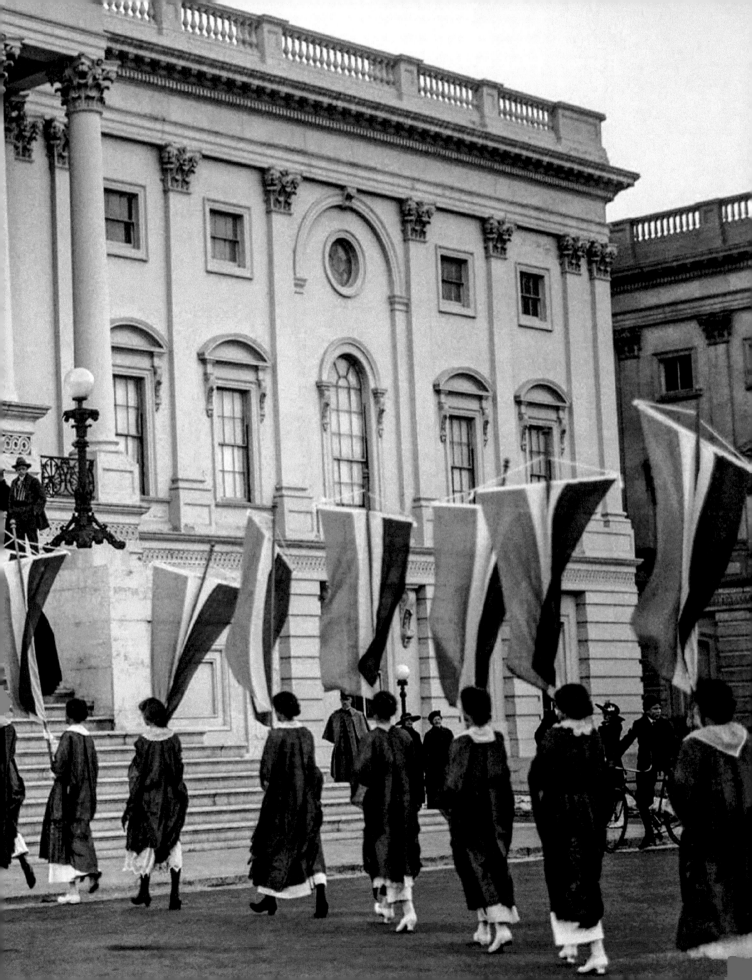

Germany, 1904

ABOVE Before Marie Stritt (1855–1928) became president of the Federation of German Women's Associations in 1899, the organization (and others) had been fairly moderate in its pursuit of women's suffrage. The anti-Socialist restrictions that had been enacted during Chancellor Otto von Bismarck's tenure prevented any meaningful political organizing, but once these laws were relaxed after his resignation in 1890, more radical leaders like Stritt emerged, and the socialists Emma Ihrer and Rosa Luxemburg (and the Social Democratic Party) became key figures in the woman suffrage movement. World War I demolished whatever progress toward suffrage had been made prior to 1914, but to the amazement of Stritt and other German suffragists, German women gained the vote within a year of the war's end.

RIGHT Members of the International Woman Suffrage Alliance (IWSA) pose for a photograph in 1914. Carrie Chapman Catt is in the center of the second row from the front, with Millicent Fawcett (1847–1929) seated to her right; Marie Stritt is in the third row, standing second from the left. Catt, Stritt, and Fawcett co-founded the International Woman Suffrage Alliance (IWSA) in Berlin in 1904 along with Susan B. Anthony and other prominent activists. In 1946, the IWSA changed its named to the International Alliance of Women (IAW), which is still active to this day. With its headquarters in Geneva, the IAW is an international non-governmental organization seeking to promote women's human rights around the world. According to its constitution, the first objective is to promote the human rights and empowerment of women in all spheres of life.

United States, 1914

domestic sphere had extended into the public sphere, and changed the political life of the nation.

American suffragists had not been working in isolation. The European revolutions of 1848 that had helped catalyze Elizabeth Cady Stanton's Declaration of Sentiments had much the same effect for women across that continent, and indeed, the globe. Women in New Zealand and Australia, led by their national chapters of the WCTU, and modeling themselves on the early American suffragists, attained the franchise before their role models were able to (1893 and 1902, respectively).

In Europe, rapid industrialization in the latter half of the nineteenth century resulted in the emergence of a powerful labor movement. By the late nineteenth century, poor conditions faced by women workers in many industries—long hours, low pay, poor or even hazardous conditions—made the need for political power abundantly clear, and activism tying labor to suffrage became the norm in England, France, Germany, across Scandinavia, and in virtually every European nation.

Simultaneously, an increase in literacy rates across Europe allowed working- and middle-class women to gain access to knowledge and news previously unavailable to them. Just as Alice Paul had later brought the confrontational methods of the Pankhursts to the United States, so European feminists in the late nineteenth century were sustained by the methods and successes of their sisters in other countries. They eagerly absorbed news from the United States and the United Kingdom, by now the acknowledged leaders in the push for suffrage. Understanding this, the German journalist and publisher Louise Otto (1819–1895) used her weekly newspaper, *Frauen-Zeitung* (Women's Journal)—the longest-running feminist publication of that era—to advance the idea that women's suffrage was tied to progress by providing updates on developments in the women's movement in the United States as well as across Europe.

There had long been an impetus to make the movement for women's legal and political rights international and conjoined. Though they had differing agendas with regard to class, suffrage leaders Marie Stritt, Millicent Fawcett, Carrie Chapman Catt, Susan B. Anthony, and others united to form the International Woman Suffrage Alliance (IWSA) at a meeting in Berlin in 1904. (Renamed the International Alliance of Women in 1926, the group today represents more than fifty women's organizations worldwide.) The IWSA was headquartered in London, and it was the preeminent international women's suffrage organization of its day. The German Union for Women's Suffrage, founded by Anita Augspurg, Minna Cauer, and Lida Gustava Heymann, was also a powerful European suffrage organization. Not coincidentally, given the German origins of international suffrage groups, the first International Women's Day, when more than a million women marched for their right to vote, was held in Leipzig in 1911.

Increased instability in the international order, combined with the mechanization of industry and

the modernization of home life and communications, also had an effect, if not of pushing the movement forward, then of making change in women's political status seem inevitable. World War I, in addition to forcing even more women into the labor force, demonstrated to millions of people that any thought of returning to more genteel times, where women were home and quiet, was increasingly unlikely. Modernity, which incorporated the wonders of electric lights, train travel, and the motorcar, was here to stay, and women's rights activists successfully tied their campaign to notions of progress and new technological wonders.

The 1917 Russian Revolution both stiffened opposition to radical ideologies and hastened the march toward suffrage in European nations, as increasingly politicized workers and women grew harder to suppress. The Bolsheviks, for whom women workers' demonstrations had proven such a valuable asset, embraced universal suffrage without equivocation. The February 1917 revolution, which saw the overthrow of the Tsar Nicholas, was a direct outgrowth of the International Women's Day protest on March 8 (the misalignment of the Gregorian and Julian calendars accounts for the discrepancy between the "February Revolution" and the March protest). The Soviet Union became the first of the major world powers to grant women the right to vote in 1917. The new government appointed Alexandra Kollontai, a leading feminist revolutionary, the Commissar for Public Welfare, making her one of the first female cabinet ministers in history.

1918 was a banner year for winning women's suffrage across much of Europe. It was also the year that the Electoral Law of the Empire (*Reichswahlgesetz*) was adopted in Germany, granting universal suffrage to all male and female citizens— to the surprise of Marie Stritt and other suffragist leaders, whose expectations of progress were dashed by Germany's devastating defeat in the Great War. Nowhere had the close tie between the labor and suffrage movements been more evident than in Germany, where the socialist leaders Emma Ihrer and Rosa Luxemburg were key figures in the push for workers' rights, and, secondarily, voting rights for women. (Luxemburg, in particular, saw women's political rights as subordinate to the liberation of the working class as a whole, and held feminists in contempt.) German socialists squabbled with the considerable cadre of more conservative suffragists, who sought to preserve property restrictions on voting and feared the rise of the working class. Women's voting rights were curtailed when the Nazis rose to power in 1933, but were restored after World War II. In 1949, the jurist Elisabeth Selbert, one of the "four mothers" of German constitutional law, successfully argued that the sentence "men and women are equal" must be included in German *Grundgesetz*, or basic law.

Looking back at the suffrage movements of the early twentieth century, the British and American ones were perhaps most alike and influential to one another. In the U.K., a group of militant suffragists, led by Emmeline Pankhurst and her daughters,

France, 1934

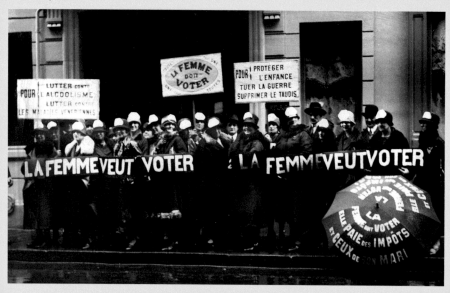

Mexico, 1911

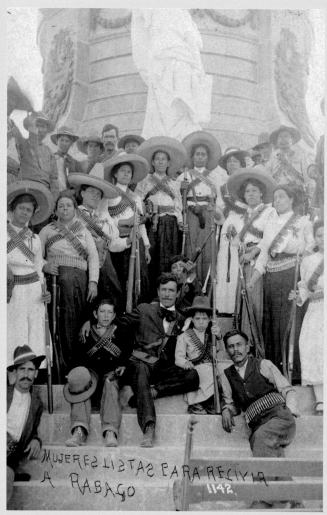

ABOVE Before Charles de Gaulle signed the law that finally granted suffrage to French women in 1944, France was the only Western country to prohibit women from voting even in municipal elections, and had been for several years. But it was not for want of trying. French suffragists had advanced bills granting women the vote no fewer than six times since 1919, each one passed by the Chamber of Deputies, only to be defeated in the Senate. The French Union for Women's Suffrage, which produced this poster in 1934, was a moderate pro-suffrage group founded in Paris in 1908. The emergence of a progressive Catholic party at the end of World War II, one of many groups associated with the French Resistance, ultimately brought about the enfranchisement of women in France.

LEFT Women had played a significant role in the Mexican Revolution, and the so-called "Adelita," a romanticized version of the woman soldier, became an international symbol of the resilience and independence of women. This photograph shows political writer and journalist Lázaro Gutiérrez de Lara surrounded by Mexican revolutionary soldiers, mostly women, on the base of the Benito Juárez monument in Ciudad Juarez, Mexico, awaiting the approach of federalist army commander Antonio Rábago and his troops. Full citizenship finally came to Mexican women in 1953 with the ratification of a 1952 law granting women the right to vote and run for office.

Christabel and Sylvia, recruited working-class members to their Women's Social and Political Union (WSPU) and generated headlines and heat, escalating from a campaign of protest and civil disobedience to one that destroyed carefully targeted public and private property using stones, arson, and bombs. These provocations achieved the goal of WSPU activists getting arrested, and from here they further escalated confrontations—and gained sympathetic press coverage—by conducting hunger strikes in prison, to which authorities responded, as their counterparts in the U.S. did, with brutal force-feedings. There were tensions between them and the more moderate wing of the movement, the "law-abiding suffragists" led by Millicent Fawcett and the National Union of Women's Suffrage Societies, each group placing legitimate claims on the ultimate success of the effort.

Of the major European countries, Spain and France were outliers, delaying suffrage for women until 1931 and 1944, respectively. The relative lateness of women's suffrage in these Western nations reveals majority religion to be a crucial factor in cultural receptiveness to women voting. The Catholic Church has generally been a force for conservatism, promoting a traditional (strictly domestic) role for women. In Spain, where politics tended toward extremism on both the left and the right, feminists chose not to challenge Catholic orthodoxy on suffrage, but rather to seek incremental improvements in other rights for women, including reproductive rights. The rise of fascist rule after the

Spanish Civil War in 1936 put an end to any question of democratic representation—or favorable reproductive laws—until 1977, when fascist rule gave way to the current constitutional monarchy. In France, meanwhile, the Napoleonic code, which granted few rights of any kind to women, was so deeply ingrained that when the Provisional Government declared "universal suffrage" after toppling the monarchy in 1848, there was never any question that this decree excluded women. It was not until the invasion and occupation of France by Nazi forces during World War II that the Free French Forces, headquartered in Algiers, agreed that universal suffrage should indeed include women. After nearly a century of frustrated efforts, French women won the right to vote after the occupation ended in 1944.

After the war, the ratification of the United Nations Declaration of Universal Rights in 1948 made universal suffrage a benchmark of modern nations, accelerating the process for many of the countries that gained their independence around that time or thereafter. This included large swaths of Asia, Africa, South and Central America, the Caribbean nations, and the Middle East.

Most Latin American countries came relatively late to women's suffrage because of their deeply conservative Catholic cultures and their historically colonial status. Once Latin nations achieved independence, most of them had to deal with nearly constant political upheaval, forcing women's rights to the bottom of most political agendas.

The most common response to instability was to turn to political repression rather than to cultivate democratic rights, let alone those of women. Suffrage came to most Latin American women between 1928 (Guyana) and 1961 (Paraguay). Brazil's progress toward women's suffrage was accelerated by the vision and persistence of Bertha Lutz, a Sorbonne-trained zoologist who befriended Carrie Chapman Catt and founded the Brazilian Federation for Female Progress in 1922, which succeeded in gaining the franchise for women in 1932. After decades of political upheaval, Mexican women won the right to vote in 1953.

In the Muslim world, Islamic law had an effect similar to that of Catholicism in Europe and Latin America, influencing national cultures toward conservatism and traditional roles for women. According to Islam, Quranic law (sharia) is subject to interpretation by scholars and secular leaders, a process called *fiqh*. Only when secular law contravenes divine law is it acceptable for Muslims to resist; otherwise, secular laws (such as those governing polygamy) must be obeyed by observant Muslims. Laws governing women's behavior, in other words, are subject to secular rule.

The disposition of Islamic societies toward women has been complicated by fears of the Westernization of women that is closely associated with modernization in general. For this reason, pan-Islamists have argued that Muslims are best served by rejecting modernism and returning to traditional ways, including the wearing of the veil and male supervision of all public activities by women. Around the time that suffragists were fighting for the vote in the U.S. and most of Europe, feminists and intellectuals in Egypt, Iran, Syria, and Turkey were debating the proper role for women in a world of encroaching technological and societal changes. Generally, the African and South Asian Muslim states granted rights to women earlier than those in the Middle East. Women in Saudi Arabia only gained the right to vote in municipal elections in 2015, and the kingdom continues to be among the most repressive nations for women. (Women in Saudi Arabia must have written approval from a male guardian to leave the country, work, or undergo certain medical procedures.) In Tunisia, by contrast, women gained the vote after independence in 1957, and the democratic republic remains a leader among Muslim nations in the World Economic Forum report on the global gender gap, which measures factors like economic participation and opportunity, educational attainment, and access to political decision-making.

The movement toward secularization began in Turkey with the rise of Mustafa Kemal Atatürk, the founder of the West-facing Turkish Republic, in 1923. Atatürk believed that women should participate in public life as full citizens, but they were not granted the franchise until 1934. Egypt, after a period of Ottoman rule and status as a British protectorate, likewise extended the franchise to women in its new constitution in 1923; in practice, however, women were not permitted to vote until 1956, in the wake of Gamal Abdel Nasser's revolution of 1952.

Saudi Arabia, 2015

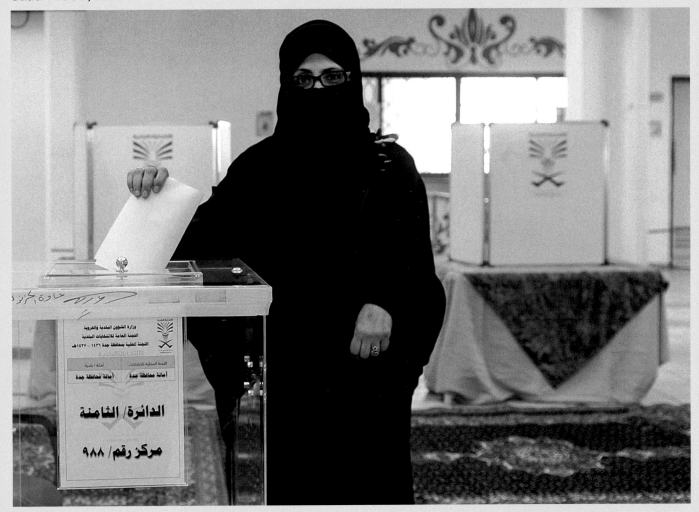

ABOVE Though Saudi Arabia is a hereditary kingdom, municipal elections were introduced for men in 2005 and opened to women, as voters and as candidates, in the election of 2015. The kingdom remains one of the most powerful, and among the most repressive to women, on earth. Saudi women must be in the company of a male guardian while outside of the home or traveling abroad, and they must get the consent of their male guardians to undergo certain medical procedures. The sign in this photograph reminds women of their responsibility to wear the hijab into the polling station. Part of the Saudi government's rationale for denying women the vote prior to 2015 was that there were not enough women to staff the women-only registration centers, and because women seldom had the required photo IDs for registration.

NEXT SPREAD (Tunisia, 1959) Shortly after independence in 1956, the new Tunisian government passed the Code of Personal Status, which introduced the principle of the equality of the sexes in relation to citizenship, granting Tunisian women access to higher education, the right to file for divorce, and opportunities to hold jobs in fields forbidden to women in neighboring Muslim countries, such as medicine. Women gained the vote for national elections and the right to run for office in 1959. Harsh repression of political opponents and widespread corruption in the government led to the Jasmine Revolution of 2010–2011, in which women played a leading role. Here, women assemble at a polling place in the first national election in which they could participate in 1959.

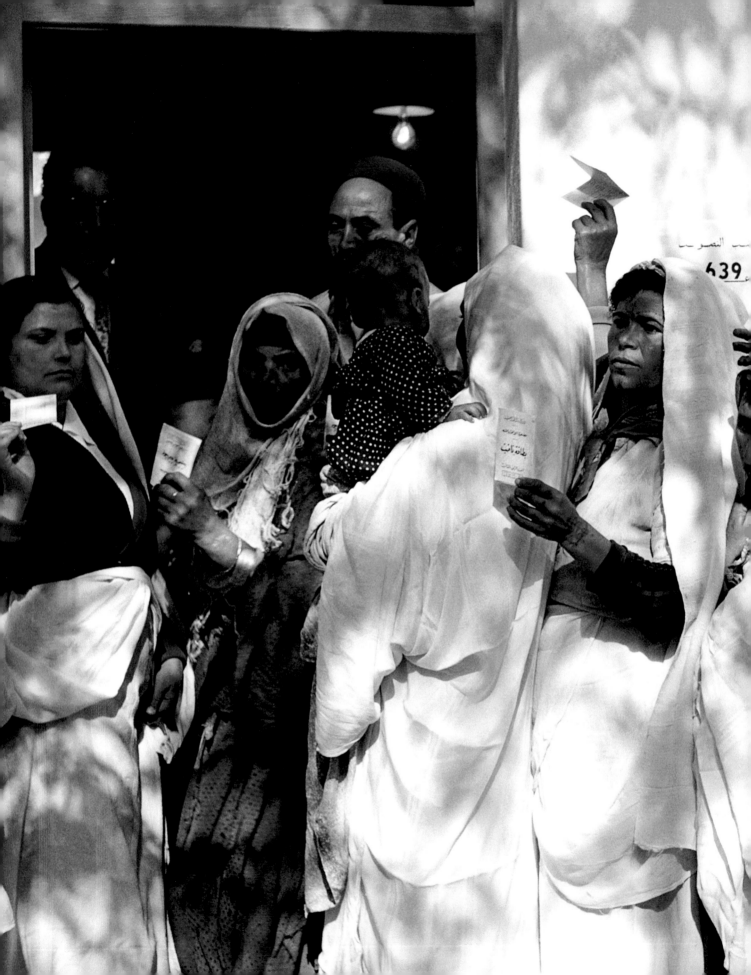

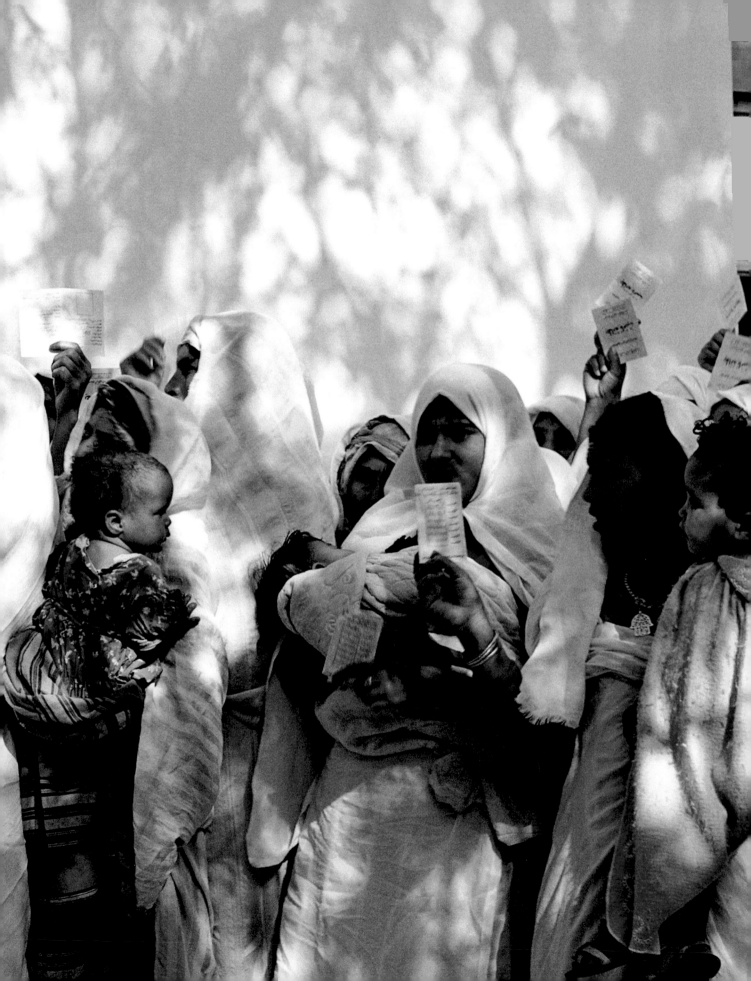

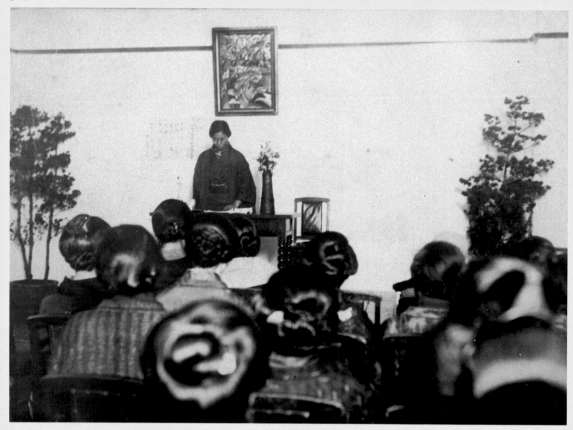

Born in the rural Aichi prefecture, Fusae Ichikawa (1893–1981) rebelled against her abusive father and left for Tokyo in 1910. Women's legal status was rigidly subordinate to men's in pre–World War II Japan, but small challenges to women's exclusion from political life began to occur in the second decade of the twentieth century, as more women entered the labor force as teachers or nurses. The chief obstacle was the Meiji-era law prohibiting women from attending political meetings. By 1923, the New Woman's Association, co-founded by Ichikawa only three years earlier, succeeded in overturning that prohibition. In 1924, she founded the Women's Suffrage League of Japan, which in 1930, held Japan's first national convention on the enfranchisement of women. Nonetheless, as Japan's buildup to war took precedence in the 1930s, the women's movement was thwarted. The U.S. occupying forces imposed suffrage for women in 1945, and Japan's postwar constitution, adopted in 1947, codified suffrage and equal rights for women under the law. Ichikawa was elected to Parliament in 1953.

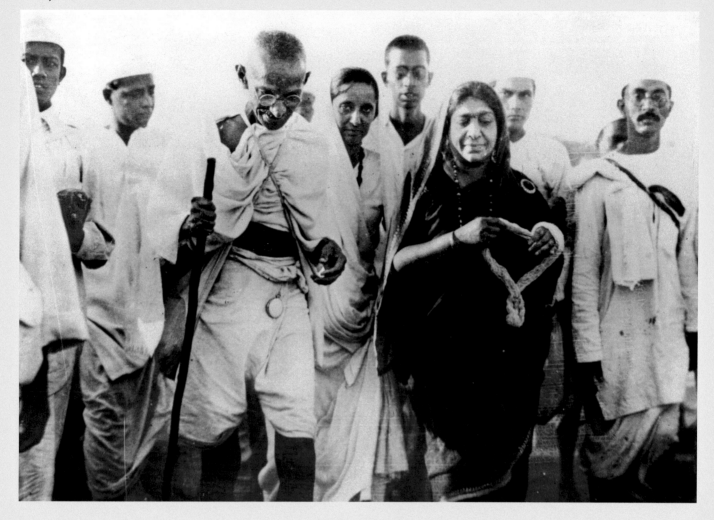

Born in Hyderabad and educated in England, Sarojini Naidu (1879–1949) was as accomplished a poet as she was a feminist and political activist. Upon returning from England, Naidu joined the Indian independence movement, establishing close ties with its leaders, including Mohandas Gandhi, pictured above with Naidu. Naidu was active in the All India Women's Conference, which promoted legislation to protect women and expand voting rights, becoming president of the organization in 1930. In this photo, Naidu accompanies Gandhi during the 1930 Salt March, part of Gandhi's campaign of civil disobedience. Her political activities led to several imprisonments, including a 1942 arrest that led to twenty-one months in jail. After independence, Naidu served as the first governor of the United Provinces (now Uttar Pradesh) from 1947 until her death in 1949, contributing to the drafting of the Indian Constitution. In 1914, she was elected a fellow of the Royal Society of Literature.

China, 1949

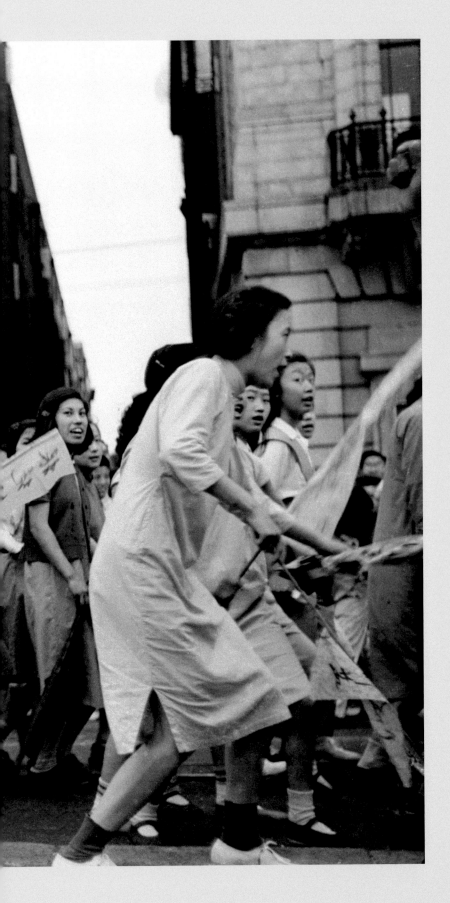

Under the Nationalist rule of Kuomintang leader Chiang Kai-shek, China has largely maintained traditional roles of subordination for women. The Chinese Communist Revolution brought enormous chaos and upheaval as well as a presumed egalitarianism of citizens and equality of the sexes. In December 1948, *Life* magazine sent the French photographer Henri Cartier-Bresson to China to document the turbulent transition from Kuomintang to Communist rule, which coincided with the siege and fall of its cosmopolitan financial center, Shanghai, in March 1948. In this August 1949 photo, students participate in a victory parade on Shanghai's famous Bund. Behind the marchers is the Soong Bank, a symbol of the Kuomintang's corruption that had been owned by Chiang's father-in-law.

South Asia's largest Muslim-majority country, Pakistan, granted women the right to vote upon gaining independence in 1947 (reaffirmed in 1956), yet in 2014, it ranked 141 out of 142 in the World Economic Forum (WEF) report's study of national gender gaps. After Bangladesh (formerly East Pakistan) split off from Pakistan in 1971, voting rights for women were incorporated into the new nation's constitution. In the intervening decades, Bangladesh has been subject to enormous political upheavals and widespread poverty, so although in 2017 the WEF ranked the nation seventh in the world for women's political empowerment (ahead of the United States, the United Kingdom, and Germany), its rank for women's economic participation and opportunity stood at 129, suggesting the complexity of factors beyond political rights that influence the status of women.

Even in lands unaffected by European colonization such as Japan, similar concepts of Western legal coverture have existed, causing women to suffer similar status as second-class citizens and to demand their suffrage rights. Suffragists were active in Japan during the 1920s and earlier, but the country's traditional leadership and insular culture, resistant to change, denied voting rights to women until the occupying Allied government imposed universal suffrage in 1946. Prewar suffragists including Fusae Ichikawa (1893–1981) formed what in 1950 was renamed the League of Women Voters, which promoted a feminist agenda. Ichikawa became a member of Japan's legislative body, the Diet, in 1953.

In much of the world, colonialism has been the single most critical factor in determining the arrival of women's suffrage. European powers have been able to extend their dominion across the globe so effectively that their ideas about society and law have been imprinted in colonies in Africa, Asia, the Middle East, the Indian subcontinent, and in the Americas. And yet the political interests of the colonial powers have almost always been at odds with those of their colonies, and therefore true democratic participation by colonized citizens often has been a nonstarter. For most African nations (including Tunisia), women's suffrage has come with the democratic agendas of nationalist movements for independence.

Suffrage for women in India, following decades of activism from women like Sarojini Naidu (1879–1949) and Hansa Mehta (1897–1995), likewise came with independence in 1947. The nationalist movement in India, though aimed at ending British rule, adapted British democratic ideals for its own purposes, including universal suffrage. In China, the nation with the world's largest population, the fight for women's suffrage was tied to the overthrow of dynastic rule. Chinese women, led by Tang Qunying (1871–1937), had achieved a degree of success leading up to the revolution of 1911. They were ultimately thwarted by Sun Yat-sen, along with the newly formed National Assembly, who advised that women's suffrage be a long-term goal. For women in China, the right to vote finally came with the 1949 Revolution. Between women in India and China,

roughly a quarter of the world's population gained
the franchise in a little more than a year.

Nation by nation, decade by decade, women have
shifted political debate and cultural norms until
woman suffrage went from being unthinkable
to becoming law in nearly all the world. Armed
with the right to vote, women have been able to
address the larger inequities once enumerated
by Elizabeth Cady Stanton in her Declaration of
Sentiments. With the vote, they could begin to
take control of their bodies, their pocketbooks,
and even their notions of self.

No woman can call
herself free who
does not control her
own body.

Margaret Sanger

The Right to Choose

In the modern era, women's bids for citizenship have rested on establishing and legally enshrining women's control over their bodies—consolidating their rights to determine their medical care and make decisions about their own motherhood. Just as calls for women's suffrage hinged on the fundamental equality of their personhood, women's full economic and political participation likewise requires that each woman have control over when or if she becomes a mother. Women's rights advocates have never argued against motherhood—that caricature has its roots in anti-suffrage and anti-feminist rhetoric—only that women ought not to be forced to become mothers. Feminists have argued that access to birth control and abortion, as well as support for babies and mothers, provides women the freedom and independence necessary for citizenship. Abortion has never been the goal; the intent is to give women the power to control their own lives.

There is a long history of women taking steps to prevent pregnancy and to control the timing and the number of children they have. In ancient Egypt, Mesopotamia, China, and India, the oldest human societies, women used a mixture of plants and viscous extracts to create a pessary to block sperm from entering the uterus. Honey, elephant and crocodile dung, and natural pitches or resins, in combination with plants such as acacia leaves, willow, date palm, pomegranate, and myrrh formed natural barriers to block conception. Women also took herbs to control fertility, some of which induced abortion in the early stages of a pregnancy. Mothers in many societies used lactation, or breastfeeding, for up to three years of a newborn's life for birth control purposes. The single most effective method of birth control before the advent of rubber barrier methods was *coitus interruptus* or withdrawal before ejaculation. Mothers, midwives, and families sometimes resorted to infanticide after birth, often due to superstitions about twins, or because babies were born with physical deformities—or were female. A third-century Chinese philosopher wrote that a father and mother "celebrate" when they produce a boy but "when they produce a girl they put it to death." "Folk wisdom" around matters of pregnancy, abortion, and birth control has historically been the knowledge of women, namely female relatives, who have aided in dealing with these matters discreetly.

Nevertheless, two powerful, male-controlled institutions eventually challenged women's pre-modern authority over the birthing process: the Catholic Church and the medical profession. In medieval western Europe, the Catholic Church deemed all efforts to prevent pregnancy immoral and persecuted women whom the church saw as intervening in God's will. A new wave of witch hunts that began in the late 1400s targeted so-called "devil worshippers," whom the church believed to possess satanic knowledge about life and death. Believers accused witches (and midwives) of murdering infants in the womb (abortion), killing men's seed (contraception), as well as infanticide.

The European and American medical establishments of the nineteenth century likewise shored up their own authority by denouncing women's folk knowledge about pregnancies. Doctors challenged midwifery and took the place of midwives at the side of laboring women. New medical inventions like forceps and lying-in hospitals contributed to the medicalization of reproduction, as postpartum confinement became the medical standard and men dominated the professional field of obstetrics. Many midwives bitterly opposed the involvement of men in childbirth, claiming that men who practiced gynecology and helped with childbirth lacked understanding and were prurient. By the late nineteenth century, the delivery of babies by male doctors had become widespread in the U.S. and the training of midwives was more narrowly standardized. At the same time, medical colleges forbade women from attending births and banned them from formal training. Elizabeth Blackwell, considered to be the first female doctor in the United

Greece, 308–277 B.C.E.

Germany, 1487

MALLEVS
MALEFICARVM,
MALEFICAS ET EARVM
hæresim frameâ conterens,
EX VARIIS AVCTORIBVS COMPILATVS,
& in quatuor Tomos iustè distributus,

QVORVM DVO PRIORES VANAS DÆMONVM versutias, præstigiosas eorum delusiones, superstitiosas Strigimagarum cæremonias, horrendos etiam cum illis congressus; exactam denique tam pestiferæ sectæ disquisitionem, & punitionem complectuntur. Tertius praxim Exorcistarum ad Dæmonum, & Strigimagarum maleficia de Christi fidelibus pellenda; Quartus verò Artem Doctrinalem, Benedictionalem, & Exorcismalem continent.

TOMVS PRIMVS.
Indices Auctorum, capitum, rerúmque non desunt.

Editio nouissima, infinitis penè mendis expurgata; cuique accessit Fuga Dæmonum & Complementum artis exorcisticæ.

Vir siue mulier, in quibus Pythonicus, vel diuinationis fuerit spiritus, morte moriatur Leuitici cap. 10.

LVGDVNI,
Sumptibus CLAVDII BOVRGEAT, sub signo Mercurij Galli.

M. DC. LXIX.
CVM PRIVILEGIO REGIS.

ABOVE, LEFT According to early classical texts, abortion in ancient Greece was performed by midwives who likely used the herb silphium as an abortifacient. Silphium was also used as a seasoning, perfume, and an aphrodisiac. The plant, now extinct, was an export of Cyrene (part of current-day Libya), and Cyrenian coins such as this one depicted it. It is possible that some regions of ancient Greece had bans on abortion, but the fact that it was often discussed by Greek philosophers such as Plato and Aristotle suggests that it was not uncommon. The Greek physician Hippocrates provided several recommendations for inducing miscarriage: exerting pressure on the uterus, jumping up and down, and using herbal purgatives.

ABOVE, RIGHT The *Malleus Maleficarum*, translated as the *Hammer of Witches*, is one of the oldest and best-known treatises on witchcraft, second only to the Bible in sales for nearly two hundred years. Written by a discredited Catholic clergyman, Heinrich Kramer, and published in Speyer, Germany in 1487, it endorsed the extermination of witches, the majority of whom were women, many over the age of forty. Advocating torture to obtain confessions and death as the only cure for sorcery, Kramer argued that women are "prone to believing," and as such, demons target them for corruption. The *Malleus* developed a detailed legal and theological approach to witchcraft and was used by royal courts during the Renaissance. Writings such as this were used to justify brutal witch hunts across Europe and America in the fifteenth, sixteenth and seventeenth centuries.

States, applied to nearly thirty medical schools in the mid-1800s and was rejected by all on account of her sex. The Geneva Medical College in western New York finally admitted her. In 1868, she founded the first American medical school for women, an important step in women reclaiming a place at the side of laboring women. Blackwell eventually became a Professor of Gynecology at the London School of Medicine for Women.

Slowly, sex-segregated medical training gave way to co-education, led by the University of Michigan in 1870 and Johns Hopkins Medical School in 1893. Women training to be doctors had a shallow form of equality in a field that limited their numbers in medical schools, routinely blocked them from membership in medical societies, offered them limited hospital access, and blocked them from being hired as interns. Nevertheless, women persisted, with some 20,000 women graduating from U.S. medical schools between 1930 and 1970, when the numbers of women in medical school surged to new highs.

An issue of central importance to a small, more radical contingent of women's rights activists in the nineteenth century was voluntary motherhood, or the right to decide when to have a child and whether to limit family size. Too many women had seen the dangers of multiple pregnancies. Elizabeth Cady Stanton, the organizer of the Seneca Falls Convention and a mother of seven, wrote powerfully about women's need for self-sovereignty in an 1892

speech. "The strongest reason for giving woman all the opportunities for higher education, for the full development of her faculties, forces of mind and body; for giving her the most enlarged freedom of thought and action; a complete emancipation from all forms of bondage, of custom, dependence, superstition; from all the crippling influences of fear," she asserted, "is the solitude and personal responsibility of her own individual life." This call for selfhood rested on women's right to physical and reproductive autonomy. For Stanton, self-sovereignty and economic autonomy went hand in hand, one being impossible without the other. Victoria Woodhull, a charismatic supporter of women's rights who was the first woman to run for president of the United States (in 1872), likewise offered the radical idea that women's equality began with the freedom to control the number of children they had without government interference. A vocal advocate of "voluntary motherhood" and a wife's right to say no to sex with a husband, Woodhull supported women's right to choose the terms of their own lives in much the same way men did. Women's lives were different from men's, but she surmised that much of that difference came as a result of numerous pregnancies and large families. Both Stanton and Woodhull highlighted what eighteenth- and nineteenth-century reformers called the "slavery" of women trapped in marriages by economic hardship, children, and fear. Women's lives and social contributions could be greater if they could control their reproductive lives, they argued, benefiting society as a whole.

THE

BOOK OF NATURE;

CONTAINING

INFORMATION FOR YOUNG PEOPLE

WHO THINK OF

GETTING MARRIED,

ON THE

PHILOSOPHY OF PROCREATION

AND

SEXUAL INTERCOURSE;

SHOWING

HOW TO PREVENT CONCEPTION

AND TO

AVOID CHILD–BEARING.

ALSO, RULES FOR

MANAGEMENT DURING LABOR AND CHILD-BIRTH.

BY JAMES ASHTON, M. D.

Lecturer on Sexual Physiology, and Inventor of the "Reveil Nocturne."

NEW YORK:

PUBLISHED BY WALLIS & ASHTON, 243 GRAND STREET.
1861.

UNIMPREGNATED FEMALE FORM.

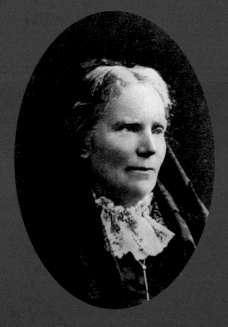

ABOVE Published in 1861 in New York City, *The Book of Nature*'s subtitle left nothing to the potential reader's imagination: "Containing information for young people who think of getting married, on the philosophy of procreation and sexual intercourse; showing how to prevent conception and to avoid child-bearing. Also, rules for management during labor and child-birth." As the publishing of books extended the reach of experts, and as the medical profession elbowed its way into intimate life, sex manuals like this displaced older sources of guidance and became important conduits to establishing oneself as knowledgeable in the ways of the world.

RIGHT Elizabeth Blackwell, who completed her medical education in 1849, is considered to be the first female doctor in the United States. Blackwell worked tirelessly to establish medical schools for women. She was not the first female doctor to serve. That title goes to Marie Josefina Mathilde Durocher, a Brazilian obstetrician, midwife, and physician, who became the first female doctor in Latin America in 1834.

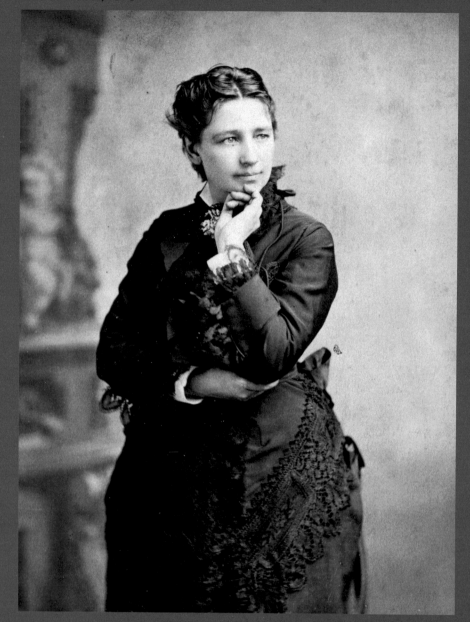

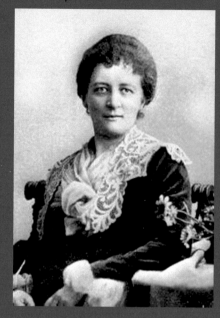

ABOVE, LEFT In the mid-nineteenth century, American
Victoria Woodhull (1838–1927) linked women's personal and
political liberation by demanding the right of women to control their
reproductive and sexual lives. Woodhull took her place among
such controversial "free love" advocates as Germany's Lily Braun
and Minna Cauer, Madeleine Pelletier of France, and Edith Lees
and Emmeline Pankhurst of the U.K. Blackwell's commitment
to promoting women's health was far-ranging, and included opening
a free dispensary to provide outpatient treatment to poor women
and children in 1851 and authoring a book about girls' physical and
emotional development, titled *The Laws of Life* (1852).

ABOVE, RIGHT Lily Braun (1865–1916) was a German feminist
activist and writer. Throughout her life, Braun worked against the
economic and social oppression of women. She was particularly
interested in reforms that would help single and working mothers.
As a radical voice in the Social Democratic Party, Braun argued that
women should be given maternity insurance, allowing them to leave
their jobs to give birth and care for their infants. She proposed that
the government should pay for the insurance through a progressive
income tax. With these protections in place, Braun believed that
all women would have a chance at being mothers and participating
in the workforce at the same time.

Yet most discussion of female sexuality remained couched in biblical terms that stigmatized women by limiting them to the extremes. In this context women were viewed either as virgins or whores, a phenomenon Sigmund Freud later described as the Madonna-whore complex. So-called "good" women were virginal until marriage, and "bad" or "fallen" women—especially those who did sex work—warranted none of the protection "good" women received. The nineteenth-century social purity movement, made up largely of white, middle-class women who protested against prostitution and the spread of venereal disease, addressed the double standard of men being granted the social license to visit brothels as they left their wives vulnerable to disease. The movement was less successful in removing sexual stigma from the "fallen women" forced by economic hardship into lives of prostitution, though it did shed some light on the double standard that shamed prostitutes more than the men who visited them. Although this was one of the early critiques of male sexual appetites and a society that indulged them, more often than not, women were still demonized for feeding those appetites rather than expecting men to control their sexual impulses.

Frances Willard, the leader of the Woman's Christian Temperance Union (WCTU) in the United States from 1879 to 1898, insisted that sexual activities in marriage should occur only under conditions of "mutual assent." As a social purity advocate, Willard crusaded against prostitution, rape, and the sexual exploitation of children, as well as against alcohol consumption, claiming that drunkenness led to sexual degeneracy. In its battle against the sexual exploitation of women, Willard's WCTU targeted the age of consent, the age at which a girl could legally agree to sexual relations. Most states had fixed the age of consent at ten. A massive petition drive organized by the WCTU raised the age of consent to sixteen by the turn of the century, making men who had sex with an underage woman liable for arrest and prosecution for statutory rape. At the same time, however, Willard also supported the passage of the Comstock Act in 1873, which made it a criminal act to send "obscene, lewd or lascivious materials"—pornography—as well as items intended "for any indecent or immoral use," such as condoms, through the U.S. Postal Service. In time, government officials came to use the law to block the mailing of information disseminated by birth control advocates to help women prevent unwanted pregnancy. The moral judgments of sexual purity advocates left a mixed legacy. On the one hand, they identified double standards in the sexual behavior accepted in men and women. On the other hand, they continued to couch women's sexuality in terms of morality, rather than in terms of self-sovereignty or natural rights, thus doing little to rid women of the virgin-whore binary that damned them at either extreme.

Settlement houses (see p. 59) in large cities like Chicago, New York, and San Francisco offered protection to young women from procurers and sent volunteers to the country's major immigration centers like New York's Ellis Island and San

Francisco's Angel Island to offer aid to women traveling alone. The high point in the rescue work occurred in 1910 with the passage of the Mann Act, making it a federal crime to take a woman across state lines for an "immoral" purpose. This law, known as the White Slave Traffic Act, was aimed at keeping innocent girls from being lured into prostitution, but in practice was used to criminalize many kinds of consensual sexual activity, including interracial sex and adultery. The law has since been amended, but not overturned.

Although all women have sought predictable and safe birth control, none have struggled more to get it than immigrant, minority, and working-class women. The Comstock Law made that search more difficult. At the turn of the twentieth century, the essential contours of birth control remained unchanged: women relied on sponges, pessaries, and douching, and practices like the rhythm method and charting menstrual cycles. But these methods could be unreliable. Many women, desperate not to have another child to feed, relied on underground networks of abortionists. Margaret Sanger witnessed firsthand the toll multiple pregnancies, large families, and botched abortions took on women. In 1914, she began to publish a monthly newsletter, *The Woman Rebel*, in which she advocated the use of contraception to support the health of working families. Deemed obscene under the Comstock Law, the paper was banned from the mails. With a warrant out for her arrest, Sanger fled to England while her allies in the United States distributed her 16-page pamphlet, "Family Limitation," in which she described a variety of contraceptive devices and techniques. Sanger visited a Dutch birth control clinic where she learned about diaphragms, the birth control method she came to favor and popularize in the United States.

Undeterred by her legal troubles, Sanger returned to the U.S. in 1915 determined to equip poor and working women with knowledge about their bodies and reproduction. She started the first birth control clinic in Brooklyn, New York. In 1921, she founded the Birth Control League (later renamed the Planned Parenthood Federation of America), and turned her attention to changing federal laws forbidding contraception. In 1936, Sanger directly challenged the Comstock Act by ordering a large shipment of a new kind of diaphragm from Japan, which was promptly seized upon arrival. The resulting Supreme Court case, *United States v. One Package of Japanese Pessaries*, overturned restrictions on medical professionals to ship and receive contraceptives and condoms. Sanger organized the first birth control clinic staffed by all-female doctors as well as a clinic in Harlem with an all–African American advisory council. Sanger lobbied the United States Congress to legalize contraception, and by 1940, all states except Massachusetts and Connecticut had legalized the distribution of birth control information to married couples.

Modern anti-abortion advocates have shunned Sanger as an abortionist with Social Darwinist

United States, 1889

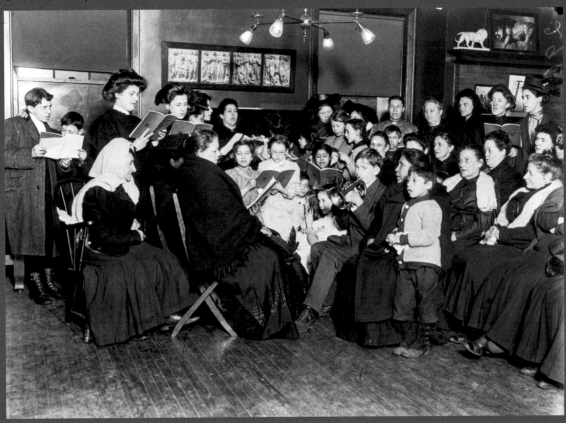

United States, 1892

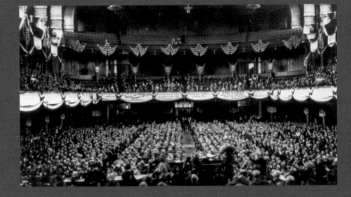

ABOVE Jane Addams and Ellen Gates Starr opened Hull House, a Chicago "settlement" house, in 1889. Modeled on Toynbee Hall in the East End of London, Addams and Starr established educational and social services for working-class people, most of whom had recently emigrated from Europe to find work in the industrial factories ringing most major American cities. Hull House classes sought to train and uplift by teaching immigrants American standards of sanitation, food preparation, laundering, and house cleaning. Part of their Americanization efforts involved classes in history, literature, and, as seen here, singing. Hull House addressed not only the perceived needs of immigrants, but also those of the educated middle-class women in search of outlets for their political views and professional talents.

RIGHT In 1892, Cincinnati, Ohio hosted the National Prohibition Convention. The Prohibition Party, the oldest third party in America, accepted women as party members in 1869, fifty years before the passage of the Nineteenth Amendment. Prohibiting alcohol was a women's issue, thanks in no small part to the efforts of Frances Willard and the Woman's Christian Temperance Union, which had its beginning in 1873 as a branch of the Prohibition Party. Women's activism was instrumental to the passage of the Eighteenth Amendment prohibiting the selling and distribution of alcohol.

THE WOMAN REBEL

NO GODS NO MASTERS

VOL. I. MARCH, 1914 NO. 1.

THE AIM

This paper will not be the champion of any "ism."

All rebel women are invited to contribute to its columns.

The majority of papers usually adjust themselves to the ideas of their readers but the WOMAN REBEL will obstinately refuse to be adjusted.

The aim of this paper will be to stimulate working women to think for themselves and to build up a conscious fighting character.

An early feature will be a series of articles written by the editor for girls from fourteen to eighteen years of age. In this present chaos of sex atmosphere it is difficult for the girl of this uncertain age to know just what to do or really what constitutes clean living without prudishness. All this slushy talk about white slavery, the man painted and described as a hideous vulture pouncing down upon the young, pure and innocent girl, drugging her through the medium of grape juice and lemonade and then dragging her off to his foul den for other men equally as vicious to feed and fatten on her enforced slavery — surely this picture is enough to sicken and disgust every thinking woman and man, who has lived even a few years past the adolescent age. Could any more repulsive and foul conception of sex be given to adolescent girls as a preparation for life than this picture that is being perpetuated by the stupidly ignorant in the name of "sex education"!

If it were possible to get the truth from girls who work in prostitution to-day, I believe most of them would tell you that the first sex experience was with a sweetheart or through the desire for a sweetheart or something impelling within themselves, the nature of which they knew not, neither could they control. Society does not forgive this act when it is based upon the natural impulses and feelings of a young girl. It prefers the other story of the grape juice procurer which makes it easy to shift the blame from its own shoulders, to cast the stone and to evade the unpleasant facts that it alone is responsible for. It sheds sympathetic tears over white slavery, holds the often mythical procurer up as a target, while in reality it is supported by the misery it engenders.

If, as reported, there are approximately 35,000 women working as prostitutes in New York City alone, is it not sane to conclude that some force, some living, powerful, social force is at play to compel these women to work at a trade which involves police persecution, social ostracism and the constant danger of exposure to venereal diseases. From my own knowledge of adolescent girls and from sincere expressions of women working as prostitutes inspired by mutual understanding and confidence I claim that the first sexual act of these so-called wayward girls is partly given, partly desired yet reluctantly so because of the fear of the consequences together with the dread of lost respect of the man. These fears interfere with mutuality of expression —the man becomes conscious of the responsibility of the act and often refuses to see her again, sometimes leaving the town and usually denouncing her as having been with "other fel-

lows." His sole aim is to throw off responsibility. The same uncertainty in these emotions is experienced by girls in marriage in as great a proportion as in the unmarried. After the first experience the life of a girl varies. All these girls do not necessarily go into prostitution. They have had an experience which has not "ruined" them, but rather given them a larger vision of life, stronger feelings and a broader understanding of human nature. The adolescent girl does not understand herself. She is full of contradictions, whims, emotions. For her emotional nature longs for caresses, to touch, to kiss. She is often as well satisfied to hold hands or to go arm in arm with a girl as in the companionship of a boy.

It is these and kindred facts upon which the WOMAN REBEL will dwell from time to time and from which it is hoped the young girl will derive some knowledge of her nature, and conduct her life upon such knowledge.

It will also be the aim of the WOMAN REBEL to advocate the prevention of conception and to impart such knowledge in the columns of this paper.

Other subjects, including the slavery through motherhood; through things, the home, public opinion and so forth, will be dealt with.

It is also the aim of this paper to circulate among those women who work in prostitution; to voice their wrongs; to expose the police persecution which hovers over them and to give free expression to their thoughts, hopes and opinions.

And at all times the WOMAN REBEL will strenuously advocate economic emancipation.

THE NEW FEMINISTS

That apologetic tone of the new American feminists which plainly says "Really, Madam Public Opinion, we are all quite harmless and perfectly respectable" was the keynote of the first and second mass meetings held at Cooper Union on the 17th and 20th of February last.

The ideas advanced were very old and time-worn even to the ordinary church-going woman who reads the magazines and comes in contact with current thought. The "right to work," the "right to ignore fashions," the "right to keep her own name," the "right to organize," the "right of the mother to work"; all these so-called rights fail to arouse enthusiasm because to-day they are all recognized by society and there exist neither laws nor strong opposition to any of them.

It is evident they represent a middle class woman's movement; an echo, but a very weak echo, of the English constitutional suffragists. Consideration of the working woman's freedom was ignored. The problems which affect the

LEFT Margaret Sanger published eight issues of her feminist magazine *The Woman Rebel* during a period when open discussion of sex education, birth control, and abortion could result in arrest, jail time, or deportation. Through literary pieces on topics like women's rights, love, marriage, unionism, work, prostitution, and suffrage, the magazine brought attention to issues relevant to working-class women. Articles detailing methods to prevent pregnancy brought scrutiny from the U.S. Postal Service for violating the federal Comstock Act, a law that outlawed the publication and circulation of "obscene" materials.

LEFT, BELOW Women in all societies have sought to control their reproductive lives. Folk remedies specifically for "lady troubles" made their way into the marketplace in the seventeenth and eighteenth centuries. The plant pennyroyal, also called squaw mint and mosquito plant, is native to Europe, North America and the Middle East. Its leaves have long been used in traditional folk remedies and as an abortifacient.

NEXT SPREAD (United States, 2017) Photographer Alex Webb captured the ongoing influence of birth control advocate Margaret Sanger. The pink "pussy hat" shown here became an iconic image of the 2017 Women's March protesting the election of President Donald Trump despite accusations of his racist and sexist behavior. Sanger's presence at the march linked women's activism from the turn of the twentieth century to that of that of the #nomore and #metoo movements in the twenty-first.

beliefs. In seeking birth control for poor women, Sanger had indeed made alliances with eugenicists who advocated birth control as a means of "racial purification," but for Sanger, racial purity was not her motivation, nor was abortion her preferred method. Sanger saw birth control, not abortion, as a right: "Do not kill, do not take life, but prevent." This view—that abortion can be avoided by improving access to birth control—informs family planning programs around the world today.

Despite the efforts of people like Sanger, terminating a pregnancy in the United States from the 1910s to the passage of *Roe v. Wade* in 1973, remained the purview of what were called "back-alley" abortion providers, who kept in the shadows to escape prosecution. Abortionists, who were often unlicensed practitioners, took advantage of the women who found them, charging high fees and often doing their work in unsanitary places and without proper medical care. Women with the financial means could travel to hospitals and clinics overseas to get the procedure done or pay a psychiatrist to clear her for a "therapeutic" abortion. Poor and minority women who secured hospital approval, meanwhile, ran the risk of being sterilized without their consent. Others turned to self-induced abortions, using instruments found at home. Thousands of women poured into emergency rooms each year in need of urgent care from botched procedures. The risk of dying from an abortion was closely linked to race and class: nearly four times as many women of color as white women died as a result of back-alley abortions.

After 1965, the Supreme Court started to issue rulings that changed the political landscape for the better for women trying to control their procreation. In *Griswold v. Connecticut* the Court ruled that laws limiting access to birth control violated "the right of marital privacy," establishing the right to privacy as the grounding principle for cases that followed. In 1968, activists from twenty-one states organized to repeal all laws restricting abortion and formed the National Association for the Repeal of Abortion Laws (NARAL). The debate over the legal status of abortion came to a head in 1973, when the Supreme Court finally decided the famous case of *Roe v. Wade*. The court struck down the patchwork of different state abortion laws, arguing that they invaded a woman's right to privacy. In the place of state laws, the court established a new formula that allowed the termination of a pregnancy before the end of the first trimester, after which the state could regulate it. The *Roe v. Wade* ruling established a woman's unprecedented control over her body, but at the same time, it laid the legal groundwork for anti-abortion advocates to argue that where her control ended, a fetus's right to life began. This "right to life" was the rallying cry that defined the culture wars of the decades to come.

Anti-abortion advocates fought the ruling in other ways, too. Opponents of abortion chipped away at federal health programs and the financial support that enabled women to access the procedure by arguing that a woman's right to an abortion did not guarantee the government's funding of it. The Hyde Amendment, which excluded abortion

MARGARET
SANGER
ed To Provide Access To Birth Control
17

Marched To End Segr
1964

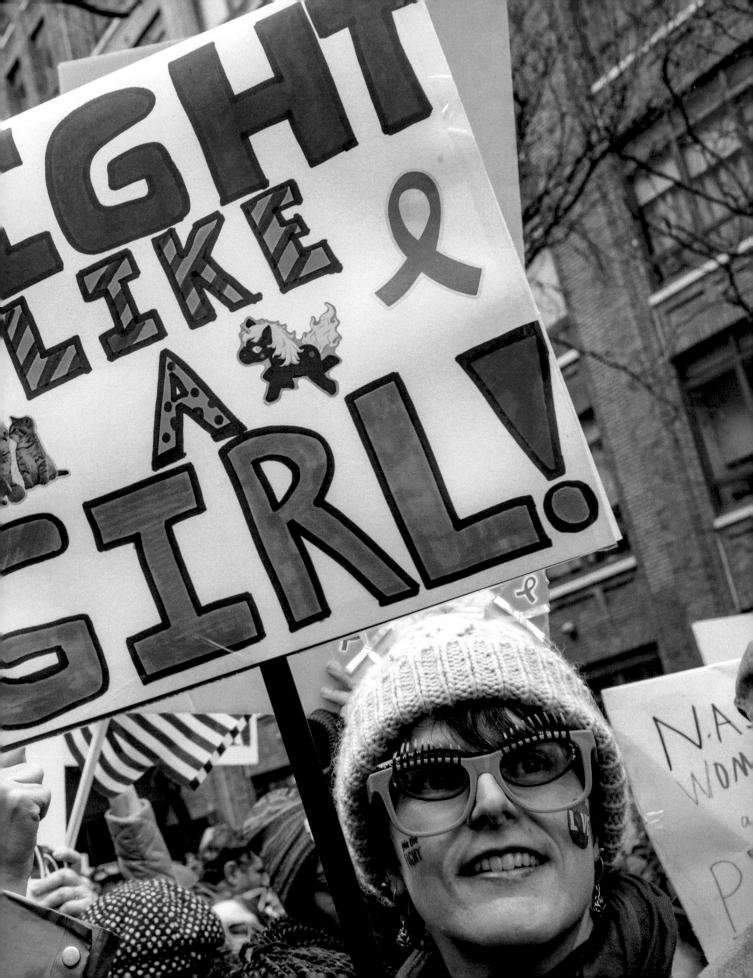

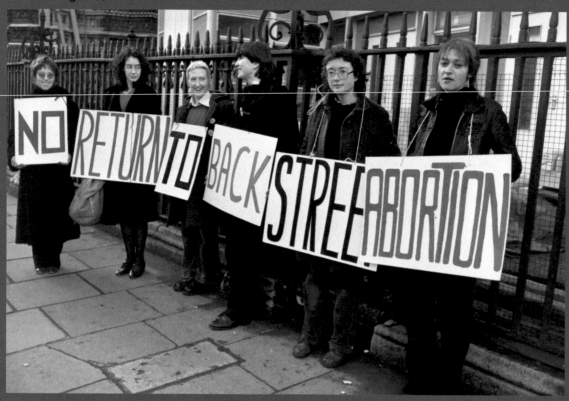

ABOVE Many women, like these in London, took to the streets in the 1980s to protect hard-won access to safe, clean, and legal abortion services. Reproductive freedom had been a rallying cry for feminists and women's rights supporters since the late nineteenth century. Illegal "back-alley" abortions were costly and dangerous, and for activists, underscored the injustice of male politicians, religious leaders, and doctors deciding on when a woman should have a baby. Botched illegal abortions resulted in emergency room visits, infections, and even death for women.

RIGHT (United States, 1965) In *Griswold v. Connecticut* (1965), the United States Supreme Court ruled that states could not deny the sale of contraception to married couples based on a couple's right to privacy. That led ten states to legalize birth control, including Washington, D.C. While married people could get birth control from Planned Parenthood and other doctors, millions of unmarried women still had no legal access to contraception. The introduction of the birth control pill in 1960 and the intrauterine device (IUD) in 1968 gave women more options to control their fertility and helped turn the tide toward legalizing contraception, which happened in 1972. *Eisenstadt v. Baird* legalized birth control for all citizens, irrespective of marital status.

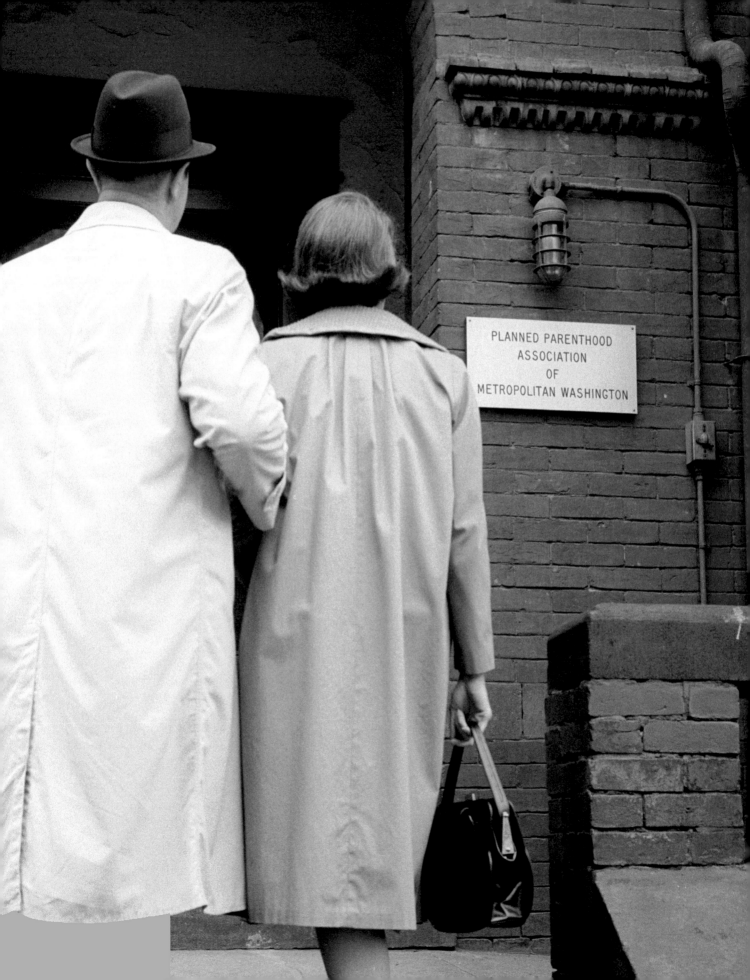

from Medicaid and low-income healthcare programs by refusing to fund the procedure, passed in 1976. In 1989 the Supreme Court ruled in *Webster v. Reproductive Health Services* that states could restrict funds for performing, assisting with, or counseling on abortion, including the use of facilities and the work of staff. Two years later, the court upheld the "informed consent" rule that required doctors to provide women with information about the health risks, waiting periods, and parental permission for minors. In 2014, Obamacare regulations granted states the right to decide whether or not the insurance they offered would pay for the procedure.

No doubt, *Roe v. Wade* did much to reduce the incidence of unsafe abortion in the United States. But it did not eradicate it completely, and it still remains a problem in countries that don't provide for legal abortions or where modern contraceptives are unavailable. Unsafe abortion remains a significant cause of maternal death around the world, leading the World Health Organization to call legal abortion a "fundamental right of women, irrespective of where they live." Yet access to safe abortions has always required social and political activism. Women have not waited to be granted the right to birth control and abortion—they have organized to demand access.

Until 1967, abortion in the U.K. was illegal except to save a mother's life or if it was determined that pregnancy would render the woman "a physical or mental wreck." Before the Protestant Reformation, abortion was dealt with in the ecclesiastical courts, church courts that adjudicated spiritual matters. The defining moment of pregnancy became specified as the "quickening" of the fetus, the moment that fetal movement is felt by the mother. After the Reformation, in the sixteenth and seventeenth centuries, such cases moved to secular courts where abortion was criminalized without distinction. Women who wanted to end a pregnancy relied on folk customs like performing strenuous activities, climbing, paddling, lifting heavy weights, or diving. Others methods involved ingesting irritant leaves, fasting, bloodletting, pouring hot water on the belly, and lying on heated coconut shells. In the early modern period, English women tightened girdles.

As medical knowledge improved in the nineteenth century, advances in surgery, anesthesia, and sanitation made abortion safer, yet no more available to the ordinary woman. Europe and the U.K. passed laws banning the procedure, no matter the stage of pregnancy. Advertisements for elixirs for inducing miscarriage and other abortifacients still ran discreetly in newspapers and other printed materials, as did notices for the services of "backstreet" abortionists, despite their illegality. Concoctions such as "Chichester's English Pennyroyal Pills," "Hardy's Woman's Friend," "Dr. Peter's French Renovating Pills," and "Madame Drunette's Lunar Pills" treated "female complaints" and helped to remove "irregularity" and "obstructions" and ostensibly promoted "menstrual regulation." Similarly, in France, abortion was viewed as a problem of

unwed women, but gradually became seen as a failure of family planning. By the mid-nineteenth century, abortion gained limited social acceptance as a solution to unwanted pregnancies caused by poor contraceptives, despite the country's Catholicism.

In 1929, the criminality of abortion in the United Kingdom was made more dramatic with the passing of the Infant Life (Preservation) Act. This act criminalized the deliberate destruction of a child "capable of being born alive" and presumed that all fetuses *in utero* more than twenty-eight weeks along were viable. With the passage of the Abortion Act in 1967, another exception was added to legislation: a woman could terminate a pregnancy up to twenty-eight weeks, as long as the National Health Service was providing the procedure. In Ireland, abortion had been prohibited since 1861. The Eighth Amendment, allowing for abortion in cases where the mother's life was threatened, was added to the constitution by referendum in 1983, based on a woman's right to privacy. The amendment included a clause that permitted the *Oireachtas* (parliament) to set legislation regarding the procedure. A widely publicized case in 1992 involved a thirteen-year-old girl who had become pregnant as a result of rape. The Attorney General sought to block her from obtaining an abortion in England under the terms of the Eighth Amendment. On appeal, the Irish Supreme Court ruled that the suicidal teenager would be permitted to travel to England to obtain an abortion. Another high-profile case in Ireland centered on Savita

Halappanavar, who died after having been repeatedly denied an abortion while suffering aseptic miscarriage in 2012; her doctor had been prohibited by law from performing an abortion so long as a fetal heartbeat existed. Although it was known that her fetus would not survive, her medical team waited until the fetal heartbeat had stopped, allowing sepsis to take hold. Her case led to widespread protests and eventually the repeal of the Eighth Amendment in September 2018.

Today, most countries in the European Union allow abortion on demand during the first trimester of pregnancy, after which it is allowed only under certain circumstances, such as risk to a woman's health or life, fetal defects, a woman's older age or other circumstances of the conception. In parts of Europe, doctors are allowed to refuse to perform the procedure if it goes against their moral or religious convictions. Malta is the only European country that bans abortion in all cases, including when it can save a woman's life. Germany is unique among European countries for its Nazi-era ban on the advertising of abortion services and information about the procedure by medical clinics and doctors, known as 219a. Abortions are legal in Germany in the first trimester despite efforts to discourage women from getting the procedure. A lifting of the ban would allow doctors to inform patients that they perform abortions. Likewise, if the ban is lifted, the German Medical Association would be allowed to compile a list of doctors and hospitals who offer abortion services.

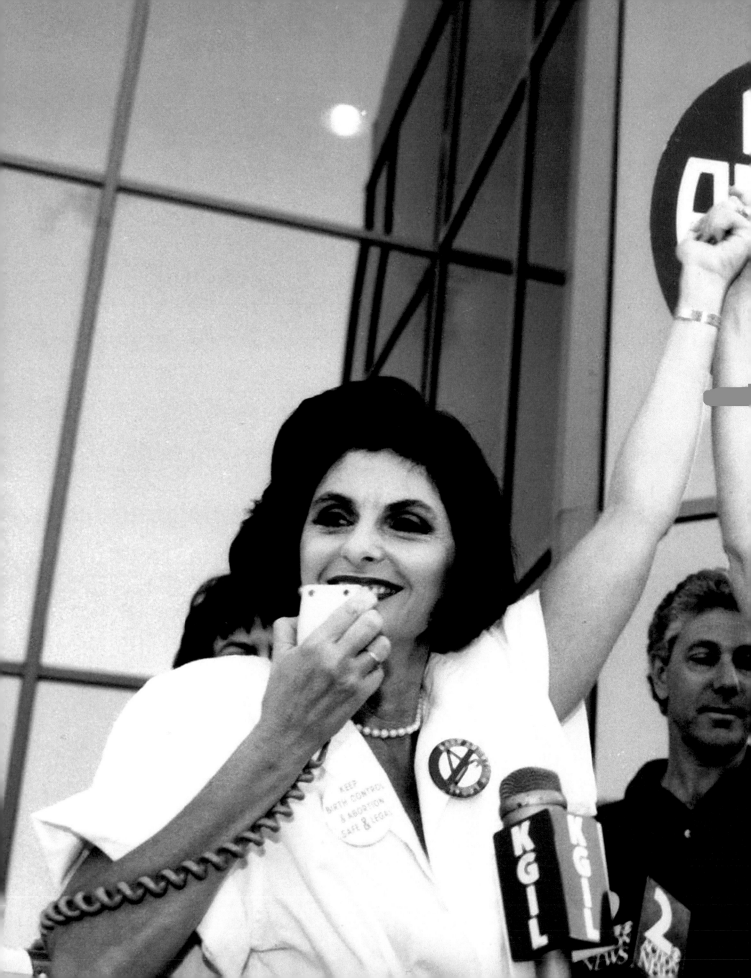

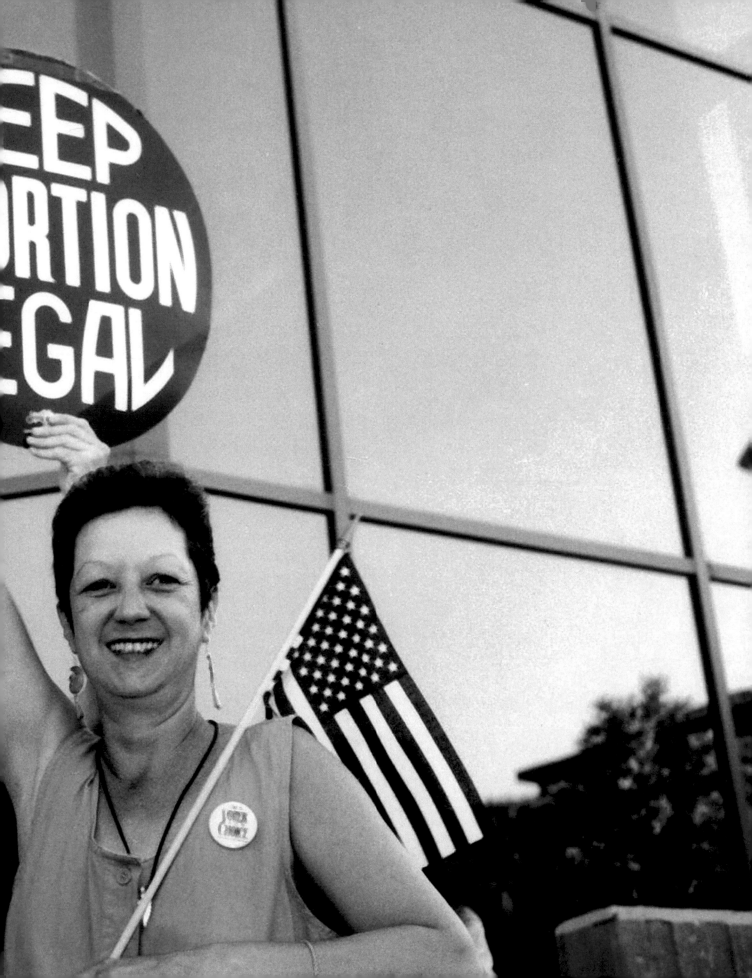

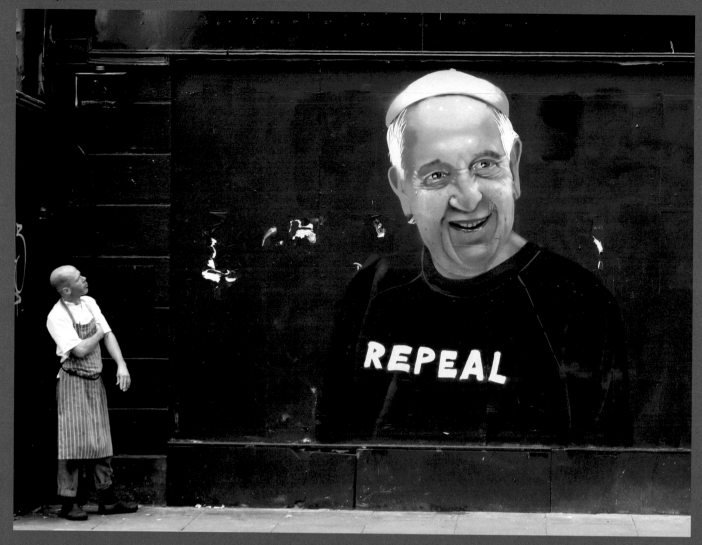

PREVIOUS SPREAD (United States, 1989) Norma McCorvey, aka "Jane Roe" in the 1973 *Roe v. Wade* case, right, and attorney Gloria Allred, at a pro-choice rally in California in 1989. In 1994, McCorvey converted to Catholicism and became opposed to abortion, expressing regret over her role in the Supreme Court case. She joined Operation Rescue, a Christian activist group that opposed abortion, and participated in picketing abortion clinics and protesting congressional hearings until her death in 2017. Activist attorney Allred represents high-profile women, including the twenty-eight women who accused actor Bill Cosby of sexual assault in 2015 and the three women who accused then-candidate Donald Trump of sexual misconduct in 2016.

ABOVE Street art in Dublin, Ireland depicted Pope Francis wearing a "Repeal" shirt in advance of the 2018 referendum on whether to repeal the Eighth Amendment of the Irish Constitution. The Eighth Amendment, established in 1983, equated the right to life of the unborn child with the right to life of the mother, making abortion available in only very limited medical circumstances. The referendum resulted in the repeal of the abortion ban in September 2018.

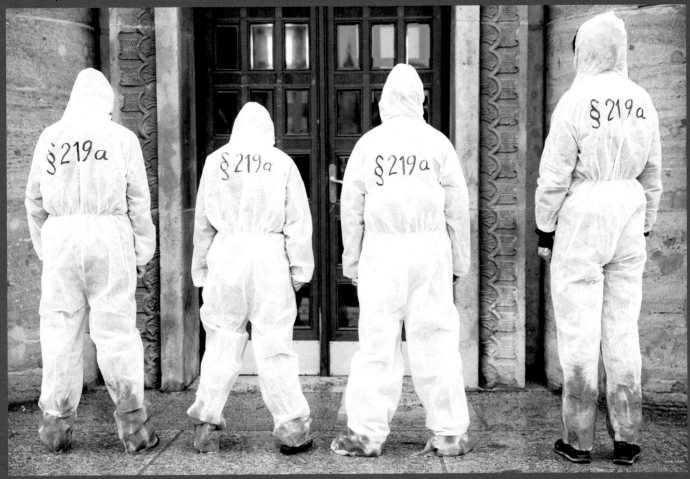

Feminist performance artists in Berlin demonstrated against law paragraph 219a (of the German criminal code) at Rosa-Luxemburg-Platz in Berlin, Germany on January 26, 2019. Introduced in 1933, this Nazi-era article of law prohibits every kind of advertisement of abortion services in Germany. Protesters gathered to register their support for open information and self-determination regarding abortion. Despite the ban, German women are still finding ways to terminate unwanted pregnancies and avoid criminal prosecution or hefty fines.

In 1920, the U.S.S.R. became the first country to allow no-cost abortion in all circumstances, overturning centuries of restrictions similar to those in Europe, the U.K., and the U.S. The Russian Revolution of 1917 brought many changes to the country, including disruptions in farming and food, as landholders surrendered their lands to the regional collective. This led to food shortages and starvation, which in turn contributed to the need for access to abortion in the early years of the revolution. At the same time, the Bolsheviks viewed women as equal members in their new society, and thus implemented changes that European and American women had long pressed for, including legal equality between the sexes, a surge in the number of women who worked outside the home, decrees promoting greater political participation for women, and easier divorce laws. Russian labor laws were generous, giving women eight weeks of paid maternity leave and insurance coverage for children. The Bolsheviks also lifted the old regime's restrictions on family planning.

With the collapse of the Soviet Union in 1989, the country's pro-family policies stayed in place but access to birth control fell, leaving women with few options for family planning. Many resorted to older and less reliable methods of controlling fertility and turned to abortion as a last resort. Between 1990 and 2000 both the number of women seeking abortions and the number of live births fell throughout the country. President Vladimir Putin introduced financial incentives to families for having a second and third child in an attempt to reverse the country's overall population decline, and in 2003 and again in 2011, further restricted access to abortion procedures.

While establishing a woman's right to control her body motivated Western feminists to push for changes in laws that governed reproduction, a second and equally important concern over global population growth has also impacted national policies.

Concerns resurfaced after World War II as populations expanded in the developing regions of the world. High on the list of worries was the potential for global political instability resulting from limited food, water, and land supplies. In the United States, a small group of elites, including John D. Rockefeller III, spearheaded a second population control movement. In 1952, the newly formed International Planned Parenthood Foundation marked the expansion of family planning services from the developed to the developing world. Organizations like the Ford Foundation and Rockefeller's Population Council underwrote the costs of training programs designed to prepare a first generation of family planning leaders across the globe. By the mid-1960s, large-scale funding from international development agencies like the World Bank and the United Nations as well as contributions from Western governments boosted the scale and reach of the movement. The Swedish government supported family planning in Sri Lanka, India, and Pakistan as early as 1962. Fortunately,

ABOVE, RIGHT In the wake of the Russian Revolution, the Soviet Union embraced gender equality with historic fervor. Adolf Strakhov's 1920 poster captures the New Russian woman with the slogan: "You are Now a Free Woman—Help Build Socialism!" Russian women enjoyed access to abortion much sooner than other European and North American women. The new state valued Soviet women's labor in theory if not always in practice. Women's and men's labor did not command comparable pay. And men continued to view housework and domestic chores, including shopping, cooking, and cleaning, as women's work. This meant that Soviet women added wage work to their work day, a phenomenon that U.S. feminists in the 1980s called "the second shift."

Soviet Union, 1925

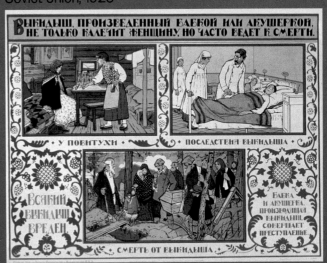

RIGHT In the wake of the Bolshevik Revolution, the Soviet Union's approach to women's reproductive care shifted with the tides of politics. Yet throughout periods of greater and lesser access to birth control and abortion, the message to women remained consistent: traditional methods of birth control, abortion, and birth are dangerous and should be replaced by modern medical care under the supervision of doctors in hospitals and clinics. This 1925 Soviet poster warns that "Miscarriages induced by either grandma or self-taught midwives not only maim the woman, they also often lead to death." The text in the lower right reads, "Any grandma or midwife who induces a miscarriage is committing a crime."

Germany, 1989

Germany, 1924

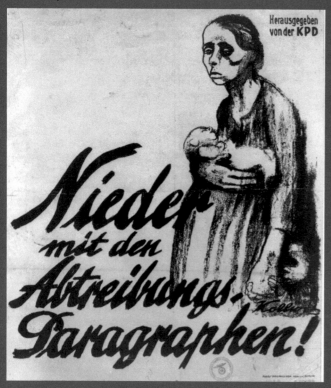

ABOVE Protesters in Memmingen demonstrate against section 218 of Germany's criminal code, which prohibits abortion. In 1976, West Germany revised the law to allow for abortions up to twelve weeks, or to be performed in cases of sexual assault or medical necessity, as long as the procedure is approved by two doctors and the patient meets counseling requirements and a three-day waiting period. After reunification, the Constitutional Court decided to uphold the original law banning abortion, with the understanding that abortions before twelve weeks would not be prosecuted as long as the patient received counseling beforehand. Though abortion still remains technically illegal according to section 218, as of 2010, a woman may seek an abortion within the first trimester as long as she agrees to mandatory counseling, and some later abortions are also allowed based on medical necessity.

LEFT German artist Käthe Kollwitz (1867–1945) depicts the effects of poverty, hunger, and war on the working class. In this etching, a working class mother holds an infant while holding hands with a child. The feeling of helpless exhaustion is instantly recognized and universally understood. The sketch dramatically captures the despair of a woman who cannot control or limit the size of her family. Kollwitz was the first woman elected to the Prussian Academy of Arts in 1928. The Nazi Party authorities forced her to resign in 1933.

Sweden, 1953

Fourth International Conference on Planned Parenthood Stockholm Aug. 1953

ABOVE The International Planned Parenthood Federation (IPPF), originally known as the International Committee on Planned Parenthood (ICPP), was founded in 1948 with the goal of collecting information and spreading awareness about birth control and sex education. Margaret Sanger played a major role in the organization and served as president from 1952 to 1959. The IPPF held a number of international conferences, including this one in Stockholm in August 1953. In the present day, the organization promotes access to safe and legal abortion services and contraception, as well as HIV and AIDS treatment, especially among poor and vulnerable populations. The IPPF lost a significant portion of its funding after the Global Gag Rule was reinstated in January 2017.

NEXT SPREAD (Laos, 2012) In the wake of the London Summit on Family Planning in 2012, more than sixty countries worldwide made the commitment to improve access to family planning and safe reproductive care for teenagers and women. As a result of a global initiative, FP2020, Lao People's Democratic Republic has continued to support maternal and child health services for poor and remote populations and ethnic minorities in clinics around the country, like the one this woman and child visited in 2012 for a pregnancy checkup. In 2017, Laos trained over 775 new family planning providers.

there were simultaneous innovations in contraception technology that would make population control efforts easier and more economical on a mass scale. The development of the modern intrauterine device (IUD) and the oral contraceptive pill in the 1960s made the dream of easy-to-use, effective, and inexpensive contraception a reality, and enabled family planning efforts on an international scale.

Before *Roe v. Wade* in 1973, the most successful arguments for birth control had not been about a woman's right to privacy or self-sovereignty; instead they were made by men in power, controlling women's reproduction for political rather than feminist ends. Feminists in the women's health movement sought to disrupt this male assumption of power. In major cities in Europe and America, women organized to combat both the medical profession's control over women's reproductive lives and the legal restrictions that put reproductive control in the hands of governments. Feminists in West Germany, for example, organized a women's health movement in 1971 to overturn paragraph 218 of the criminal code, the law banning abortion. German law enshrined the rights of the unborn child over those of the pregnant woman, asserting that abortion violated the human rights of the fetus. In response, feminists founded *Cleo*, a journal on women's health, and published a women's health manual, *Bread and Roses*, in 1974. Both became bestsellers. As pressure mounted, German law was modified in 1975 to allow abortion on doctor-approved psychological or medical grounds, and once more after reunification in 1992, to allow for on-demand (woman-initiated) terminations before twelve weeks.

Similarly, as the demand for better access to safe abortions grew internationally, in the U.S. the Boston Women's Health Collective began publishing women-centered and feminist health information in the late 1960s. They taught classes and ran workshops that re-centered women's medical care on the feminist values of choice, autonomy, and health. Their manual, *Our Bodies, Ourselves* (1973), covered sexual health, birth control, abortion, and pregnancy and childbirth, among other topics, and was widely disseminated throughout the country. The book revolutionized the approach to women's health by encouraging women to celebrate their sexuality, to de-medicalize the natural processes of pregnancy and birth, and to take responsibility for knowing their own bodies. The book has been translated and adapted by women's groups around the world and is available in twenty-nine languages.

Yet despite great feminist optimism about women controlling their futures through family planning, cultural resistance to the idea of limiting family size continues. In most developing countries, children play an important economic role in family life, thus providing an incentive to limit family planning initiatives in many regions. Poor planning and inadequate training of field workers compound the difficulties, leading social scientists to advocate for more ambitious social transformations to bring about population control, such as programs that would reduce child and infant mortality and

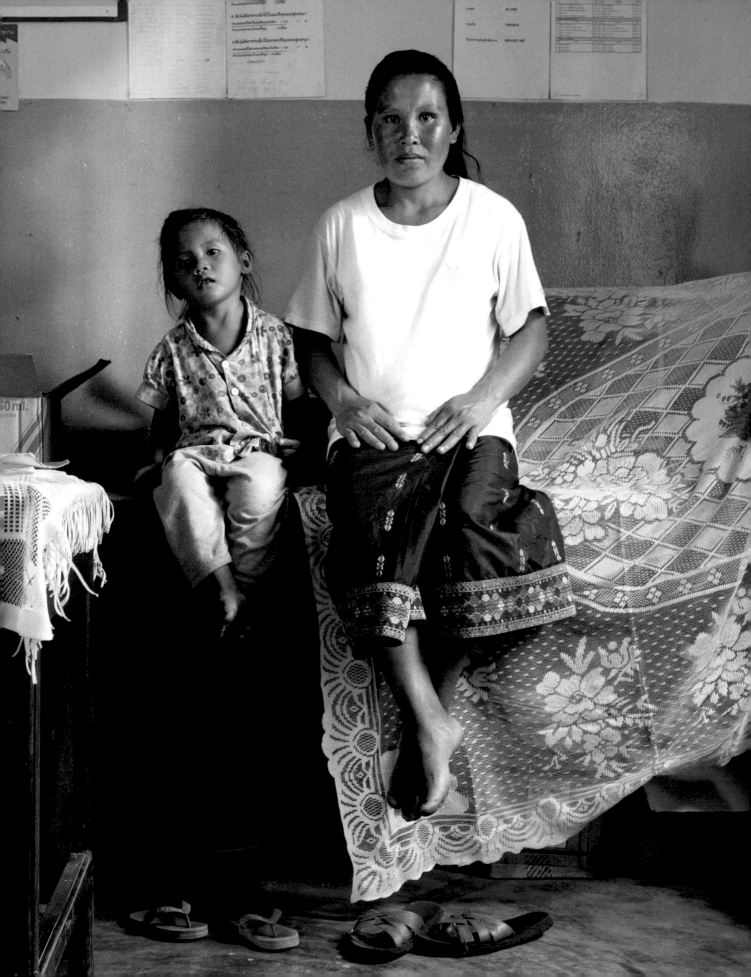

illiteracy and expand educational and economic opportunities for women. These efforts have moved the needle on fertility rates. Between the mid-1960s and the late 1990s, average fertility in the developing world dropped from around six children per woman to around three, as contraceptive use among women increased to nearly 60 percent. In Bangladesh and Kenya, where women bore an average of eight children before 1970, that number was cut to four by 1995 as a result of family planning efforts. China instituted a two-child policy in 1969 to control its population size. This was limited to one child in 1979. Before it was lifted in 2015, the government estimated the policy prevented 400 million births.

While the international family planning movement has had its successes, the rise of religious conservatism in the United States has also limited them to some degree. The "right to life" anti-abortion movement, led by Phyllis Schlafly, eventually shut down American funding for international family planning programs. In 1984, under the direction of President Ronald Reagan, the United States abruptly shifted from its longstanding commitment to population control through family planning programs to a categorical opposition to abortion. The "Global Gag Rule" required any overseas organization receiving United States aid to stop all activities affiliated with abortion. Rescinded by President Bill Clinton, the rule was reinstated by George W. Bush and then rescinded again by Barack Obama. In January 2017, one of Donald Trump's first acts as President was to reinstate the Global Gag

Rule. Unlike in its previous iterations, the new policy applies not only to funding earmarked for organizations that focus on reproductive health (approximately $575 million in 2016), but to all global health assistance "by all departments or agencies"—an estimated $9.5 billion in aid. The Global Gag Rule could result in 6.5 million unintended pregnancies, 2.1 million unsafe abortions, and 21,700 maternal deaths worldwide by 2020. The negative implications of the Global Gag Rule extend far beyond access to safe abortion information and services. In much of sub-Saharan Africa, the United States government provides significant funding for HIV prevention and treatment services through organizations that also provide sexual and reproductive health information and services to women. Particularly in low- and middle-income countries, these providers offer a range of health services under one roof, including access to contraceptives, HIV services, immunizations, and maternal health screenings, alongside information about or access to safe abortion care. Thus, the policy degrades much broader public health programs, including responses to infectious diseases, and stands to reverse global progress in promoting integrated services and people-centered policies across health systems.

The international women's health movement continues to articulate the links between a woman's right over her body to her status as a citizen, no matter the country in which she resides. Without the ability to limit fertility, a woman has little control over her economic future. This was made clear in

China, 2016

Kenya, 2014

TOP Chinese women training to be qualified nannies, known in China as "ayis" at the Ayi University in 2016 in Beijing, China. As the Chinese economic boom expanded the middle class, the need for domestic help mushroomed. Most of the women attending the program are migrants from villages who, like many young women around the world, send part of their wages home to their own families. In 2015, the government ended its one child policy, allowing couples to have two children.

ABOVE Young mothers from the Maasai tribe gather in Shompole, Kenya in 2014 for a forum organized by Amref Health Africa on family planning and other sexual reproductive health options. In this discussion, a community health worker demonstrates condom usage. Amref Health Africa was founded in 1957 to deliver mobile health services including surgeries to underserved populations. In the 1970s, it provided mobile maternal and child health services and trained community health workers to deliver reproductive health care.

United States, 1974

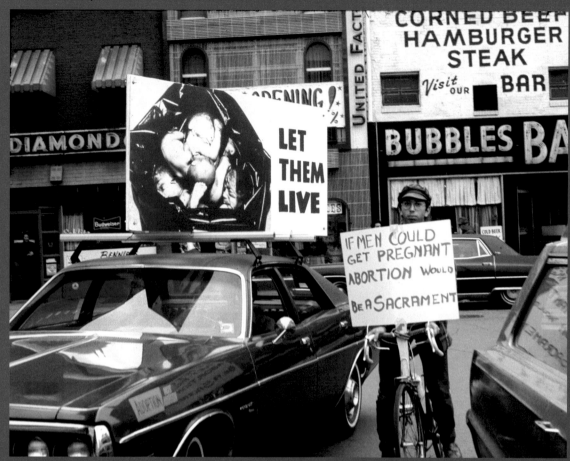

ABOVE Pittsburgh demonstrators, one in a car, the other on a bicycle, argue for and against abortion in 1974. The man on the bicycle is holding a sign with a quote from feminist activist Gloria Steinem: "If men could get pregnant, abortion would be a sacrament." Despite abortion being constitutionally protected, access to the procedure rises and falls on waves of politics. Likewise, funding for international family planning services has fallen prey to waves of conservative republican "gag rules" that limit what doctors and nurses can say about abortion.

RIGHT (Madagascar, 2018) A community health worker enters the consultation room at the Marie Stopes International mobile clinic in Besakoa, Madagascar. Organizations like these directly feel the silencing effects of the "global gag rule," a Reagan-era policy which cuts off U.S. funds for programs overseas that are involved in abortion-related activities, including counseling and informing women about their reproductive choices. Expanded by the U.S. government in 2018, the gag rule effectively cuts all U.S. aid off from any organization providing information related to safe abortion care or any other form of care, including HIV or tuberculosis treatment, contraception services, mother and child healthcare, nutrition programs, and malaria treatment. The impact is significant because the U.S. has become the largest funder of global health programs worldwide. In 2018, Marie Stopes projected an $80 billion budgetary shortfall as a result of this policy.

NEXT SPREAD (Argentina, 2017) A couple in Buenos Aires display their bellies painted with slogans reading "Your uterus, your decision" (right) and "I do insist in the freedom of choice over my body" (left) during a protest demanding the decriminalization of abortion in Argentina. Increasingly, abortion rights are being pitted against the relatively new and untested legal rights of fetuses, promising to unsettle previous social protections over a woman's right to control her body.

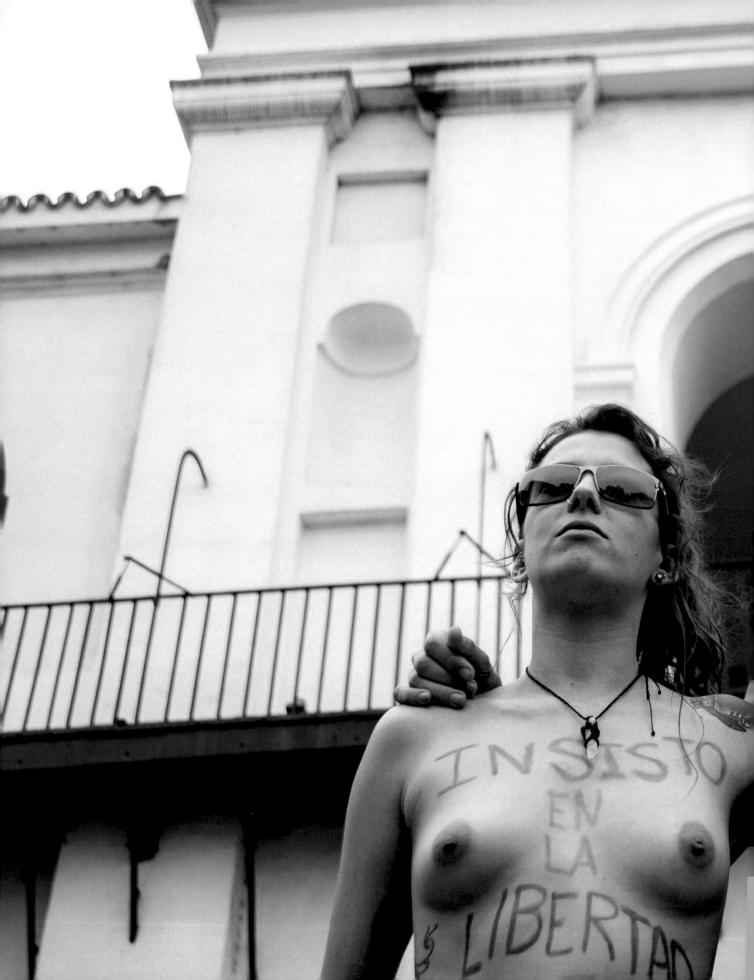

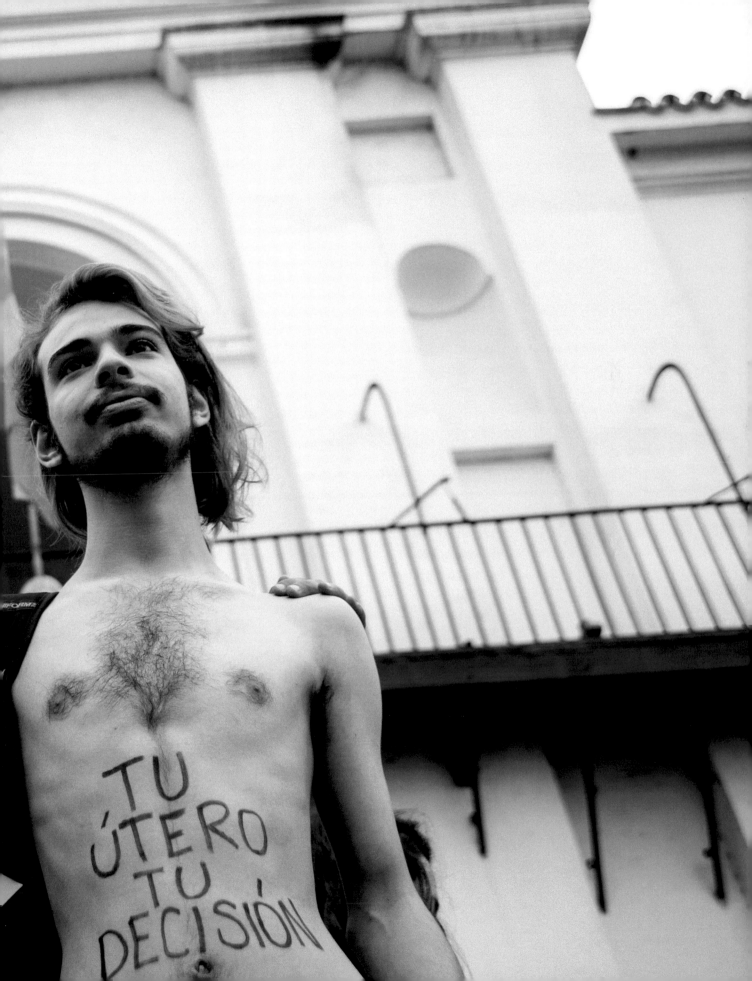

1995 when a coalition of women's health organiza-
tions at the United Nations Women's Conference
drafted the "Fourth World Conference on Women,
Beijing Declaration" in which leaders asserted that
women's "right to control all aspects of their health,
in particular their own fertility, is basic to their
empowerment." All women have a right to control
their sexuality "free of coercion, discrimination and
violence." As a defining framework for change, the
Beijing Declaration (1995) remains an important
source of inspiration and political guidance. It has
inspired ongoing efforts to promote women's health
through better access to birth control, such as the
2012 London Summit on Family Planning, where
the Bill and Melinda Gates Foundation doubled
its investment in family planning to $1 billion by
2020. Foremost, the Beijing Declaration imagines
a world where women and girls are free to exercise
their human rights to safety, education, health, and
equality. At the same time, the authors recognize
the deeper, more elusive right of self-sovereignty,
sounding a note that echoes the words of activists
like Stanton and Sanger over a century ago: "We
affirm our commitment to the empowerment and
advancement of women, including the freedom of
thought, conscience, religion and belief … thereby
guaranteeing them the possibility of realizing their
full potential in society and shaping their lives in
accordance with their own aspirations."

United States, 1989

Your body is a battleground

Artist Barbara Kruger (1945–) creates collages with photographs from newspapers and magazines. Kruger made this piece, *Untitled (Your Body is a Battleground)*, in 1989 for the Women's March on Washington, which promoted women's reproductive freedom. The image was printed on fliers and distributed at the march. Throughout the 1980s, there were a number of anti-abortion laws introduced all over the United States in response to the *Roe v. Wade* decision of 1973. In this image, a woman's face is split in half with positive and negative exposures, indicating the hostility of the abortion debate. Addressing women directly, Kruger sought to draw attention to the way that women's bodies were treated as objects in a political conflict, and perhaps also the unrealistic beauty standards promoted by mainstream magazines. As many feminists have pointed out, Kruger's message remains relevant to this day.

"You must never behave as if your life belongs to a man. Do you hear me?" Aunty Ifeka said. "Your life belongs to you and you alone."

Chimamanda Ngozi Adichie,
Half of a Yellow Sun

Out of the Doll's House

As a quintessentially human institution, marriage has changed over time, pulled and shaped by changes in economics, political orders, and demographic trends. At various times in its long and complex history, marriage has been defined as both a secular and religious contract between two adults, which confers rights and responsibilities on the couple, establishes clear lines of parentage and inheritance, and creates socially recognized family groups. Today, in many places around the world, marriage can happen between same-sex couples or between two non-binary people. And more so than ever before, people also have the option of remaining unmarried or of cohabiting without serious risk to reputation or career. In the twenty-first century, fewer couples formalize their relationships with marriage, but that does not mean that families are not being formed. Rather, it indicates the evolution of the institution and its pliability as societies and women's lives change.

But this was only after centuries of marriage remaining a relatively unchanged bedrock of most societies in the world. Marriage has been so fundamental an institution that the rules governing it predate recorded history. For many centuries, marriage was a vehicle for forming strategic alliances between families, the key agents being not the bride and groom but the couples' parents. Keeping alliances within the family, in cases such as cousins marrying each other, has been a longstanding custom and still remains common, particularly in the Middle East. In some cultures, marriage has accommodated polygamy, the practice of a man having multiple wives. Biblical figures from Jacob to King David had anywhere between two and several hundred wives. Early non-Christian societies granted men the right to dissolve marriages or take other wives when spouses could not produce a living male heir. Although early Christians highly valued procreation, the church did not grant men the right to dissolve marriages when wives could not conceive. Between the sixth and ninth centuries, the Catholic Church gained ascendency and promoted monogamy as the ideal form of marriage, supplanting the practice of wealthy or noble men having multiple wives. Monogamous marriage before the nineteenth century nonetheless gave men wide latitude to engage in extramarital affairs, though children resulting from these unsanctioned unions were deemed illegitimate and without claims to paternal wealth. In stark contrast, women faced serious social and legal consequences for having extramarital trysts.

Although the major world religions all hold that women should marry freely, they differ as to the extent to which they view women as sexually or emotionally autonomous within marriage. Jewish law views marriage as the merging of souls between husband and wife, and couples are commanded to have children. The Talmud dictates that the husband should support his wife materially and love and honor her more than himself, and in return, the wife makes pleasing her husband her highest ideal. Hindu marriage tradition recognizes seven different types of marriage, ranging from arranged unions to forced marriages. Generally most are arranged with the consent of the bride and bridegroom and their families. In some parts of southern India, marriages between cousins are considered normal. Islamic law, or sharia, puts a strong emphasis on mutual love and respect between a husband and wife. The Quran commands husbands to treat their wives with kindness and respect and views emotional and sexual expression between a husband and wife as a form of worship. Sexual relations in Islam, then, are not solely for procreation but are viewed as a way for a couple to connect and strengthen their relationship. Fidelity is also highly stressed, with spouses expected to be loyal and faithful to one another.

Patriarchal societies have ideas about marriage that uphold male privilege and family honor. In Christian countries where monogamy is the law, husbands long enjoyed full, and until recently, unquestioned control over women and children. States that permit polygamy do so for men but not

Chimamanda Ngozi Adichie (1977–) is the Nigerian-born author of *Purple Hibiscus*, *Half of a Yellow Sun*, *Americanah*, and the short story collection, *The Thing Around Your Neck*. Her 2012 TED talk "We Should All Be Feminists" sparked a worldwide dialogue about the meaning of feminism, and was published as a book in 2014. Adichie's clear-eyed delineation of the sexism she experienced growing up in Nigeria, and the hidden realities of sexism in institutions and cultural behaviors around the world, helps readers see and understand the often-masked levers of sexual politics. Adichie convincingly argues that gender inequity is as corrosive for men as it is for women. She was awarded a MacArthur Foundation Fellowship in 2008.

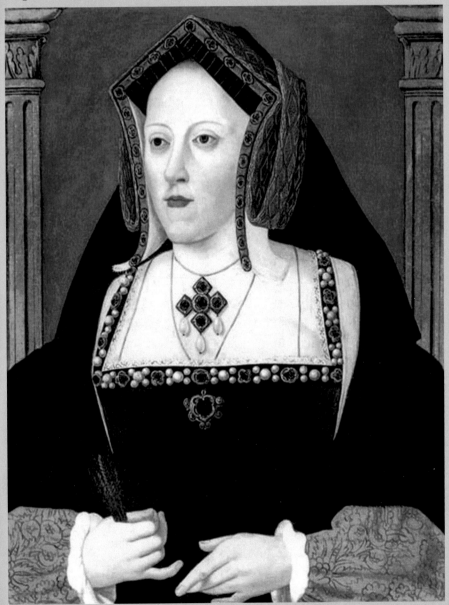

Since antiquity, marriages have been used as tools to form, consolidate, and preserve political power. In addition to providing strategic advantages by joining territories and resources of different families or clans, marriages yield a predictable line of succession, even in parts of the world where multiple spouses and partners are condoned. In the late Middle Ages, the concept of chivalric love emerged. The lover saw himself as serving an all-powerful god of love and worshipping his lady-saint. Catherine of Aragon (1485–1536), the subject of this portrait (painted in the eighteenth century), was married to Henry VIII of England in a dynastic union that was apparently also characterized by love. Henry's quest to end their marriage led to Catherine's banishment and to the formation of the Church of England's after Henry's break with the Roman Catholic Church.

In the *Ramayana*, one of the great Hindu epics, the goddess Sita devotedly follows her husband Rama into exile, living in the forest for twelve years. Sita is kidnapped by the evil Ravana during her exile, but is rescued by Rama. Seeking to prove that her virtue remained intact during her captivity, Sita mounts a lighted pyre. She is unscathed by the flames, and so Rama happily accepts her back into his household, as Sita exemplifies the behavior of the proper Hindu wife. The story is enacted yearly in villages and cities all over India. In this photo, children play the parts of Sita, Rama, and Rama's younger brother Lakshman (right to left) during the Ramnavmi Festival in the Punjabi city of Amritsar. Other Sanskrit texts, vernacular writings, and oral traditions also demonstrate that the happiness or salvation of a woman is a function of her faithful devotion to her husband.

Nigeria, 2003

Iran, 2018

ABOVE Thirty-one-year-old Amina Lawal was sentenced to death by stoning in 2002 for having a child out of wedlock in her rural village in Katsina, in northern Nigeria. Lawal, who was divorced, had admitted to having had a relationship with the man she identified as the father of the child, but the man denied the charge and was deemed innocent by the trial court. Lawal's conviction was overturned in 2003 by a Katsina State Shariah Court of Appeals, largely on the basis of technicalities in the application of Islamic law. Her case became an international cause célèbre that highlighted the plight of women in Nigeria's northern Muslim states, where extreme interpretations of sharia law have become increasingly common.

LEFT A woman on Enghelab (Revolution) Avenue in Tehran protests the obligatory Islamic headscarf by removing hers and waving it on a stick, part of a larger protest against strict Islamic law in Iran. For some Muslim women, the hijab is a symbol of oppression; for others, it is an indicator of religious devotion and modesty, and a protection. The woman in the photo was arrested.

for women. Sharia law as it is practiced in Saudi Arabia, Bangladesh, and Pakistan, allows for the practice of polygamy but limits the number of wives a husband may have to four. Polyandry, or a woman marrying more than one husband, is not permitted, because such a practice would disrupt channels of children's inheritance as heirs. In patriarchal societies, the activities of girls and women are closely monitored. Protecting a woman's virginity and sexual purity are considered to be the responsibility of husbands, brothers, and sons. At the extreme are honor killings where male family members kill girls and women for supposedly engaging in "sexually immoral" actions, ranging from rape and adultery to openly talking to men who are not related to them. Women can be targeted for murder for a range of reasons, such as refusing an arranged marriage, seeking a divorce, or for acting suspiciously. Female relatives often defend the killings. Male-dominated societies also set the age of marriage for girls as low as eleven, enabling male control of female sexuality to transition from father to husband.

Over time, marriage moved from being arranged by families to being a matter of individual choice where women could exercise more power. But it took time for that more romantic view of marriage to become established. In the Middle Ages in Europe, families, not judges or priests, oversaw marriage rites and ceremonies. No vows or witnesses were required. A couple's word that they had married was sufficient proof of their union. Even notifications of marriages were not required until 1215, when the church ruled that partners had to publically post notice of their upcoming nuptials at their local place of worship. Since the seventeenth century, the state has played a growing role in officiating unions. In 1639, the Commonwealth of Massachusetts required marriage licenses, and the requirement was common throughout the United States by the nineteenth century.

When the ideal of romantic love figured into the choice of a spouse in the eighteenth century, it was seen as spiritual and emotional and a necessary corrective to the so-called animalistic and primitive qualities of sexual lust. It took time for "love matches" to become more common than family-arranged marriages; historians attribute the shift to the rise of the market economy. Whereas fathers once controlled land and inheritance, which gave them power over a child's marital options, sons eventually made their way in the world without the help of their fathers and with only the value of their own labor to count on. Greater independence translated into greater freedom over many other aspects of life, including marriage—at least for men. For women, their economic dependence on male heads of household meant they had very little de facto say over whom and when they would marry.

While marriage granted a husband command over family and home, women were seen as uniquely unfit for such responsibility. The biblical story of Adam and Eve taught of an essential weakness in woman that made her vulnerable to the serpent's

temptations. Medical doctors believed that dislocations of the uterus left women's judgment severely impaired, or "hysterical" (from the Greek for womb, *hystera*). Their so-called "wandering wombs" made them unstable, the logic went, and hence women lied, gossiped, and lacked sexual control. In pre-modern Europe, such views led to accusations that women were witches, under the control of Satan, or susceptible to the temptations of pagan magic. As a consequence, men restricted women's role in the church and even looked at midwives who served at bedsides during birth or death with suspicion (see p. 52). The notion that women needed patriarchal protection and guidance extended from households to government. In most societies, husbands managed money, property, and all other assets their wives brought to their marriages.

English common law subsumed a wife's legal identity into her husband's under the rules of coverture (see p. 14). In countries that followed Roman law, such as Spain, the Netherlands, and France (unlike in England and the U.S.), a married woman maintained the right to hold any property she inherited from her father. In Spain, girls and boys could inherit property from both their mothers and their fathers, just as they inherited both their parents' names. Spanish women could keep rights over property they brought into a marriage, and if they were childless, siblings and parents claimed their property upon death, not their husbands.

Laws and customs of coverture nevertheless began to erode as Enlightenment ideals of freedom and personhood took root. In America and elsewhere, voluntary allegiances to authority—the ideal of governmental legitimacy emanating from the people, not from a monarch or titled aristocrat—overturned older ideas of patriarchal control. In the American colonies, choosing one's spouse dovetailed with new forms of political independence. Yet the enshrinement of independence was not extended to all people. Legal restrictions on who could marry became part of the first United States legal code. Marriage implied that the two people were free agents able to set the course of their own lives, a situation denied to enslaved people, who thus were not allowed legally to marry. Nevertheless, bonded men and women formed partnerships and "abroad marriages," unions between spouses on different farms or plantations. Poor whites in the South also practiced informal marriages, foregoing the fees and legalities of a formal union. State courts throughout the country recognized these common law marriages as legal as long as the couple was not interracial. Interracial couples were careful to keep their marriages outside of the courts, given the ban on miscegenation, or mixing of the races. At the turn of the twentieth century, states throughout the American South and West adopted "anti-miscegenation" laws, forbidding unions between a white person and a Native American, African American, "Oriental," or biracial person. These laws existed until the 1967 Supreme Court case *Loving v. Virginia*, which overturned all state-based anti-miscegenation laws.

Low Countries, 1460s

This illuminated manuscript by the Flemish artist Willem Vrelant
(d. 1481) depicts Eve's surrender to the serpent's temptation in the
Garden of Eden, perhaps the single most influential piece of evidence
in the millennia-long disparagement of the character of women.
For two millennia, religious scholars and clerics from three of the
world's great religions have used the story of the fall of Adam and Eve
to demonstrate that women are by nature disobedient, credulous,
weak-willed, prone to temptation and evil, and therefore, dangerous.

"An Old Woman Accused of Witchcraft," a nineteenth-century painting by William Powell Frith, depicts a witch trial in England, most likely one that took place in the early to mid-seventeenth century, when these cases reached their peak. As was typical in witchcraft trials, a nobleman presides over the prosecution of an elderly woman, who stands accused by another woman. "Witches" were often women who resisted social norms or were otherwise inconvenient to the vested powers in society. They were accused of crimes from shape-shifting to cavorting with demons to cannibalism. In the Salem witch trials in the United States, which occurred in the late 1600s, many witnesses later recanted their testimony, and officials such as judge Samuel Sewall publicly confessed their error and guilt after the witch trial craze died down.

Reform movements in early nineteenth-century America opened suffrage to more white men by doing away with laws requiring that they own land to be able to vote. But white women remained in legal limbo. Legislators first granted women the legal right to own property as a way to protect their family wealth from a volatile boom-bust economy. The first married women's property laws in the 1830s were originally meant to establish protected estates, which ensured that any assets placed in a wife's name would survive a husband's sudden bankruptcy. These rights did not extend over other kinds of assets, however, and were limited. Women were not allowed to keep any money they earned, nor could they exercise control over their property. These responsibilities fell to their husbands. But then laws like one passed in Michigan in 1844 made it illegal for creditors to seize a woman's property to pay her husband's debts, and other states passed limited married women's property laws by the end of the Civil War. The United Kingdom passed the Married Women's Property act in 1870 that likewise protected a married woman's property from any of her husband's creditors, in essence freeing these women from coverture.

In industrializing America in the 1880s and 1890s, a convergence of issues around marriage emerged to address women's uniquely constrained social position. More wage-earning women joined men in the material support of their families, undercutting both the idea of a "separate" women's sphere of work based solely in the home and myths about men's economic protection of women. Increasingly, women were forced to support themselves without husbands, even though their wages were set lower than most men's. Pressure mounted to change laws and customs regarding married women's control over their wages. Frances Willard and the Woman's Christian Temperance Union (WCTU) brought to light the growing problem of husbands drinking their wages away on payday, leaving their wives legally and economically vulnerable. Although temperance women were socially conservative and believed in traditional marriage, they fought for women's increased rights within marriage to prevent female destitution and improve the moral health of families.

In 1893, the WCTU established an international arm, the World Woman's Christian Temperance Union. By 1920 it had WCTU unions in forty countries including Australia, Germany, Finland, Japan, New Zealand, Norway, and South Korea. Its all-women membership peaked in 1927 at 766,000. In the case of India, the WCTU joined a robust temperance movement already flourishing and men and women together organized to battle the social blights associated with drunkenness. India's movement became closely tied with the Indian independence movement in the 1910s. Mahatma Gandhi, its leader, viewed alcohol as a foreign import and the reason that no national prohibition had yet been established as an outgrowth of British foreign rule. In 1914, Indians peacefully picketed saloons under Gandhi's direction. With India's

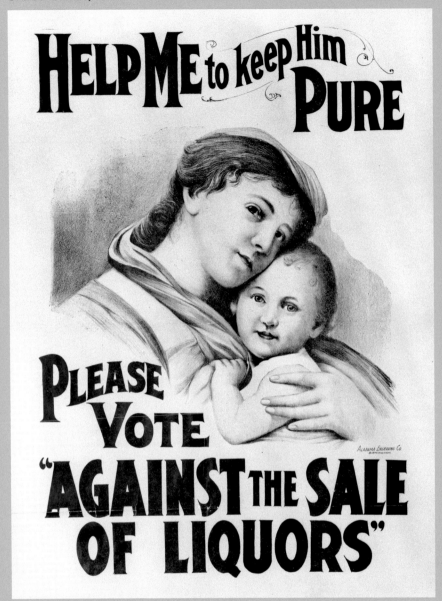

The Woman's Christian Temperance Union (WCTU) was by far the largest temperance organization of its day, but it was only one of many. This temperance poster from an Ohio organization illustrates the emotional appeal that temperance activists made in linking the banning of alcohol to the protection of families, especially children. Alcohol abuse was widespread, and it caused innumerable hardships for women and children, often leading to violence and criminal behavior. From an economic standpoint, alcohol was a drain on the family budget (most often the purview of the wife) and could even lead to job loss and insolvency. The WCTU and other temperance organizations became powerful advocates for a wide variety of pro-woman positions, including legislation to protect working women from workplace exploitation, and to increase the age of legal consent.

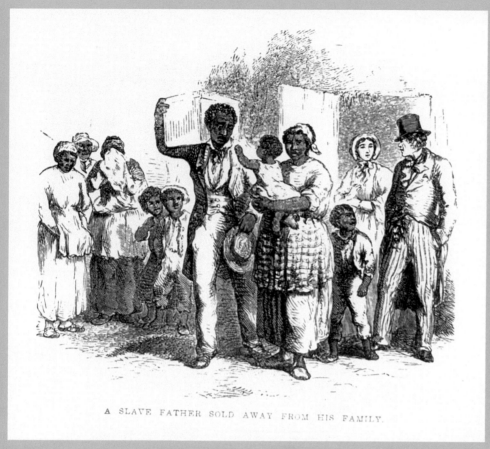

A SLAVE FATHER SOLD AWAY FROM HIS FAMILY.

ABOVE Prior to the ratification of the Thirteenth Amendment in 1865, colonial and state laws considered enslaved Africans property and commodities, so they were prohibited from entering into contracts such as marriage. Nonetheless, many enslaved people entered into relationships that they treated like marriage. Some owners honored enslaved peoples' choices in partners; others assigned partners, forcing people into relationships they would not have chosen for themselves. Some enslaved people, if they had the same owner, lived in nuclear families. Others lived in "abroad marriages," near-nuclear families in which the father had a different owner than the mother and children. Visits were typically allowed twice a week, but work took precedence. Enslaved people lived with the perpetual possibility of separation through the sale of one or more family members, and the possibility that their owner might choose one of their own as a sexual partner.

RIGHT *Loving v. Virginia* pitted seventeen-year-old Mildred Jeter and her childhood sweetheart, twenty-three-year-old construction worker, Richard Loving, against Virginia's "anti-miscegenation" laws prohibiting interracial marriage. Prior to 1967, marriage between the races was illegal in seventeen states: all of the former slave states plus Oklahoma. The Supreme Court ruled that the Virginia law was a violation of the "equal protection" clause of the Fourteenth Amendment (ironically, an amendment opposed by the early suffragists Elizabeth Cady Stanton and Susan B. Anthony for its failure to guarantee women the vote), thereby declaring the laws to be unconstitutional in all fifty states. Expanding the protections of the Fourteenth Amendment became a shared goal and legal weapon of the Civil Rights and the women's movements, and later, of LGBTQ activists. Here, Richard and Mildred Loving sit in the offices of their attorney in Alexandria, VA, after their Supreme Court victory.

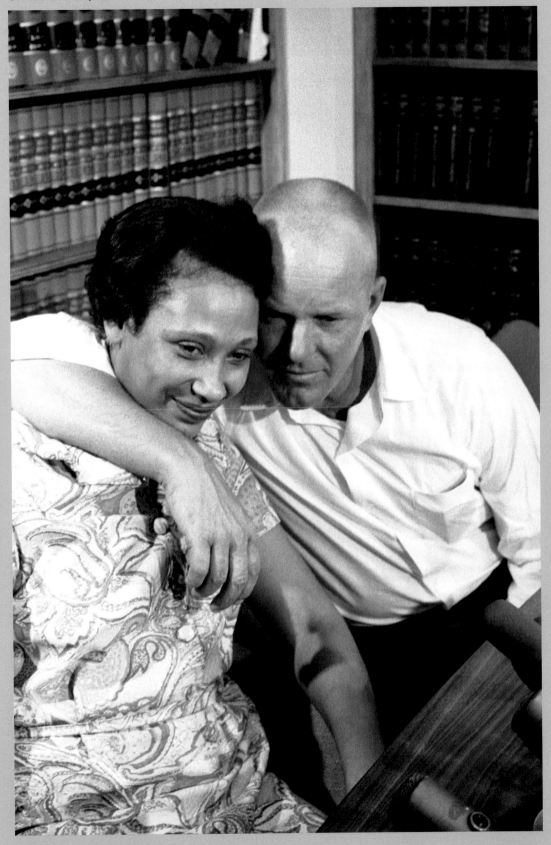

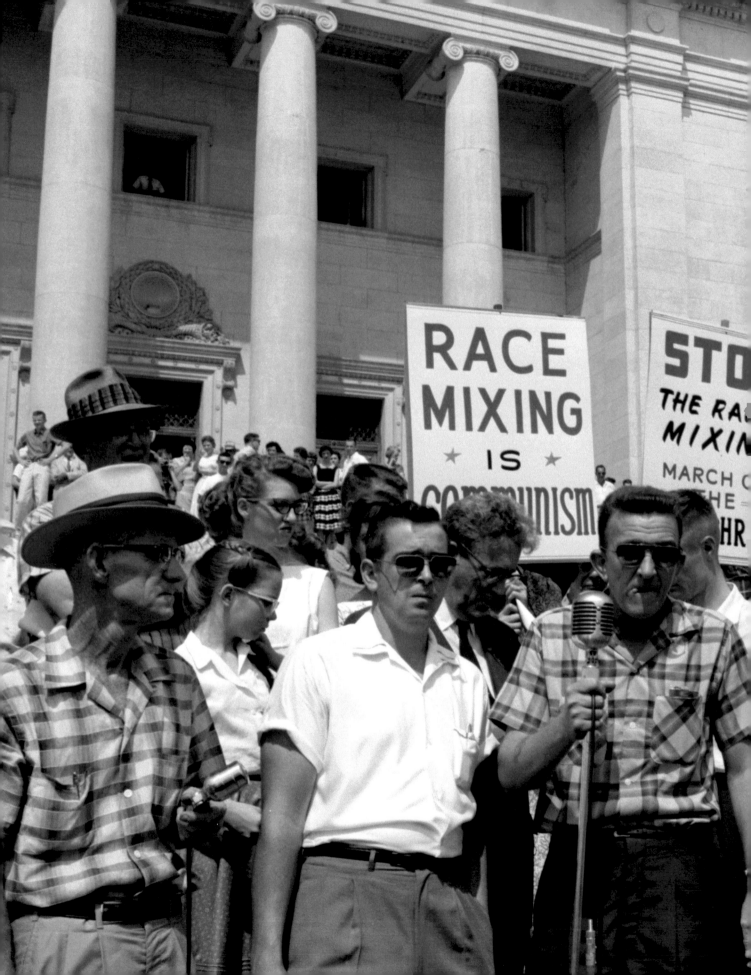

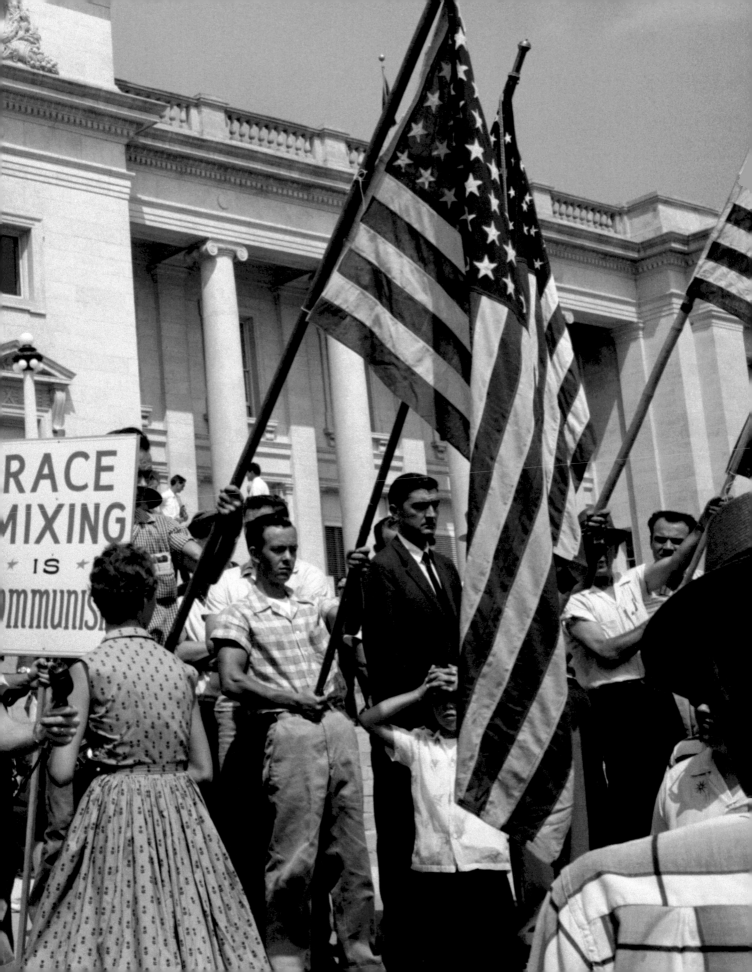

Canada, 1884

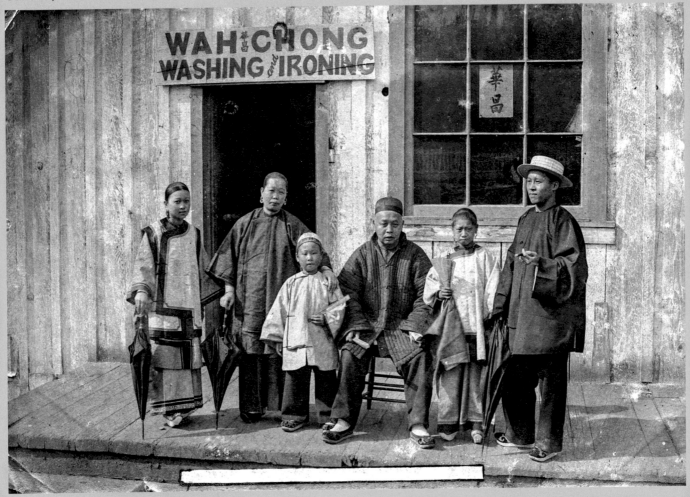

PREVIOUS SPREAD (United States, 1959) Following the *Brown v. Board of Education* decision and the enrollment of nine African American students called the "Little Rock Nine" in Little Rock Central High School in 1957, segregationists held ongoing protests at the Arkansas State Capitol. Beginning on September 23, 1957, President Eisenhower ordered the Arkansas National Guard to protect the black students. In this photo, taken in August 1959, white protestors hold American flags and signs that proclaim, "Race Mixing is Communism." Photographs of the Little Rock protests are evidence of the overt racism and violence that came as a response to desegregation efforts in the 1950s. The nine students, including Elizabeth Eckford and Minnijean Brown-Trickey, faced physical and verbal harassment from their fellow high school students and from crowds of protesters outside the school.

ABOVE Wah Chong and his family stand in front of his laundry shop in Vancouver, British Columbia, circa 1884. This remarkable photograph documents Chinese immigrant life in Canada in the nineteenth century. Chinese miners first arrived in British Columbia in the 1850s during the Fraser River gold rush, and thousands of Chinese laborers were hired in 1880 to work on the Canadian Pacific Railway. This period was marked by intense anti-immigrant sentiment, with several exclusionary laws aimed at limiting Chinese immigration to Canada and municipal restrictions on employment opportunities. Beyond these racist policies, there were anti-Chinese riots in Vancouver in 1886 and 1907. Some Chinese immigrants like Wah Chong established hand laundry businesses, which involved long hours of physical labor.

independence in 1947, a number of states outlawed alcohol consumption, claiming women, children, and families would benefit.

In the United States, shifting demographics also brought about changes to women's status in marriage. The Great Migration of African Americans from the rural South to the urban North and Midwest began in the 1910s and continued through World War II, causing a mixing of northern and southern, urban and rural customs. Many working people continued to practice serial monogamy and often preferred common-law marriage as they established themselves in new cities. Immigrants brought their traditions to bear on marriage in America, too. Chinese and Jewish immigrants worked to preserve Old World arranged marriages, often against the wishes of their Americanizing children. Italian immigrants allowed daughters to select their future husbands, subject to their approval. For most wage-earning women, marriage remained the surest way out of factory work. Making a family and raising children at home, even while taking in extra sewing, laundry, or boarders for cash, was a life many working women aspired to.

By now, most young American women saw the ideal husband as a man who could be a friend, lover, and provider. Yet at the same time, rising expectations of compatibility within marriage also contributed to an accelerated rate of divorce. In 1900, the United States had the highest divorce rate in the world—one marriage in every six.

Traditionalists complained that since women could support themselves, they no longer felt compelled to stay with men who displeased them. Such women, critics cried, focused too much on their own pleasure and not enough on their family duties. Modern women demanded the right to marry whomever they wanted and to leave marriages if men abused, mistreated, or abandoned them. This new generation of women who demanded more compatibility with their husbands also redefined "the good wife," as sex appeal mattered more than one's housekeeping skills. By the time the Nineteenth Amendment passed in 1920, modern, sexualized "companionate" marriages looked largely to be love matches in which women expected an emotional bond or otherwise felt free to dissolve the union.

In China, similarly modern ideas of marriage only came with the Marriage Law of 1950. Although China had a long history of polygamy, which put husbands in the position of authority, the new law enshrined a set of values that supported women's equality based on the free choice of partners, monogamy, and by prohibiting features of traditional marriage such as multiple wives and child brides. The law also granted women the right to initiate divorce, a right also granted to married Hindu women in India around the same time.

Modern marriage and divorce went hand in hand, a dynamic that enabled women to assert more control over their lives and that resulted in a complex web of changes for families. The divorce rate in the United States dropped during the Great

A black family heads out of Florida in the wake of the Great Depression. In the 1940s alone, approximately 1.4 million black southerners moved to major northern and western cities including New York, Chicago, Philadelphia, St. Louis, Los Angeles, Denver, and Detroit. The Great Migration caused a major demographic shift, with more than five million African Americans leaving the South between 1916 and 1970. A number of factors contributed to this massive migration, including a demand for workers in northern factories and oppressive economic conditions in the South, along with the violence of lynching, Jim Crow laws, and the denial of suffrage to African Americans in southern states. Black-owned newspapers like the *Chicago Defender* and the *Amsterdam News* became conduits for black southern women to seek employment before reaching the North.

Depression of the 1930s, when households were forced to consolidate resources, and increased in 1946 immediately after World War II, when rushed marriages done in the heat of wartime deployments ended. The economic boom years of the postwar period resulted in a high number of girls marrying younger than they had for nearly a century. In 1946 the average American woman was marrying at twenty; in the 1950s, some fourteen million girls had married by seventeen. Whereas American families in the Depression elected to have fewer than two kids on average, in the 1950s the average was closer to four. The seeming domestic bliss of the fifties was short lived, for these trends led to spiking divorce rates by the 1960s and '70s, partially driven by women's growing level of education and economic autonomy. California adopted the first "no fault" divorce in 1969, and by 1973, thirty-six states had followed suit. As a result of efforts by feminist activists, new divorce laws considered both mothers and fathers as potential earners and caretakers, required that material assets be divided equitably, and that alimony be gender neutral. And yet, women typically won custody of children, which marked a significant change from the nineteenth century, when courts sided with the father. This new trend rested on its own set of gendered assumptions about the centrality of mothers to children. No longer was the fitness of a parent judged solely on his or her economic status.

In England, the Divorce Reform Act of 1969 allowed couples to end their marriages without having to prove "fault," a marked change from prior legal precedent. For centuries, divorce was permitted only for men and involved an Act of Parliament, which made it prohibitively expensive. In 1857, the Matrimonial Clauses Act allowed ordinary people to divorce, though women had to provide proof of their spouse committing adultery, cruelty, rape, or incest. The law was changed in 1937 to permit divorce on other grounds, such as drunkenness, insanity, and desertion. Germany similarly adopted no-fault divorces in the 1970s, as did Australia. The courts had already established no-fault divorces in Sweden, Norway, and Denmark in 1915, post-revolutionary Russia in 1918, and Finland in 1929.

But while divorce can mean freedom for both parties, leaving a marriage often has carried a higher financial burden for women than for men. Since the 1970s, men have seen a 42 percent rise in their standard of living after divorce, whereas divorced women and their children have experienced a 73 percent decline in theirs. Divorce is a major factor in the feminization of poverty. The unequal earning capacity of men and women and the unequal focus on the man's career during marriage has meant that most divorced women often find themselves economically more vulnerable, relying on national welfare programs and subsidized housing.

With so many marriages ending in divorce, more couples are choosing to "cohabit" rather than marry. The legal foundations of cohabitation and marriage differ from one European country to another. In

some countries, like the Netherlands, simply living together for a few years provides a legal basis for a couple to act together in legal and economic transactions (obtain a home mortgage based on both partners' incomes, for instance). In other countries, like France, establishing cohabitation may require a contract drawn up by a notary, or registration at the town hall. Further, in some countries, dissolving legalized cohabitation must be done in court, especially if there are children involved. In most European countries (especially those that have based laws on the Napoleonic Code Civile), getting married is not a religious act, but a secular one. Civil laws, not religious ones, are then relevant for divorce.

Today, while monogamy has been enshrined legally in many parts of the world as a mechanism for promoting women's equality, there are important exceptions. Fifty-eight countries recognize polygamy, most of them Muslim-majority countries in Africa and Asia. Nigeria legally recognizes two forms of marriage: The first is consecrated and made official with the signing of a marriage act, and it is monogamous. The second is conducted under customary law and can be polygamous or monogamous. In the United States, small splinter groups of the Church of Jesus Christ of Latter-day Saints practice polygamy, as do a small minority of American Muslims, even though it is federally outlawed.

In the past, cohabiting couples missed out on many of the material benefits available to married ones. In the first half of the twentieth century, social and family policies were geared toward improving the situation of families, and yet governments did not grant benefits like marriage loans, maternity leave, and child allowances to cohabiting couples. In The Netherlands and Scotland, for example, cohabiting couples were not eligible for social services such as public housing or unemployment allowances for dependents. Apart from having social, legal, and financial advantages, official marriage promised more protection and stability and often lasted longer, if only because getting divorced was costly and difficult until the second half of the twentieth century. By the 1970s, however, as divorce rates surged, marriage lost its aura of stability and permanence.

In the twenty-first century, being married is only one of many lifestyle options in much of the world. To a greater extent than ever before, individuals can choose whether to form a family of children on their own, to be in a cohabiting relationship, or to be in a marriage. Cohabitation is far more common today than it was at any time in the twentieth century. The separation of marriage and childbearing is increasingly common in twenty-first century life. Among less educated couples, early childbearing outside of marriage has become more common, whereas among more educated couples, marriage and children are often delayed until after investing in schooling and careers. Educational differences shape divorce rates as well. Divorce rates have risen for women without a college education and fallen for college-educated women. By 2010, nearly 40 percent of French couples between the ages of twenty-five and forty-four were

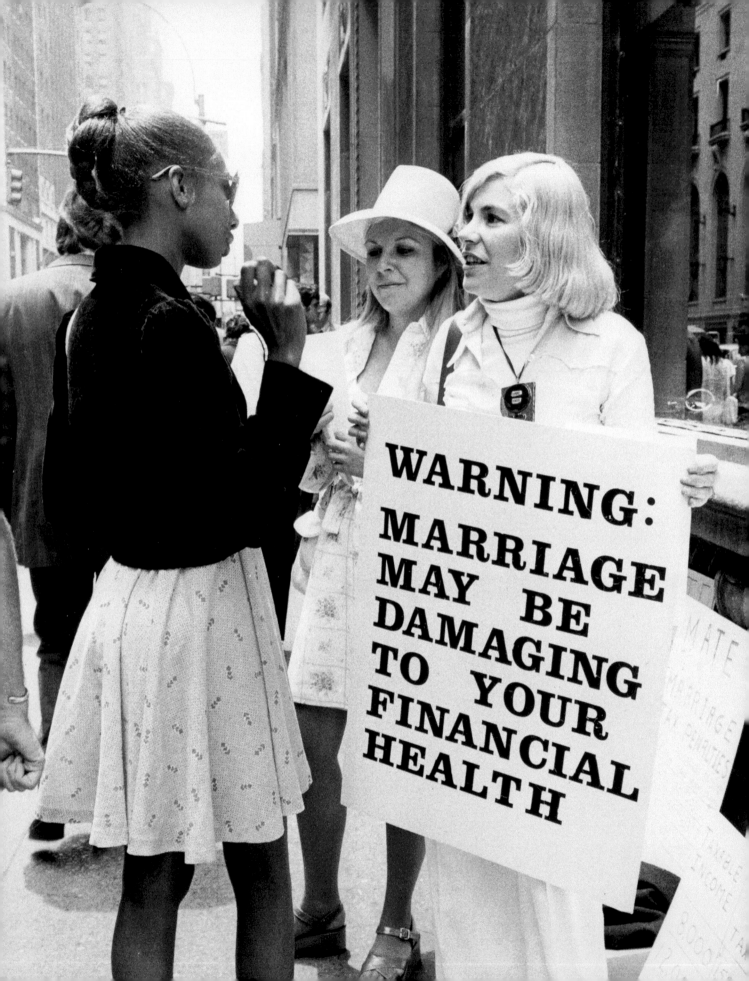

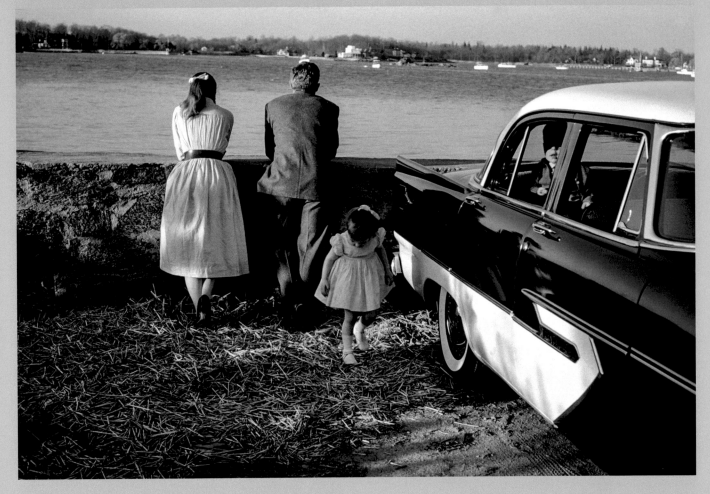

LEFT (United States, 1974) The provocative message on the placard in this photograph is subject to many interpretations, including the lack of financial value or reward placed on the traditional jobs performed by women within marriage: those involved with keeping a home and rearing children. More likely, the sign is a warning of the financial difficulties women face in the event their marriages should end. Beyond simply facing limited opportunities and unequal pay because of their gender, divorced women's job prospects are frequently compromised by gaps in their resumes due to child-rearing or by the scheduling compromises needed to maintain a single-parent family. Many women receive spousal support (as do some men), but the vast majority of both genders do not.

ABOVE The postwar economic boom cemented in popular culture the image of the quintessential American family: white, car-owning, comfortably middle class, with two children. This idealized image became one of the United States' chief exports. American women in this period married younger and bore more children (nearly four, on average) than in previous decades. This ideal outlived the reality. As more women earned post-secondary degrees, and increasing numbers entered the work force—most out of economic necessity— the economic and personal strains drove divorce rates to all-time highs in the decades that followed.

Belgium, 1981

Nigeria, 1960s

ABOVE AND LEFT The Nigerian feminist and anti-colonial activist Funmilayo Ransome-Kuti (1900–1978; pictured, left), educated in England, was among the leaders in Nigeria and West Africa of the fight for independence, for women's suffrage, and for fair labor practices and economic policies for women. She founded the Abeokuta Women's Union, Nigeria's most influential women's organization, which had an estimated membership of twenty thousand women at its peak. Her son, Fela Kuti (1938–1997), became an international musical star and anti-colonial activist as well. His renowned club in Lagos became known as a hotbed of dance grooves and a space of opposition to Nigeria's military regime. Ironically, while Fela's infectious Afro-beat music helped propel his message of liberation, he was also known for his occasional physical abuse of his wives (he had twenty-seven) and for his generally misogynistic views. Fela died of complications from AIDS in 1997; his mother died from injuries sustained after being thrown from a third-floor window during a military raid on Fela's compound by government forces in 1978. Above, Fela relaxes backstage in Brussels in 1981 with some of his wives and children.

Polygamy, or more precisely, polygyny, is most commonly found in developing countries in Africa and Asia, but it is present in the Western world as well. Approximately thirty thousand to fifty thousand people are currently living in polygamous relationships in the United States, many of them in sects that splintered from the mainstream Mormon church, which renounced polygamy in 1890. Others are living discreetly in polygamous Muslim communities. Few practices so dramatically highlight the uneasy tension between religious freedom and the rights of women. In this photo, polygamy advocates protest at the Utah State Capitol against a proposal to broaden the state's anti-polygamy laws.

cohabiting, registered or unregistered. In Sweden, the figure reached just over 50 percent, a stark contrast from the near universality of marriage in the 1950s and '60s. Childbearing within cohabitation has also become more frequent, with 25 to 30 percent of all children between 1995 and 2004 born to cohabiting parents in the United Kingdom and the Netherlands.

Making a distinction between the civil and religious meanings of marriage has provided an opening for the formation of civil unions or partnerships in lieu of marriage. These partnerships have been legally recognized but do not bring the same rights and privileges as marriage. For example, civil partnerships in the United Kingdom and in Denmark do not automatically include the right to adopt or obtain joint custody of a child. In the United States, couples in civil unions do not enjoy the same tax benefits as couples in a heterosexual marriage. This "lesser form" of marriage has only fueled the fight for same-sex marriages for some activists.

These restrictions on same-sex unions are fast disappearing in Western democracies. In 2001, the Netherlands became the first country to establish same-sex marriage by law. Other countries followed suit: Belgium in 2003; Spain and Canada in 2005; South Africa in 2006; Norway and Sweden in 2009; Portugal, Iceland and Argentina in 2010; Denmark in 2012; and Brazil, France, Uruguay, and New Zealand in 2013. England, Wales, and Scotland passed the Marriage (Same Sex Couples) Act in 2013 and 2014, with provisions guaranteeing that no religious institution would be required to perform same-sex ceremonies. By 2015, same-sex marriage had reached all fifty states in the U.S. through state legislation, direct popular vote, and state and federal court rulings, culminating in the landmark civil rights case, *Obergefell v. Hodges*. That case asserted the fundamental right of same-sex couples to marry on the same terms and conditions as opposite-sex couples, with all the accompanying rights and responsibilities as guaranteed by the Fourteenth Amendment, a clear example of expanding the circle of inclusion for the rights and privileges of citizenship. Germany and Australia legalized same-sex marriage in 2017. As of 2018, twenty-eight countries have legalized same-sex marriage and most allow some form of civil partnership.

As the right to marry expands, the issue of child marriages, in some cases involving girls as young as six or seven, has become a pressing human rights issue that illuminates the ongoing coercive use of marriage to oppress women. The prevalence of child marriage cuts across countries, cultures, and religions, but early and forced marriage is most common in sub-Saharan Africa, where 38 percent of girls become child brides. In South Asia the rate is 30 percent and in Latin America, 25 percent. In the United States more than 167,000 children were married between 2000 and 2010, and in the United Kingdom an estimated 8,000 children were forced into marriage in 2015. In many communities where child marriages are common, patriarchy and poverty converge. Families view girls as intrinsically

The Netherlands became the first country in the world to pass a law fully legalizing same-sex marriages, with rights fully equivalent to traditional marriages, in 2001. Denmark had passed the Registered Partnerships Act in 1989, but stopped short of allowing same-sex couples to adopt or to be wed in the state church, in fact designating the unions "partnerships" rather than "marriages." Peter Wittebrood-Lemke, Frank Wittebrood, Ton Jansen, Louis Rogmans, Helene Faasen and Anne-Marie Thus (*left* to *right*) cut the wedding cake after exchanging vows at Amsterdam's City Hall on April 1, 2001. They were among four gay couples to be married under the new law on the day it took effect.

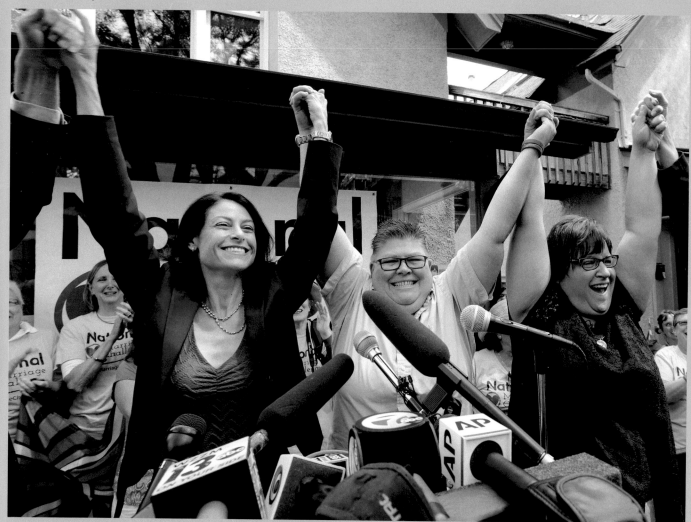

Jayne Rowse (*center*) and April DeBoer (*right*), plaintiffs in the
Obergefell v. Hodges case celebrate with current Michigan Attorney
General Dana Nessel (*left*) after the U.S. Supreme Court ruled in
favor of same-sex marriage in June 2015. This landmark decision
required all states to issue marriage licenses to same-sex couples
and to recognize same-sex marriages from other jurisdic-
tions. Rowse and DeBoer filed a lawsuit in 2012 that challenged
Michigan's ban on adoption by same-sex couples. This case, along
with three others, were eventually reviewed by the Supreme Court.
After making its ruling, the Court declared that, "The Constitution
promises liberty to all within its reach, a liberty that includes
certain specific rights that allow persons, within a lawful realm,
to define and express their identity."

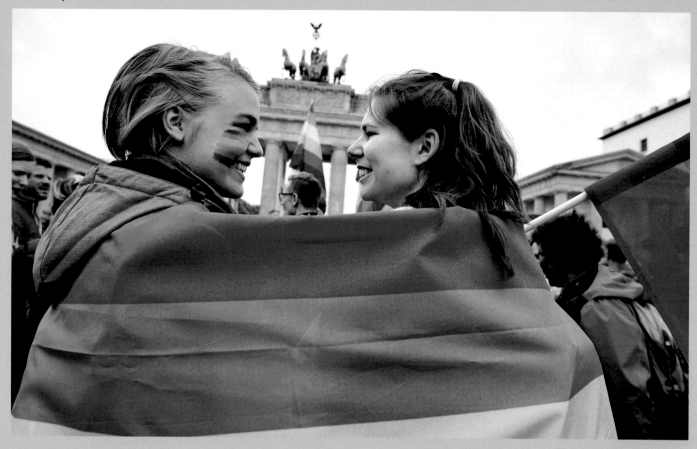

In June 2017 the German Bundestag, or federal parliament, passed legislation legalizing same-sex marriage, the culminating moment after more than a decade of gradual expansion of same-sex rights under the Act on Registered Life Partnerships of 2001. In the year following passage, more than 10,000 same-sex couples were married in Germany, some after decades of waiting. Here, two women celebrate the law's passage in front of the Brandenburg Gate in Berlin. Worldwide, roughly two-thirds of the countries that allow gay marriage are in western Europe. Laws recognizing same-sex marriages went into effect in Ecuador in 2019 and Costa Rica in 2020.

less valuable or as economic burdens. Marrying off a young daughter shifts the burden of feeding, clothing, and schooling to another family. Where poverty is acute, families might also believe that marrying off daughters early will help them secure resources for their future. At the same time, early marriage is also a way to eliminate the stigma that can come from daughters having premarital pregnancies. Some families use child marriage as a strategy for controlling their daughters' budding sexuality by using marriage to ensure that they do not become pregnant outside of marriage, while also providing a means to repay debts, manage disputes, or forge social and political alliances. Custom and religion affect the practice. For many societies, as soon as a girl menstruates, she is considered ready for marriage. Such traditions can put girls in harm's way by exposing them to pregnancies for which they are physically and emotionally unprepared. Each year, thousands of girls are injured by long labors and deliver infants that too often do not survive the first year of life. Activists around the world have launched campaigns to stop the practice of child marriage through education, legal action, and programs of female empowerment.

Marriage has adapted so much over the centuries as to be unrecognizable. One has to wonder if it will change even more in the twenty-first century, or will it slowly fade away as a bedrock institution in modern life? The British philosopher Clare Chambers says it is likely to do both. She believes that marriage cannot escape its history;

despite shifting consciousness about the purpose of marriage, it remains an unflagging ideal for many people. Couples want to marry because it is romantic, because they believe the legal commitment it represents is important, or because it is a cherished part of their faith tradition. And yet many of the historical and economic structures that made marriage the center of a woman's life no longer exist. New manifestations of marriage and family— in which women have property rights, can initiate divorce, and have agency in their choices regarding motherhood—enable women to reshape the institution to fit their circumstances, rather than the other way around.

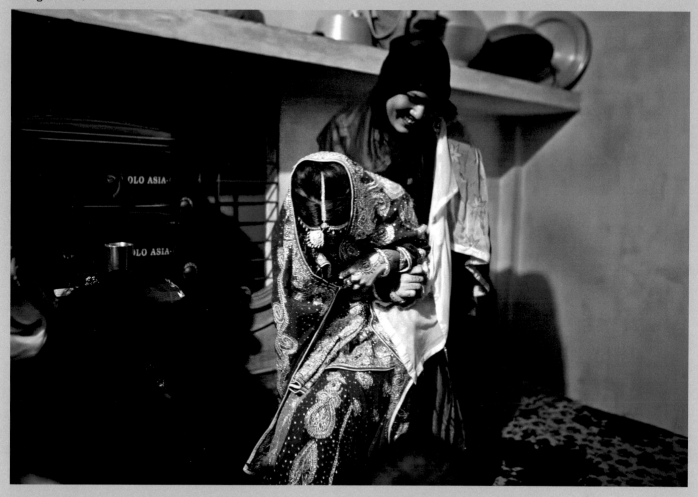

On the day that fifteen-year-old Nasoin Akhter is to marry a thirty-two-year-old man in Manikganj, Bangladesh, a relative good-naturedly tries to drag her onto a bed for photographs. Bangladesh has one of the highest rates of child marriage in the world, with 29 percent of girls marrying before the age of fifteen, and 65 percent of girls marrying before they turn eighteen. Views on child marriage vary by culture, economic status, and geographical location. Frequently, impoverished parents marry off young girls as a means to reducing their financial burden and receiving (typically) a small dowry. Some view early marriage as a protection for their daughters against rape and potentially disastrous unwanted pregnancies. The majority of young brides drop out of school, leaving them unedu-cated and with limited job prospects. The risk of domestic violence has been established to increase with spousal age difference, and girls under twenty are at least twice as likely to die in childbirth than those twenty or older.

How much more respectable is the woman who earns her own bread by fulfilling any duty, than the most accomplished beauty!

Mary Wollstonecraft

We Can Do It

Woman's bid for economic citizenship—the right to the fruits of her own labor—began with industrialization in the middle of the nineteenth century in the developing economies of the United States and Europe. As the nature of work itself changed, so did women's understanding of the work they did. The introduction of wages and classifications of skilled and unskilled work impacted social connections, spurring women workers to question their relationship with management and to join labor movements. At the same time, joining a common cause with other workers not only brought women out of the isolation of the private world of family and home, but into greater awareness of their unfair treatment as a collective. Women's activism and advocacy have resulted in fairer workplaces, better protections against gender violence and sexual harassment at work, more wage equality, and new awareness of unsafe work conditions for all workers.

Women worked well before they received wages in the Industrial Age. In most of the pre-industrial world, the individual, family, and the farm were virtually indivisible; in Russia, these familial economic units were described as "having eaten from one pot." With few exceptions, women were a vital set of contributing hands, and girls were expected to contribute from an early age. In urban environments, the family was likewise the central economic unit. In a weaver's home, for example, children did the carding and combing, older daughters and wives spun, and fathers and older boys wove. The wives of craftsmen such as tailors, shoemakers, and bakers assisted their husbands, procuring and preparing materials, sewing, carrying, measuring, stoking the fires—whatever was necessary to keep the family business running. Women tended to be the financial managers of the household, though in most places they had very limited capacity to transact business.

With the advent of the cash economy, eventually women brought coins and currency into their families. Women sold or traded extra butter, cheese, and soap at local markets. Others worked as day laborers for wealthy families, as dairymaids and laundresses, and contributed their wages to their families. In all circumstances, women in agrarian economies like England were paid less for their work than men. In 1388, England enforced wage inequality by passing a law dictating that dairymaids would earn a shilling less per year than plowmen. Wage inequality, in combination with prevailing laws that forbade or limited women's right to own property, created a structural discrimination against women's full economic citizenship. From the start, women's work was perceived as "extra," not crucial to the overall support of families. Men, in their capacity as workers and heads of household, were presumably the sole support of families, while women, like children, were viewed as dependents. But few economic protections beyond husbands existed for wives. The mandated lower wages for women led to increased numbers of women living in poverty when they found themselves widowed, abandoned, or unmarried.

The situation had been different, however, for Native American women, who had lived outside a wage economy for centuries before Europeans arrived in North America. Surprisingly, this meant that their families and communities tended to better acknowledge their economic contributions. When fur trapping became a lucrative business for the French who settled in Quebec in the eighteenth century, skilled Native American women made hides into leggings, jackets, and moccasins, and made bones into needles and ladles. French traders depended on Native women to help them survive harsh winters and guide them through unfamiliar lands, often marrying them for access to the tribe. In this way, the labor of Native American women helped to sustain the cash-rich fur trade, but they did not share in the wealth they helped to create. They were remunerated with tools, trinkets, and household wares, not currency.

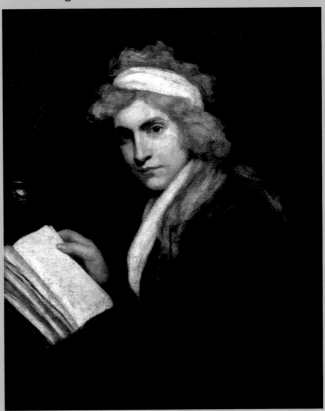

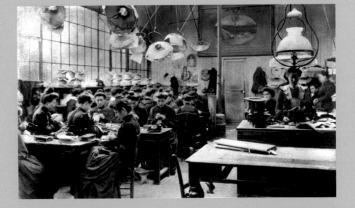

ABOVE Mary Wollstonecraft (1759–1797) is considered to be one of
the most important early feminist philosophers. Born in London,
she was a prolific intellectual, writer, and activist. Wollstonecraft
also co-founded a girls' school in London in 1784. She published her
most well-known work, *A Vindication of the Rights of Woman*, in 1792,
in which she advocated for women's fundamental right to education.
This essay is often considered to be a point of departure for the
modern women's rights movement. In the treatise, Wollstonecraft
wrote, "my main argument is built on this simple principle, that if
she be not prepared by education to become the companion of man,
she will stop the progress of knowledge and virtue." She died eleven
days after the birth of her daughter, Mary Wollstonecraft Godwin
(later Shelley), the author of *Frankenstein* (1818).

RIGHT Women sewing hats in a factory in New York City at the turn
of the century. This oil painting, with its bright colors and romantic
lighting, belies the truth of industrial work for women in this era.
Factory floors were messy, dusty, crowded, and often fire traps; white
women had been replaced by immigrants by this time and many
were underage; and men typically supervised women's work, not
other women.

Germany, 1550

France, 1750s

ABOVE, TOP Open markets, like the one represented here in Munich, became social and economic points of exchange. On the whole, the sixteenth century was a time of economic expansion for Europe. One sign of this expansion, as well as a cause of it, was a growth in population and an expansion of agriculture. Women sold goods in markets and worked alongside men as the economy transformed from one based in bartering to one based in currency exchange.

ABOVE, BOTTOM Candlemaking in England and France became a guild craft by the thirteenth century. Formed by an association of artisans or merchants, guilds oversaw the practice of their craft in a particular region and blocked non-members from selling their goods. These professional organizations functioned similarly to what would later become trade unions. Medieval guilds limited women's participation, and typically permitted only the widows and daughters of a master to be admitted. Even if a woman was admitted, she was excluded from holding any office.

RIGHT (United Kingdom, 1897) Parishes formed workhouses for the poor and homeless as a public health strategy in the United Kingdom. Inmates, as they were called, lived in crowded conditions where they were expected to work, pray, and if young, attend school. Old women and women without families were particularly vulnerable to poverty. This image shows mealtime at St. Pancras Workhouse, London.

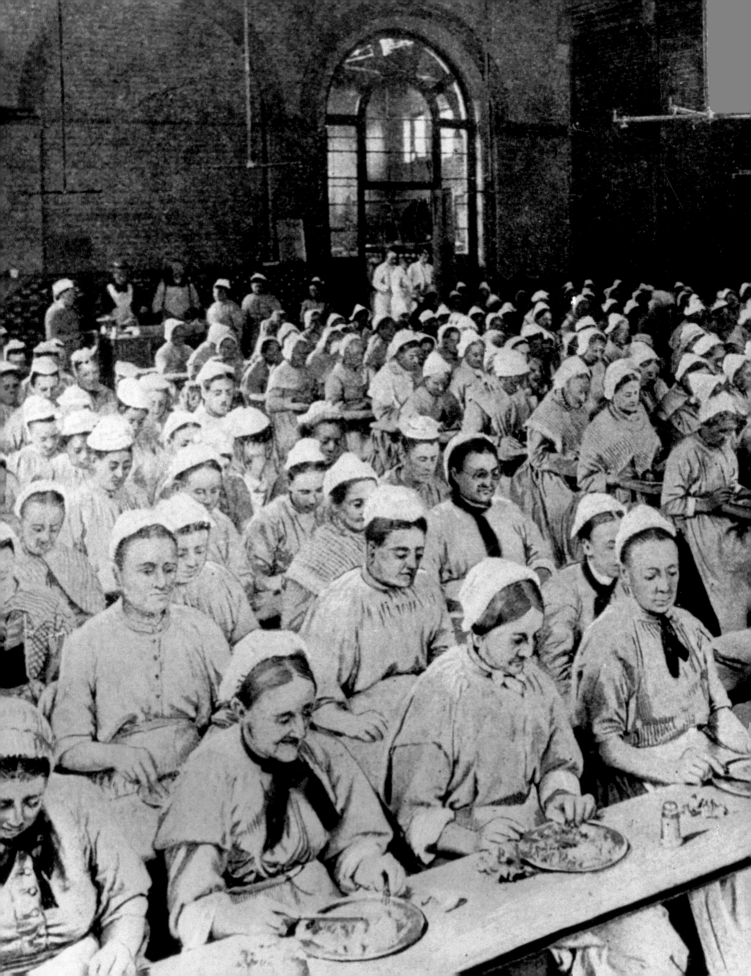

When seventeenth-century immigrants from England to America settled on the eastern seaboard, they brought economic and gender traditions with them. Both men and women found work on the expanding tobacco plantations of Virginia and Maryland. Women worked alongside men tending and harvesting the crops. This left them less time to cultivate home gardens and visit local markets to trade goods like soap, chicken, and cloth, however. One-fourth of women from England arrived as indentured servants who generally contracted to work for their masters for four to seven years to pay for their passage to the American colonies. Slave women from Africa gradually replaced indentured servants, especially in the American South; by 1660, there were more slave women in Virginia than indentured women. Slave holding, in addition to its terrible inhumanity, had the effect of creating a distorted economy in which a glut of workers gave advantage to a wealthy planter class, resulting in the explosive growth of large tobacco, rice, and cotton farms. Slavery distorted enslaved women's reproductive lives by the routine violence, rape, and coercion they encountered, often at the hands of their masters. A slaveholder increased his wealth and exploitable workforce through laws that dictated that any child born of a slave woman would be a slave, no matter the child's biological father.

By the time of the American Revolution in 1776, women's contributions to the economic life of the colonies often remained uncompensated, but were essential. Wives of land-owning men moved from the fields to the home and spent their days producing and trading small domestic products in the market. Interestingly, married and widowed women in growing cities along the eastern seaboard came to make considerable headway as tavern keepers, since this was the sort of hospitality already expected of domestic women. Husbands might have legally owned the taverns' licenses, but women learned to manage them as prototypical business owners. Eventually, city officials granted widows licenses to run taverns and other businesses so that they would not require public assistance when they inherited businesses from their fathers or husbands. In eighteenth-century Boston and Philadelphia, for example, women operated nearly 50 percent of the city's businesses, working in dry goods, or as seamstresses and as button- and candle-makers.

And yet, despite the expansion of women's economic participation in the eighteenth century, such gains did not always translate into lasting economic independence. As land grew scarce, men increasingly passed whatever inheritance they had to their eldest sons, with the understanding that they would care for their widowed mothers. In this way, some widows lost what little economic independence they had gained. But for others, widowhood created the economic hardship that forced them to become especially enterprising and self-reliant for the first time—they opened businesses and offered goods and services that they once had produced for free in their own households. For the first time,

United Kingdom, 1856

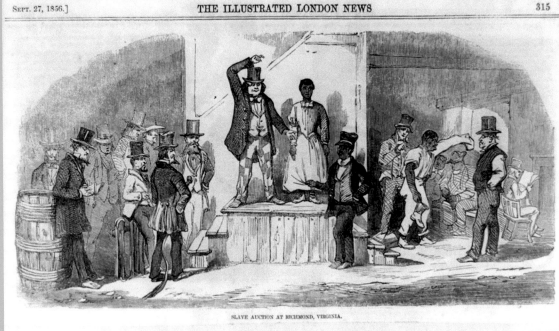

SEPT. 27, 1856.] THE ILLUSTRATED LONDON NEWS 315

SLAVE AUCTION AT RICHMOND, VIRGINIA.

United Kingdom, 1913

STARVATION

WAITING FOR A LIVING WAGE

ABOVE This image of a slave market ran in the *Illustrated London News* in 1856. The illustration of a slave market in Richmond, Virginia, depicts the auctioning of a woman in inhumane conditions. Slave sales represented economically vital activity in Virginia from the late eighteenth century until the abolition of slavery in the U.S. in 1863. Richmond became a hub of the slave trade. The United Kingdom abolished slavery in 1833 and became an important locus of abolitionism. The auctioneer and gentlemen traders are represented as grotesque, and the slave woman, innocent.

RIGHT Starvation and oppression haunt the woman portrayed in this poster, "Waiting for a Living Wage." The Suffrage Atelier, a group of artists who used their creative skills to promote the "Votes for Women" campaign in England, produced the image. A major aim of the suffrage movement was to improve the conditions of working-class women by achieving representation in Parliament and in trade unions. Catherine Courtauld Osler designed the poster. Osler was an avid supporter of women's rights, acting as the president of the Birmingham Women's Suffrage Society from 1903 until she resigned in 1909, in objection to the force-feeding of suffragette prisoners. While she criticized the suffragettes' militant behavior, she condoned their right to protest. Osler joined the executive committee of the National Union of Women's Suffrage Societies in 1911.

their remuneration did not belong to their fathers or husbands. The money they made from their labor could legally belong to them, at least until another husband came along and the earnings were transferred to him.

Women's economic subordination to their husbands, sons, and brothers was also a feature of the economic development of western Europe. Until the eighteenth century, German women, for example, had no property rights and widows required a male guardian to represent them in court. Wealthy women brought dowries from their families and retained the rights to them even as husbands or brothers managed them. This meant that women could bring dowries into second marriages. Daughters and wives could inherit money or a business, and women who inherited an artisan business could manage affairs but not officially join or participate in guild meetings. It was expected that any matter that required attention legally could be addressed by way of a male representative. As one historian noted, "The state recognized a burgher but not a burgess." Within the educated classes, German women received just enough of an education to be what were considered good mothers and interesting wives, but no more. Lower-class women, many who were uneducated, worked in a variety of capacities, often as servants or craftswomen, and often lived with their employers. An owner's wife oversaw the labor of the women who lived under her roof.

By the nineteenth century, a new system of organized work supplanted the *ganzes Haus* (or whole house) in Germany. In the new system, a man managed his labor and family on his own farm, which opened up the possibility for wives to assume a new role as head of the domestic sphere. In previous centuries, the shortage of land meant that not everyone could marry, and those who did married after the age of twenty-five. After 1815, increased agricultural productivity enabled more couples to marry earlier and to have more children. Such developments elevated the role of mothering in women's lives, though many German women still didn't have the luxury of devoting their lives to their children. Shortages of land drove many Germans out of the country in search of economic opportunity. Between 1820 and 1870, over 7.5 million Germans, like other Europeans who faced rising industrialism, immigrated to the United States to settle farms or work in urban factories.

The first industrial revolution of the 1820s, centered in England, opened new opportunities for women's work outside the home and thus sowed the seeds of greater economic independence. As cities grew and economies diversified from purely agricultural to a mix of industrial and home production, women's work lives changed. Spinning and weaving were no longer home industries, as new technologies required power sources and space that only factories could provide. Manchester became the center of the textile industry in England, drawing women from all over the region to jobs in textile mills. In the largely rural Italian region of Lombardy, where the silk industry has a long history, women went to work

in nearby silk mills, returning home as the season and work demanded. Even with the added opportunities of factory work, by the end of the nineteenth century, the majority of working women in England were engaged as domestic servants or in gendered and home-based tasks like cooking, laundry, cleaning, and taking care of the young or sick. About 20 percent were textile workers, and nearly 16 percent were in dressmaking trades.

In the United States, women moved between farm and factory based on the season and their age. Textile factories in New England, starting with Slater Mill in Rhode Island, transformed the production of cloth by way of water-powered looms and started hiring women. By the 1830s, reams of textiles rolled off mechanized looms in Manchester, New Hampshire and Lowell, Massachusetts, and factories that once employed poor families rapidly grew into huge multi-storied, multi-building campuses that employed hundreds of workers, mainly young unmarried women between the ages of fifteen and thirty. By 1860, the factories of New England employed more than sixty thousand women.

At first, paternalistic employers at American textile mills paid young women's wages to their fathers, thus maintaining patriarchal authority over daughters. But soon some companies preferred to pay their workers in "scrip," a form of credit at the company store. It was common for factory owners to provide company houses, schools, and churches for their workers. These company towns fostered a sense of community among the men, women, and children who lived and worked together. By the 1840s, the paternal system frayed because of the cost to employers and at the insistence of workers who did not want to live under the thumb of mill owners. The contract shifted to paying workers as individuals, not as family members.

Though they were obliged to send money home, some women saved for their dowries. Steadily, more of these young women also used some of the wages they received in scrip to buy ribbons and collars to brighten up their old dresses, showing signs of economic autonomy. Eventually, living and working together strengthened women workers' sense of solidarity, which in time became a nascent form of labor unionism. In succeeding generations, they would mobilize into collective action when factory owners tried to cut wages, speed up work, or eliminate hours. Women's expanding economic lives gave them a taste of independence that led to a new consciousness about their political rights (or lack thereof).

They would come to believe that they were entitled to the fruits of their labor, just as their fathers and sons had been. New Englanders defended their heritage as freemen and women who should not be oppressed by the heavy hand of a greedy industrialist. They were willing and ready to enter contracts that respected labor as much as capital. This spirit infused the Lowell factory women who attended the city's educational and cultural events, listening to lectures by famous authors and ministers, and sought to improve themselves in whatever way they could.

Germany, 1874

FROM THE OLD TO THE NEW WORLD—GERMAN EMIGRANTS FOR NEW YORK EMBARKING ON A HAMBURG STEAMER.—[SEE PAGE 918.]

This painting depicts German emigrants in Hamburg boarding
a steamer bound for New York City. The largest flow of German
immigration to America occurred between 1820 and World War I,
during which time nearly six million Germans arrived in the United
States. Young, single men were the first and largest group to migrate;
unmarried women came in relatively large numbers as well. In some
cases, entire families left their homes behind for the promise of
a better life in the United States

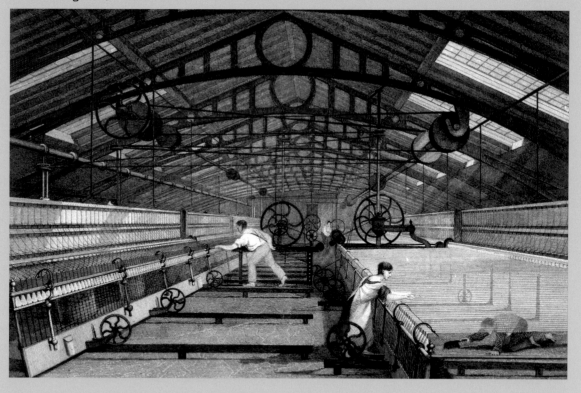

Before the eighteenth century, individuals and families manufactured cloth, but technical innovations enabled the creation of larger spinning looms, that in turn required large buildings, many workers, and an industrial infrastructure. New factories with room-sized looms opened near streams to power their water wheels. The increased production in mills around Manchester generated a need for a cotton exchange and warehousing as the industry grew. Women's and children's small, "nimble" hands were seen as assets as the work of textile production was increasingly machine-driven.

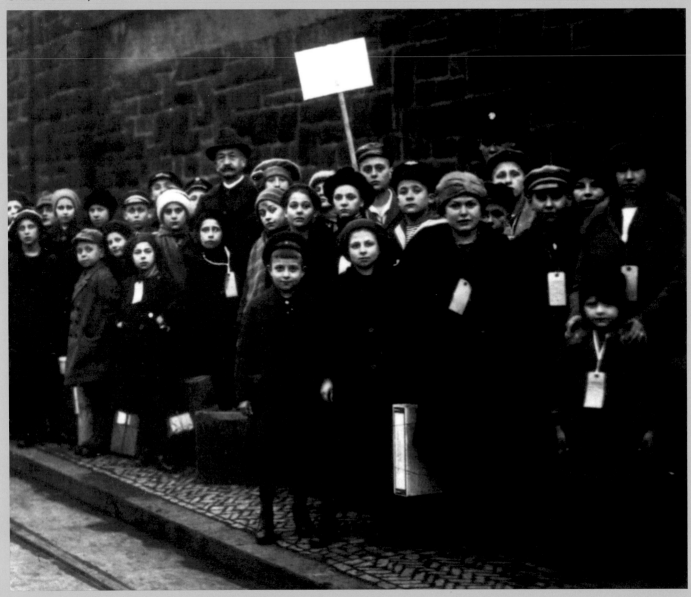

The city of Lawrence, Massachusetts had been at the forefront of the
Industrial Revolution and labor activism throughout the nineteenth
century. In the 1840s and 1850s, workers formed labor unions to
combat terrible work conditions in the factories, low wages, and
"speed ups," episodes where more work was extracted out of laborers
without an increase in pay. Child labor was pervasive. Here, children,
many of whom worked in the factories, are shown supporting a labor
strike. By the twentieth century, sustained labor activism resulted
in widespread protections and better wages for industrial workers.

No doubt, more women had begun to contribute significantly to the family wage in the industrial labor market, and yet the cultural assumption that women did not contribute as primary household breadwinners persisted and continued to limit their earning potential. Women's wages, it was believed, were supplemental, not essential— "pin money," as opposed to the take-home pay of a bona fide bread-winner. This willful prejudice disempowered the women who needed more substantial wages for food and shelter. Moreover, in the U.S., U.K., and Europe, husbands retained the legal right to their wives' wages before the 1860s. If a woman was married to an abusive or alcoholic husband, she found herself with little recourse to protect her family or any wages she earned and he squandered.

Industrialism, with its ample opportunity to earn wages, became one avenue for women to enter public life—and they did. In 1870, one in eight American women worked for a wage. By 1910, one in four did, more often than not in sex-segregated sectors. Men took on "skilled" jobs in better-paying heavy indus-tries like steel and transportation, while women worked in lower-paying light manufacturing. The booming industry in ready-made clothes led to the hire of more than two hundred thousand workers, but it was the men who worked as better-paid tailors and cutters, while women served as lower-paid stitchers and piece-workers. While men worked on finer grades of clothing like suits and cloaks, women sewed cheaper items like shirts, shirtwaists or blouses, and underwear. It was also easy to exploit

women's labor as they left the shop floor to assemble pre-cut garments at home. This kind of subcon-tract work, called "cottage" or "piecework," was the lowest paying in the industry, done by women whose household duties kept them from working in the factory, and children often helped their mothers.

Eventually, by the end of the nineteenth century, the desperate work conditions, terrible pay, and the chronic indifference to the safety of workers led women to organize. Nearly all of the European trade unions had excluded women (a practice held over from medieval guilds), but around 1880 some began to recruit unskilled workers and women to their ranks. One of the first and most visible labor actions—largely because it was successful and became a template for the modern labor movement—was a strike by women workers at the Bryant and May match factory in East London. Still, by 1910, though women made up almost one-third of the workforce in the United Kingdom, they accounted for only 10 percent of union membership. Opposition by male-dominated trade unions to women workers, in particular their initiatives regarding equal pay and treatment, continued well into the twentieth century.

In the United States, poor treatment of workers led to the formation of two large international labor unions for women, the International Ladies' Garment Workers Union (1900) and the Women's Trade Union League (1903). Young women garment workers in New York went on strike to protest poor working conditions in 1909, triggering a flurry of

similar actions in New York, Philadelphia, Cleveland, Milwaukee, and St. Louis, and drawing the attention of the Industrial Workers of the World (IWW), the newly formed international labor union whose purpose was to organize all workers, regardless of race, gender, or trade. The Triangle Shirtwaist Factory fire in New York City in 1911 epitomized both the sex-segregated nature of industrial work and the dangers of unregulated sweatshop conditions for many women in the garment trades. The predominantly immigrant work force sewed in crowded conditions, their machines side by side in long rows, with piles of fabric stacked in corners and underfoot. Their supervisors routinely locked the doors to the stairways to discourage workers from taking breaks. When the Triangle factory caught fire, 146 textile workers died, 123 of whom were women, many of them leaping from the upper stories of the factory to escape the smoke and flames.

As a consequence of the tragedy, labor and city leaders were sufficiently moved to better regulate work conditions in the textile industry. Frances Perkins, a sociologist who worked in the settlement house and suffrage movements, had witnessed the fire and left her position as the head of the New York Consumer League, an organization that opposed harsh, unregulated working conditions, to become the executive secretary for the Committee on Safety of the City of New York. Two years later she was instrumental in getting a "fifty-four-hour" bill passed in New York, capping the number of hours women could work in industrial settings. Eventually, Perkins went on to serve as the Labor Secretary under Franklin D. Roosevelt, bringing a much-needed ally of women workers into the White House during the New Deal, Roosevelt's far-reaching network of programs and projects aimed at reducing poverty and creating a social safety net.

Labor organizing provided one important avenue for fighting wage inequality. Protective legislation enacted on the state and federal levels provided a second critical component. Legislation initially designed to protect women in the 1910s expanded in the 1930s and 1940s to set limits on minimum wages, maximum hours, and exposure to dangerous work conditions in select industries for all workers. Rose Schneiderman, a Polish-born member of the Women's Trade Union League, Labor Secretary Frances Perkins, and First Lady Eleanor Roosevelt took up the cause of worker safety and helped extend such protections as the forty-hour workweek, worker's compensation, and old age pensions to more employees by way of New Deal legislation in the 1930s.

Not all women worked in factories in the industrial era; some began to enter service trades too, in which they experienced a different kind of sex discrimination. The turn of the twentieth century saw a rise in overall consumption, or spending, on new mass-produced products such as vacuum cleaners, washing machines, cars, clothes, and furniture, which in turn created new jobs in the growing service industries. White middle-class American

United States, 1910

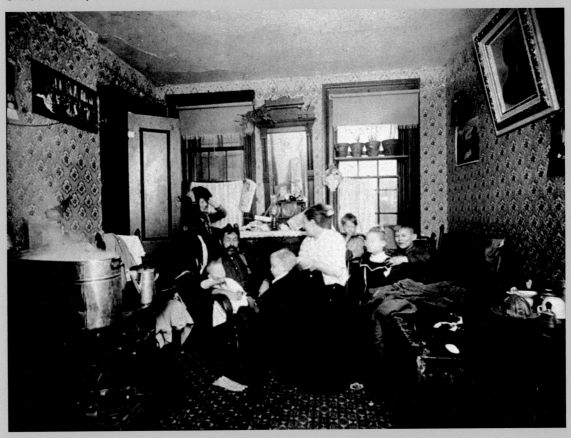

ABOVE In New York City, the population doubled every decade between 1800 and 1880. Buildings that had once been single-family dwellings were increasingly divided into multiple living spaces to accommodate the newcomers. The Lower East Side neighborhood, with its narrow, low-rise tenement apartment buildings, was crowded, cramped, poorly-lit, poorly-ventilated, and lacked indoor plumbing. By 1900, 2.3 million people, a full two-thirds of the city's population, lived in tenement housing. Here, a mother and her seven children eke out a living doing garment piecework.

NEXT SPREAD (United States, 1911) A gruesome photograph taken at the scene of the Triangle Shirtwaist Factory shows the dead bodies of young women who had jumped to escape the inferno. As the building went up in flames, standard workplace procedures, such as locking doors to stairwells to discourage idleness and allowing large piles of fabric scraps to build up along walls and in corners, worsened the disaster, and fell under city and state scrutiny in the aftermath. Workplace safety protections became federally mandated by the New Deal in the 1930s, thanks to Frances Perkins, a New York City employee who witnessed the fire, and who later became President Franklin D. Roosevelt's Secretary of Labor.

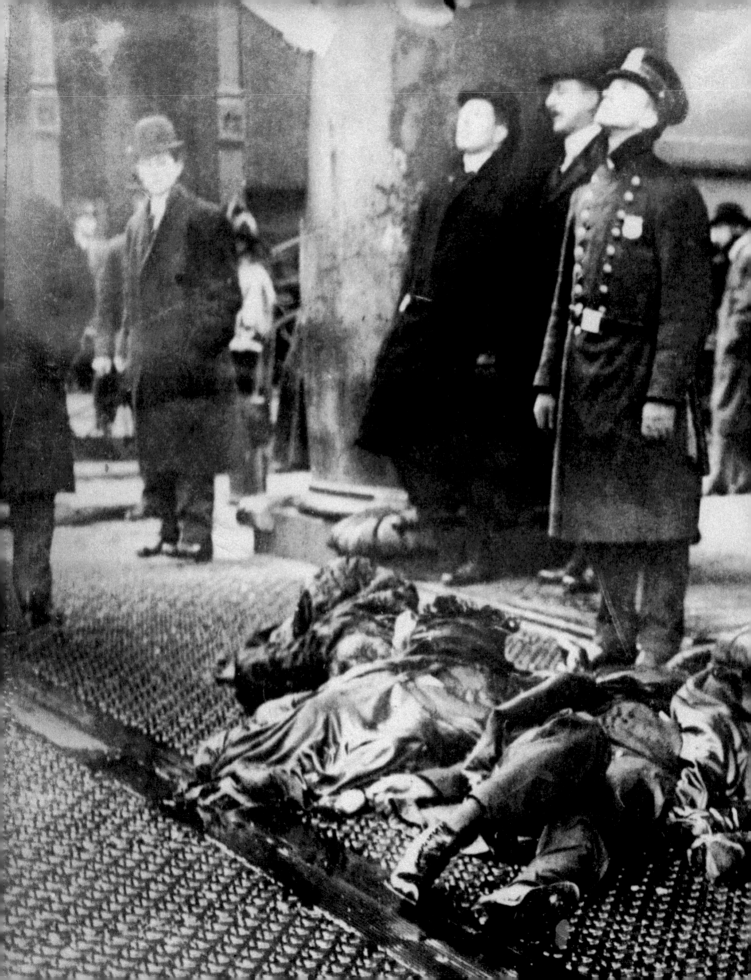

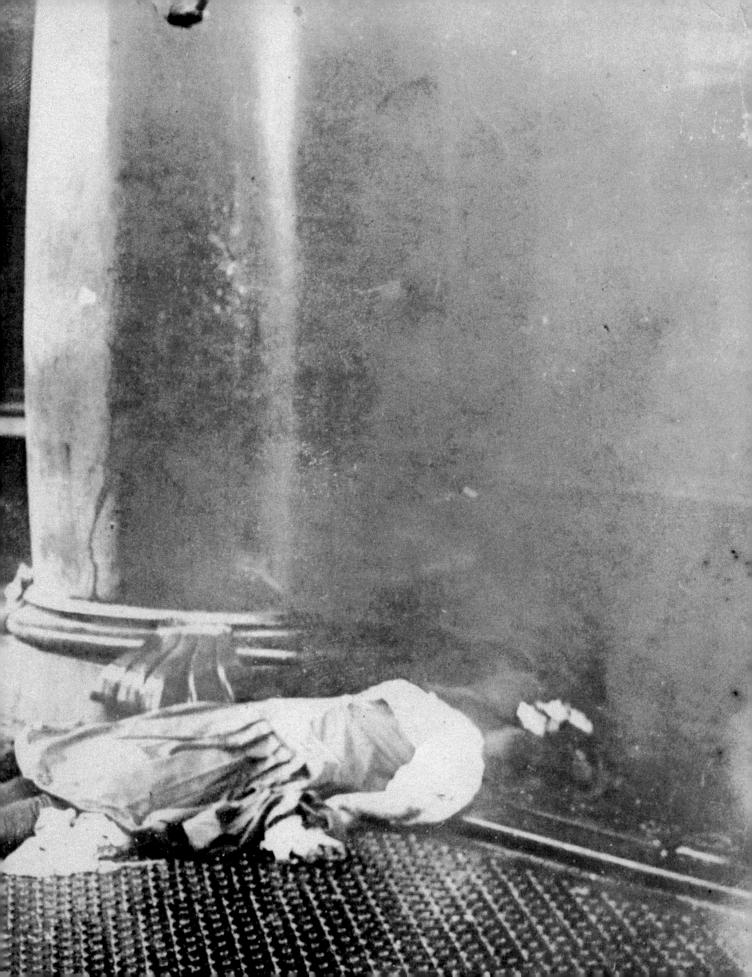

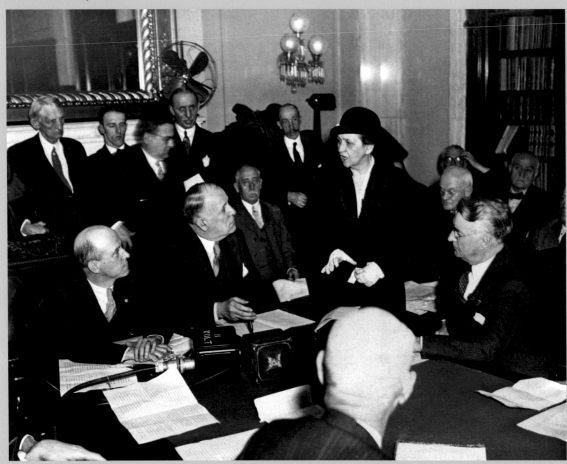

ABOVE Frances Perkins (1880–1965), the Secretary of Labor under President Franklin Roosevelt, testifies on behalf of Roosevelt's reforestation program. Perkins was the first woman appointed as a cabinet secretary and she served in the position from 1933 to 1945, the entire length of Roosevelt's presidency. Perkins played a key role in a number of New Deal programs. In 1933, Roosevelt asked Perkins to implement the Civilian Conservation Corps, which relieved unemployment by providing national conservation jobs for American men. Perkins drafted the Social Security Act in 1935, and she laid out the standard forty-hour work week and created the first minimum wage laws through the Fair Labor Standards Act in 1938. By developing and promoting these important pieces of legislation, Perkins became chiefly responsible for the adoption of social security, federal laws regulating child labor, unemployment insurance, and the federal minimum wage in the United States.

RIGHT (United States, 1910) Rose Schneiderman (1882–1972) was a labor leader, socialist, and women's suffrage activist who immigrated with her family from Poland to New York's Lower East Side in 1890. After her father died, she went to work at the age of thirteen, first in a department store and then in a cap factory as a lining stitcher. Schneiderman later helped organize the factory into a branch of the United Cloth Hat and Cap Makers' Union. In 1906, she was elected vice president of the New York Women's Trade Union League (NYWTUL), and in 1926, she became the president of the national organization. She spoke out in the wake of the deadly Triangle Shirtwaist Factory fire of 1911 and became known for her power as an orator. "The worker must have bread, but she must have roses, too," Schneiderman said.

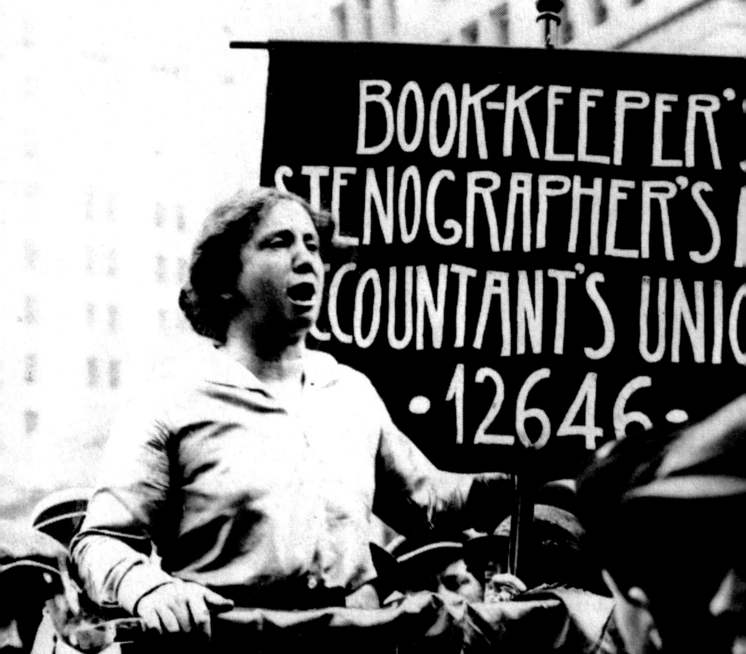

women who were fluent in English dominated jobs in department stores and offices. Such "clean work" became known as "pink-collar work," a job classification lower than the white-collar work of the boss and less remunerative than the blue collar of the industrial worker. Sales girls were expected to dress fashionably. Secretarial work, which grew in the 1910s and 1920s, was soon a field almost completely dominated by women. Before the Civil War, clerking had been seen as a skilled job for a man. But rapid growth in office and paperwork devalued the position, rendering it "more suitable" for women. In the U.K., the number of female clerks jumped from barely 1,000 in 1870 to 125,000 in 1911. Technological innovations like the typewriter and the adding machine were quickly adapted to match women's small hands. Bosses expected secretaries and office workers to appear stylish and neat, a requirement that often strained workers' meager budgets. With the expansion of pink-collar work in business, government, and industry, the number of white women in domestic service dropped, leaving such work open to African American women who faced discrimination in light manufacturing and office jobs. By 1961, 1.8 million American women earned their living doing office work. Today that number is 2.5 million. This pattern was interrupted only by major events, such as World War I and II, both of which pulled more women into factory wage labor.

Sex segregation and the gendered pay scale were a fact of both factory and pink-collar work, though the world wars necessarily opened opportunities for women to work in capacities that they wouldn't have otherwise. During World War I, which affected Europe more profoundly than it did the U.S., men joined the military and left their factory posts empty. In the U.K., two million women replaced men at their jobs, doing not only clerical work but new tasks such as commercial and military driving, nursing, and other work in hospitals. They staffed munitions factories, built ships, and performed heavy labor previously defined as "masculine," like loading and unloading coal. In Russia, the number of women in industry doubled, and in Austria, a million women joined the workforce. German working women, in contrast, did not make the inroads in male-dominated industries that other European women did. Trade unions refused to let women work, on the grounds that this would undercut men's jobs. Germans instead focused on getting more men, aged fifteen to sixty, into the work force, while men of fighting age were indisposed.

While the contingencies of World War I offered more choices to women generally, women's wages did not match men's in their expanding work roles and did not lead to improvements in their wages. In the United Kingdom, women who took a man's job did not receive a man's wage. In France, the war pulled women from domestic service, clothing shops, and textile mills into the metal trades: four out of five industrial workers were women in these years. They mobilized to protest their low wages and long hours and organized themselves into female trade unions. In the U.K., the number of women in

Germany, 1910

United States, 1953

ABOVE The introduction of telegraphy in 1844 led to the creation of a new occupational category, the telegrapher, or telegraph operator. Sending and receiving telegraphs in Morse code required skilled operators at each station; a shortage of qualified male operators led to the hiring of women. Germany and Russia first admitted women to the trade in the 1860s. The Telegraph School for Women was opened in London in 1860 and Dublin in 1862. By 1870, 31 percent of English telegraph operators were women. Despite their industry numbers, female operators were paid less than their male counterparts.

RIGHT White working-class women gained strongholds in light, clean "pink-collar" work starting in the 1920s. Working as secretaries, typists, stenographers, and saleswomen, these non-unionized jobs were prized for their aspirational proximity to professionals. Pink-collar workers, who still faced lower wages, were expected to devote a portion of their pay to looking the part with smart clothes, shoes, and other adornments. As the need for secretaries and office clerks declined after 1980, more and more women found work in fast-growing service industries.

industrial unions jumped from 350,000 in 1914 to one million by war's end. Overall, war work enabled women to earn more than they would have before the war, but less than what a man doing the same job would have earned. And assembly-line tasks once assigned to individual men were broken down into even more unskilled steps and assigned to multiple women workers, who were accordingly compensated less, while enjoying less autonomy over the work. Sadly, after the war, even modest gains in women's industrial employment were lost, as returning soldiers took back jobs employers and labor unions viewed as properly belonging to men.

This pattern of opening work opportunities to women only to close them repeated itself in the U.S. during World War II. Wartime defense mobilization opened skilled factory work to women of all races. As young men left to fight overseas, defense industries pulled women away from their old jobs and brought new women in through the lure of higher wages and appeals to their patriotism. During the war, the number of women working in the historically male-dominated heavy manufacturing sector mushroomed. Women worked in shipyards welding and riveting massive ships, and they assembled tanks, airplanes, bombers, and munitions. According to the Office of War Production, these female workers "disproved the old bugaboo that women have no mechanical abilities." Waitresses, saleswomen, and maids became riveters, welders, lumberjacks, blacksmiths, and drill press operators. Latina women found new opportunities in California's aircraft and shipbuilding industries. Twenty percent of African American women who worked in private homes as domestics left for better-paying jobs with more freedom. Large corporations like Monsanto, Du Pont, and Standard Oil hired female chemists for the first time, while Boeing hired its first five female engineers. The number of female journalists covering Capitol Hill tripled from thirty to ninety, as women toured for the first time in jazz bands and baseball leagues.

By the war's end in 1945, and for the first time in American history, married women outnumbered single women in the paid workforce, perhaps the greatest indication of a cultural shift in attitudes about women's natural place being the home. But the gains women made in the American workplace didn't continue after the war. Although most women wanted to keep their new jobs and build on wartime opportunities, most employers viewed them as only "working for the duration." As war de-escalated and men started to return from overseas, employers laid off women and most were never rehired, despite their experience and skill.

Even as the economy expanded again in the 1950s, many well-paid jobs were deemed unsuitable for women. It is easy to see in the classified advertisements of the era which jobs were considered suitable for women, because the ads themselves were clearly divided along gender lines. "Be the secretary executives fight for," urged an ad for a stenography course aimed at women looking for work that persisted into the 1970s. Not many promised a path to the

executive suite, as listings in the men's category frequently did—except as a stenographer, preferably one who can "handle male banter." Nevertheless, the dam had been broken for married women, who, as a group, stayed in the paid workforce in numbers that never decreased.

By the 1960s and 1970s, more American women, regardless of their marital status, worked for a wage outside the home. In the U.K., 53 percent of women worked outside the home in 1971. Women's entry into the professions expanded in the 1970s and 1980s, with women making up more than 40 percent of all students entering professional schools. Women who might have been school teachers, nurses, or social workers were now able to command competitive salaries in law firms and businesses. More women applied and were admitted into medical school, starting a slow transformation of the field that by 2017 had achieved gender parity in medical school admissions. That same year, 60 percent of doctors in the U.K. under the age of thirty-five were female. But despite gains by professional women, the ongoing sex-segregated labor market continued to limit women's earning capacities. Many of the new jobs created after 1950 in the U.S. were in the service sector, part of the gradual shift in the U.S. economy from heavy industry toward service work. Women in the U.K. are likewise clustered in health and social work, sales, and customer-service. Employers have typically viewed women as particularly suited to such work. Between 1955 and 1981, American women saw their actual earnings fall from 64 percent of what

men earned to 59 percent, a trend that could also be found in the U.K. Working women in these years found it hard to keep their families out of poverty.

Women's gains in the twenty-first century workforce have built on the labor and feminist activism of the 1970s and 1980s. In the U.S., labor union activists successfully marshaled popular and congressional support to pass the Equal Pay Act of 1963 after President John F. Kennedy formed the Presidential Commission on the Status of Women. The Civil Rights Act of 1964 outlawed job discrimination, and the Equal Employment Opportunity Act of 1972 gave the Justice Department enforcement power to prosecute workplace violations. These acts set the foundation for defining and ultimately litigating sexual discrimination and harassment in the American workplace.

The push for women's wage equality in the U.K. has been similarly driven by the collective action of the '60s and '70s. Women who made car seat covers for Ford automobiles walked off their jobs at the Dagenham and Halewood plants in London in June 1968 when their jobs were reclassified as less skilled, which resulted in a 15 percent drop in their pay compared to male compensation for the same work. After three weeks, their wages were raised within 8 percent of male workers' earnings, and the following year women were paid the same wage as men. The strikes led to the passage of the Equal Pay Act of 1970. Feminist activism further strengthened these protections. Women in the European Union also enjoyed a general guarantee of equal wages and

LEFT (United States, 1942) Women workers at the Douglas Aircraft plant in Long Beach, California polish the transparent noses of A-20 attack bomber aircrafts. The A-20 was one of the first American-made aircrafts to be used during World War II. During the war, women took on roles as engineers, mechanics, and test pilots. In 1943, 310,000 women worked in the aircraft industry, and in 1945, one in four married women worked outside the home. Douglas Aircraft Company recruited local housewives to work in the plant. Women in Long Beach donated thirty-seven thousand pounds of fat and grease from their kitchens in 1942 to help create explosives. The figure of "Rosie the Riveter" became an icon for the millions of women who worked in factories and shipyards during World War II.

ABOVE Rolls-Royce produced aircraft engines for the British war effort. Here, the employees, the majority of whom are women, leave the factory during a change in shift. Despite concerns from trade unions, beginning in 1941, women between the ages of twenty and thirty were conscripted by the government to support the war. The Ministry of Labour and National Service distributed propaganda posters and leaflets that requested women's participation. Overall, women's employment in the U.K. increased significantly during World War II, from 26 percent of women working in 1939 to 36 percent in 1943. According to government statistics, in September 1943, 90 percent of single, able-bodied women between eighteen and forty were directly involved with some kind of work for the war effort.

United Kingdom, 1968

PREVIOUS SPREAD (United States, 1970) Women marching in the Women's Strike for Equality, which took place on August 26, 1970 in New York, as well as other cities around the U.S. The strike was coordinated by the National Organization of Women (NOW) and helmed by feminist author and activist Betty Friedan. Approximately fifty thousand women marched through the streets of New York. The main goals were to call for free childcare, free abortion on demand, and equal opportunity in employment and education. Women carried signs with slogans such as, "Don't Iron While the Strike is Hot." The strike received widespread media attention, both at the local and national level, but the response was mixed. While detractors criticized the event as unnecessary, NOW's membership subsequently grew by 50 percent.

ABOVE Women sewing machinists at the Ford Motor Company plant in Dagenham went on strike in 1968. Though they were skilled workers, the women were ranked at the same grade as the unskilled men who swept the plant's floors, and paid less. The union initially opposed the strike, but the women were joined by their counterparts at the Ford plant in Halewood, Liverpool, shown above. The union came around. After three weeks, Barbara Castle, the Employment Minister, intervened to negotiate a settlement, bringing media attention to the strike. The attention helped lead to passage of the Equal Pay Act of 1970. The story of the Dagenham strike was made into a feature film, *Made in Dagenham*, in 2010.

other protections under the Charter of Fundamental Rights, which later formed part of the constitution in 2004. Likewise, feminists in Germany successfully petitioned to win the right for married women to work without permission from their husbands in 1977.

Protections designed to promote women's work outside the home have unwittingly transformed traditional ideas of domesticity, both in the United States and in western Europe. As more women have worked for wages, they have discovered that expectations of their contributions to housework and childcare have changed little. In essence, they have taken on a "second shift" of cooking, cleaning, and household shopping that men are often not expected to take on as presumed primary breadwinners. This is ironic, considering that women's wages have proved absolutely central to the economic well-being of most families. As divorce laws have liberalized in recent decades, more women have become primary breadwinners whether they have liked it or not, making the issue of pay inequality all the more pressing. According to a 2010 Pew Research Center study, women work forty-seven more days than men to earn the same wages, and the gender pay gap widens when women have children.

Sociologists refer to the "motherhood penalty"— the price many women pay to take jobs with greater flexibility and lower pay to accommodate family obligations that still disproportionately fall to them. Another barrier women face is the "sticky floor," a term that describes a discriminatory employment pattern that keeps women at the bottom of the job scale. Women in middle management are perceived to lack the leadership and drive that male managers are perceived to have, despite their comparable successes. Much of the perception is due to their presumed primary caregiver roles at home. The gender pay gap means that women are more likely to depend on welfare payments in old age.

A similar story has unfolded in China. World Bank data shows that in 2010, China ranked first in the world for female labor force participation. It also established retirement age for women at fifty and fifty-five, depending on the job, and for men, sixty, limiting the amount of wages, promotion, and pensions women can earn. Like British and American women, Chinese women also face a wage gap driven by fewer work opportunities, a lack of childcare options, and a resurgence of stereotypes about women's work. A study of civil service job postings found that nearly a quarter listed a preference for male candidates. Many job advertisements directed at women included height and weight preferences and requirements that applicants be married with children. One ad that ran in northern China called for "fashionable and beautiful high-speed train conductors." Even the online shopping giant Alibaba ran photos on its official blog that showed female workers in sexualized poses, including one engaged in pole dancing. Between 2005 and 2010, the total number of jobs in China increased, and yet women's share of those jobs declined.

Morocco, 2018

Kenya, 2017

LEFT, TOP Thousands of teacher trainees mobilized protests against the government's plans to cut education jobs and other public sector hiring, including this unemployed and visually impaired teacher trainee, who battled with security forces in front of the ministry of Solidarity, Women, Family and Social Development in Morocco's capital, Rabat, in 2018. Since 2011, the city's austerity program has resulted in cuts in wages for public workers, reduced subsidies, and pension reforms that have produced public outcry.

LEFT African workers cutting pineapples at a beverage manufacturer in Thika, Kenya. Kenya's largest single manufactured export is canned pineapple and one company, Del Monte Kenya Limited, controls it. Kenya is one of five exporters of pineapple worldwide. Sixty percent of its six thousand workers are women who have had to fight the company to improve their safety and wages. In 1999, the Kenya Human Rights Commission cited the company for low wages, "disgraceful" living quarters and sanitation, and use of toxic pesticides deemed extremely hazardous by the World Health Organization. In 2001, the company signed an agreement to stop its intimidation of labor union leaders and to pay restitution to workers exposed to environmental hazards.

RIGHT (India, 2016) More than seven thousand fisherwomen operate in the Brihanmumbai Municipal Corporation market, one of the largest fish markets in Mumbai, India. Most women are dry salt fish processors procuring small quantities of fish every day and selling at weekly markets. Many fish vendors are widows who supplement their earnings by working in agriculture during harvest. Female vendors form collectives and receive microloans to start their businesses if they are without family support.

NEXT SPREAD (China, 2005) Workers weigh and prepare chicken on the production line at the Deda Chicken Processing Plant in Dehui City, Jilin Province. China has one of Asia-Pacific's highest labor force participation rates for women, yet women's labor force participation has been declining since the 1990s, due in large part to gender discrimination and a lack of childcare options. In job advertisements targeting women, many include requirements for the applicant to be married with children and to match height and weight requirements unrelated to the job. Women earn on average 36 percent less than men for doing similar work, and in top positions, comprise only 9 percent of the board directors of publicly traded companies.

While political organizing has led to improvements in the working lives of many women worldwide, fast-growing global industries threaten to turn back the clock on industrial wage-workers, who fight the same battles women once fought before them. The rapid economic development of globalization has led to another generation of women facing dangerous work conditions and mobilizing to bring change. In Bangladesh, 3.5 million people work in garment factories, 85 percent of whom are women earning little more than minimum wage, which itself is below what is considered enough to provide a family with shelter, food, and education. Many work fourteen-hour days, seven days a week, in hazardous conditions. The National Garment Workers' Federation has been advocating to improve the situation of textile workers since 1984. The collapse of the Rana Plaza building in Dhaka in 2013 killed 1,100 textile workers and brought global attention to the exploitative conditions of the international textile industry, much like the Triangle Fire galvanized reform efforts in 1911.

Like young Lowell textile mill girls, the Chinese women making goods for Apple, Mattel, Nike, Reebok, and Levi's today are in their late teens and early twenties. They live in "three-in-one" facilities where production, warehousing, and living take place. The girls work six days a week and are paid between $70 and $250 a month in U.S. dollars, meals and housing deducted. They are fined for spending more than five minutes in the bathroom and work when sick. Factory bosses are disposed to like young female workers because they are regarded as hardworking and manageable.

And yet, as they did in the past, women today continue to organize for safer work conditions, equal wages, and freedom from sexual harassment in industries across the world. International Women's Day, celebrated on March 8, has become a focal point in the movement for women workers' rights. The first International Women's Day took place in 1910. Organized by the International Socialist Woman's Conference, one hundred delegates from seventeen countries used the day as a way to promote equal rights for women, including suffrage, and to end sex discrimination at work. The following year, over a million people in Austria, Denmark, Germany, and Switzerland also observed the day, and in 1917, Soviet women workers went on strike to protest their low wages, work conditions, and crippling food shortages. The day became a national holiday for Soviet women after they gained the vote. The United Nations finally adopted the holiday officially in 1975. Today, International Women's Day is a global movement for women's rights, including women's efforts to end sexual violence, poverty, hunger, and climate change, as well as serving as a reminder of the importance of women's voices in inventing a future that is more inclusive for women who work.

The time is long past when women can be said to be working for "pin money," or because their ambitions are "masculine" and they are not sufficiently concerned with their families and their domestic lives. More than ever, women work because

In 2012, two fires in Bangladesh's textile industry brought global attention to the plight of workers in "fast fashion" factories, where workers, mainly women, produce clothing under strict deadlines and for very low wages. The Tazreen Fashion factory fire killed 112 workers, and five months later, the Rana Plaza building collapsed, killing 1,134 garment workers and injuring hundreds of survivors. In the immediate aftermath, a safety pact signed by global unions and more than two hundred brands took important steps towards making global apparel companies accountable for the safety of factories in their supply chains. But five years later, workers say that these new initiatives haven't gone far enough to address the multiple attacks on workers' everyday health and well-being. In 2018, hundreds of Bangladeshi garment workers holding black flags staged a human chain during a protest demanding better work conditions in textile factories.

Switzerland, 2019

ABOVE Thousands of women across Switzerland held a strike on June 14, 2019, to protest unequal pay and workplace inequality. Here, protesters in Bern use sledgehammers to smash an effigy of the patriarchy. According to the organizers, the goal of the strike was to demand equal pay for equal work and to protest discrimination and sexual harassment in the workplace. According to a recent UNICEF study, Switzerland's family leave policies are the worst in Europe, and Swiss women earn an average of 18 percent less than men. Protesters organized using hashtags such as #Frauenstreik and #GrèvedesFemmes ("women's strike" in German and French). The strike occurred twenty-eight years after the first Swiss women's strike in 1991, which led to the passage of the Gender Equality Act in 1995.

NEXT SPREAD (Spain, 2018) Women demand equal working rights and an end to violence against women in Spanish society during a march to celebrate International Women's Day on March 8, 2018 in Madrid, Spain. The celebration began in 1910 when German revolutionary Clara Zetkin proposed March 8 be honored as a day to honor working women and to demand the right to work without discrimination.

they need to support themselves and their families; equal pay, access to affordable child care, and the other measures that feminist leaders are seeking to implement are quite simply the best means for giving women the latitude to have the time to devote to family and their domestic lives while also earning a living. Women living in poverty are even more vulnerable to the effects of unequal wages: those who are single, divorced, or widowed truly know the meaning of subsistence.

When called upon to do so, women have shown that they are more than up to the task of performing jobs that are traditionally considered to be the bailiwick of men, as they did during the two World Wars. Women have demonstrated competence in senior corporate governance at least equal to men's, while multiple studies have shown that gender diversity in the boardroom in itself can create value for corporations (yet only about 15 percent of corporate directors across the globe were women in 2018). The goal of women has never been to replace men in the work force, only to have the equal opportunity to compete in the marketplace and to be compensated equally and fairly.

Two centuries ago, the French socialist writer and activist Flora Tristan wrote, "Almost the entire world is against me, men because I am demanding the emancipation of women, the propertied classes because I am demanding the emancipation of the wage earners." Today, issues of gender and work-based equality remain tied together. No serious social movement, least of all feminism, can ignore the terrain of class on which the struggle for equality is waged. Even if gender and wage discrimination have roots in a pre-capitalist era, it is important to recognize the ongoing reproduction of the inequalities of that period in contemporary life and to collectively call for change, just as the German socialist and feminist leader Clara Zetkin did in an 1899 speech:

> Working women are absolutely convinced that the question of the emancipation of women is not an isolated question which exists in itself, but part of the great social question. They realize perfectly clear [sic] that this question can never be solved in contemporary society, but only after a complete social transformation.

On perhaps a more pragmatic note, the former U.S. first lady Michelle Obama observed, "No country can ever truly flourish if it stifles the potential of its women and deprives itself of the contributions of half of its citizens."

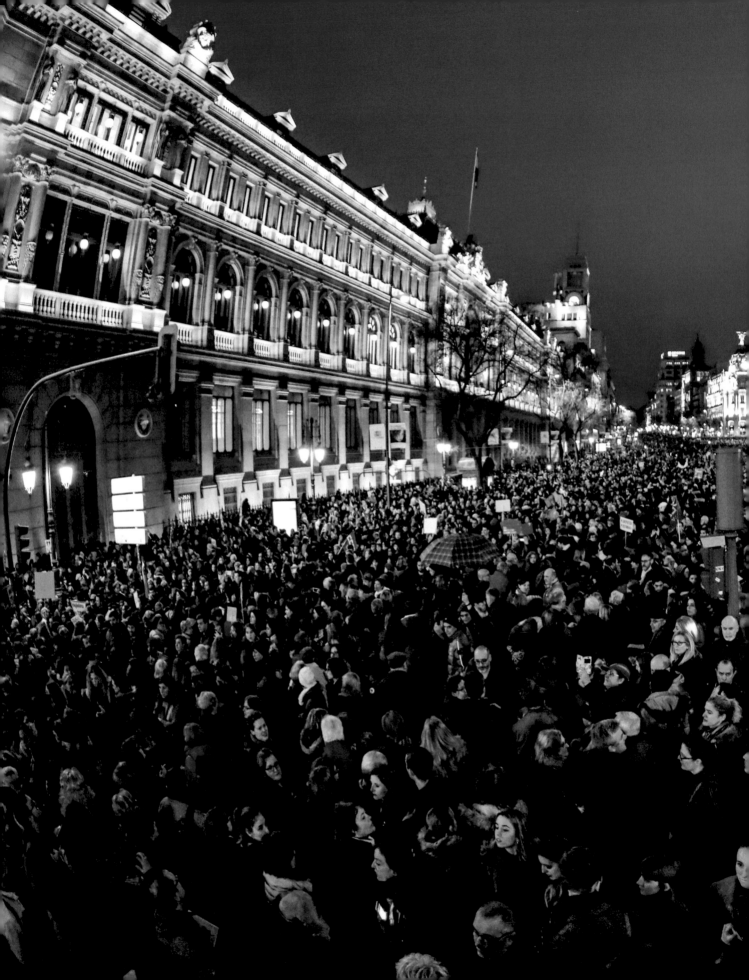

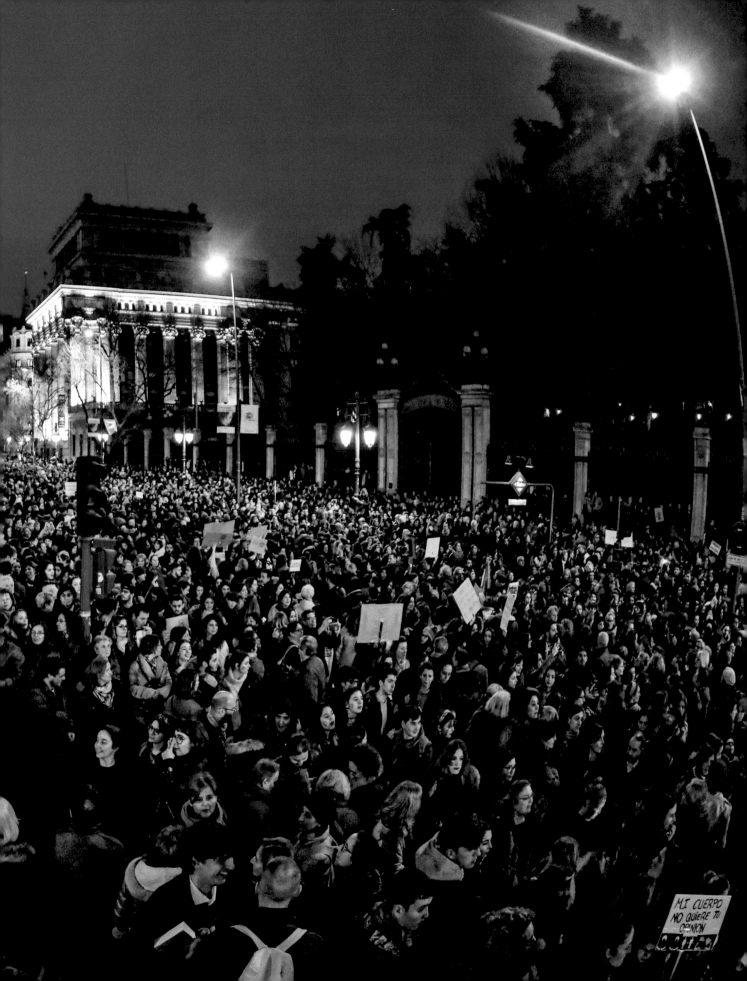

A pedestal is as much a prison as any small, confined space.

Gloria Steinem

The Eye of the Beholder

In 1914, the British suffragette Mary Richardson smuggled a meat cleaver into the National Gallery in London and attacked Velázquez's painting *La Venus del Espejo* (1647–1651), better known as "the Rokeby Venus," which represented the erotic standard of its day. In addition to exacting political vengeance for the British government's treatment of Emmeline Pankhurst, the suffragette leader, Richardson's slashes into the masterpiece struck a blow at the oppression of women, and the unequal standards of appearance that were forced upon them. "I didn't like the way men visitors to the gallery gaped at it all day," she later said. How can it be that a painting, widely regarded as a masterpiece, is oppressive to women? The answer lies in further questions: who determines standards of "art" or "beauty," and to what extent do images created by artists shape our ideas about beauty?

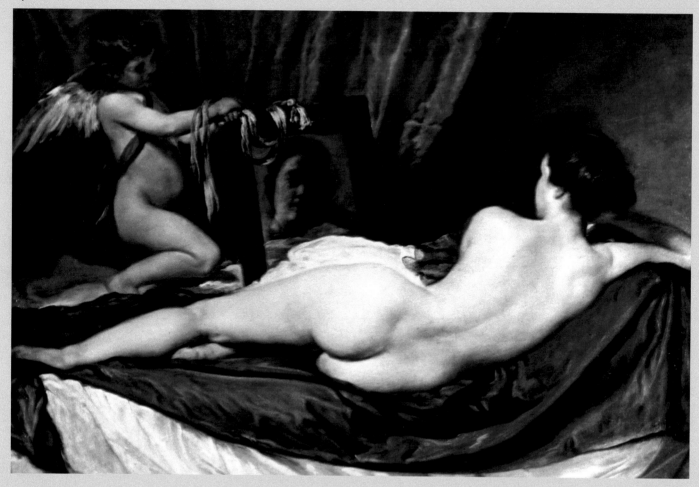

ABOVE Diego Velázquez completed "The Rokeby Venus" or *The Toilet of Venus* between 1647 and 1651. Velazquez was an official court painter of King Philip IV and is regarded among the greatest Spanish artists. This iconic yet mysterious painting depicts the goddess Venus looking into a mirror held by her son, Cupid. Art historians have asked why Venus is seen from behind and why the mirror only captures the face of the model and not the observer. Suffragists and later feminists offered a competing set of questions: What role does the female nude play in the history of art and whose gaze matters?

RIGHT, TOP Mary Richardson's attack on Diego Velázquez's Rokeby Venus was not the only suffrage assault on fine art. American Anne Hunt slashed Millais's portrait of Thomas Carlyle with a butcher's cleaver in 1914, leaving the painting much like the one seen here. While an effective publicity move, the destruction of art by suffragettes also triggered a backlash and confirmed the view of women's rights supporters as unhinged. During her trial, an unrepentant Hunt declared, "This picture will be of added value and of great historical importance because it has been honored by the attention of a Militant."

RIGHT, BOTTOM "Slasher" Mary Richardson attacked the Rokeby Venus at the National Gallery in London on March 4, 1914, slashing it seven times with a meat cleaver. This was in protest at the government's failure to give women the vote. Attacks on works of art prompted the closure of many of the country's art galleries and museums to women, and sometimes to the public completely. At places of historical interest, the rule of "No muffs, wrist-bags, or sticks" was widespread. Later, in May 1914, the Royal Academy and the Tate Gallery closed to the public. The British Museum was more flexible, opening to women accompanied by men who would accept responsibility for them.

United Kingdom, 1914

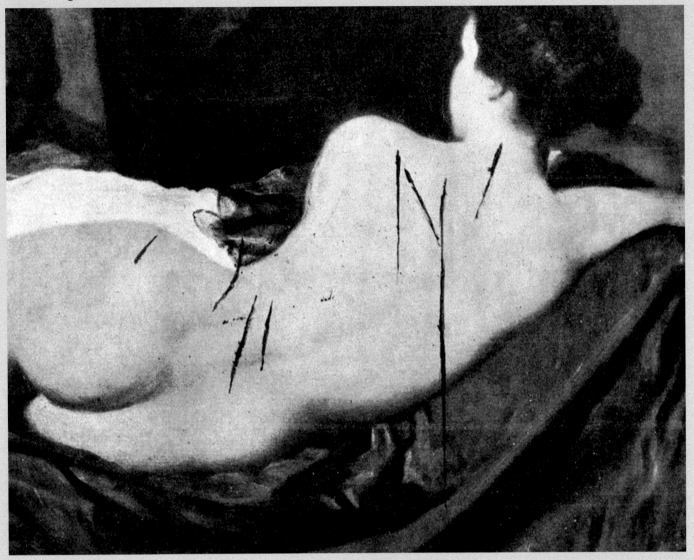

United Kingdom, 1914

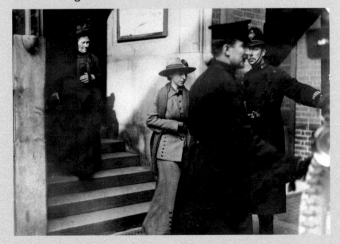

United Kingdom, 1927

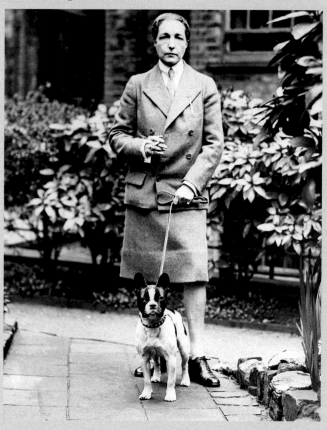

United Kingdom, 1900

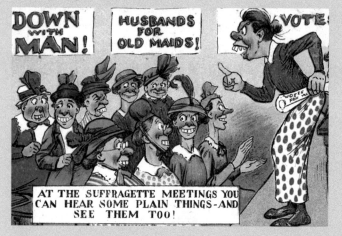

ABOVE Marguerite Radclyffe Hall (1886–1943), a prizewinning writer whose novel *The Well of Loneliness* was originally banned in Britain and the U.S. for its sympathetic approach to female homosexuality. *The Well of Loneliness* became an underground classic for gay, lesbian, and gender non-conforming readers until a new marketplace of LBGTQ books developed in the 1970s.

LEFT This anti-suffrage color postcard offers a satirical illustration of a woman with buck teeth speaking to a group of unattractive, middle-aged women, with posters on a wall in the background reading "Down with Man!" and other outrageous slogans. The historical association of political speech with men made women who spoke in public and petitioned for rights into grotesque or ridiculous figures.

For women, the threat of being labeled as un-attractive has always been a subtle but effective means to enforce their conformity. In the late nineteenth and early twentieth centuries, suffragists in the U.S. and the U.K. were frequently depicted as ugly hags in anti-suffrage cartoons, just as feminists in the 1970s were portrayed as hairy, humorless, and unattractive. The trope of the unattractive, or unfeminine, feminist continues to manifest itself on Twitter, shock radio, and YouTube. Ironically, neither feminists nor the suffragists before them proposed that women's freedom required shedding the practices and accoutrements of femininity. No one but antifeminists said that women who sought equality with men just wanted to look and act more like them. Rather, feminists believed that freedom came from women and women-identified people representing themselves in words, imagery, and art of their own, using the signs and symbols of gender in whatever way suited them.

Take for example British writer Radclyffe Hall, author of *The Well of Loneliness* (1928), whose idea of beauty or stylishness did not conform to tradi-tional ideals of femininity. She was one of the first European women to wear men's clothes as a way to craft both her unique sensibility and to announce her affinity with urban lesbian and gay subcultures. Hall's choice to dress in men's clothing, and her refusal to wear corsets and heavy dresses was as much a rejection of the strictures of upper-class British femininity as it was an embrace of lesbian and gay identity.

How are the ideals and functions of beauty defined, and who defines them? This endlessly debatable question touches on the domains of science, philosophy, and art. Perhaps the most universally recognized quality of beauty is the feeling of "exalted pleasure" it produces. Great beauty leaves us "breathless," "bowled over," or "knocked out." The philosopher Immanuel Kant posited that beauty can only be appreciated from a disinterested stance, one devoid of desires such as hunger or sexual appetite. Only then, he insisted, could aesthetic qualities be appreciated without personal bias. John Keats, the English Romantic poet, famously asserted in "Ode on a Grecian Urn" that beauty is, quite simply, truth—and truth, beauty. Evolutionary biologists understand beauty as a primary factor in natural selection throughout the animal kingdom, including for humans. The prevailing theory goes that women and men beautify themselves to entice the most attractive mates and produce the strongest offspring. Normative qualities of beauty, such as strong hair, supple skin, and a low waist-to-hip ratio in women; height, broad shoulders, and muscled physique in men, are presumed to be indicators of health and youth, and therefore indicate evolu-tionary superiority. Today evolutionary biologists are studying beauty and attractiveness in mate selection for purposes beyond reproduction, including the strengthening of social bonds within groups.

But nowhere has the debate been waged more fiercely—and arguably, with greater effect—than in the crucible of fine and commercial art. In the

ABOVE This painting, "Virgin and Child," by Flemish painter Master of the Legend of St. Ursula (1436–1505) shows the Virgin Mary breast-feeding the infant Jesus. Such devotional images, called *virgo lactans* (nursing Madonna), were popular in the fifteenth century. In the Middle Ages, depictions of the *virgo lactans* were linked to the Madonna of Humility, which generally showed the Virgin sitting on the ground and wearing ordinary clothes, a humanist conception of Mary which gained further traction in the Renaissance. Images of the breastfeeding Madonna gradually died out when church clerics started to discourage nudity in religious iconography after the Council of Trent (1545 to 1563).

RIGHT (United States, 1965) Jazz singer and actress Abbey Lincoln poses for a portrait in New York City. At the end of the 1950s, a small number of young black female dancers and jazz singers broke with prevailing black community norms and wore unstraightened hair. At the peak of its popularity in the late 1960s and early 1970s, the Afro epitomized the international "Black is Beautiful" movement. Lincoln was an early adopter, along with Angela Davis, Pam Grier, and South African singer Miriam Makeba.

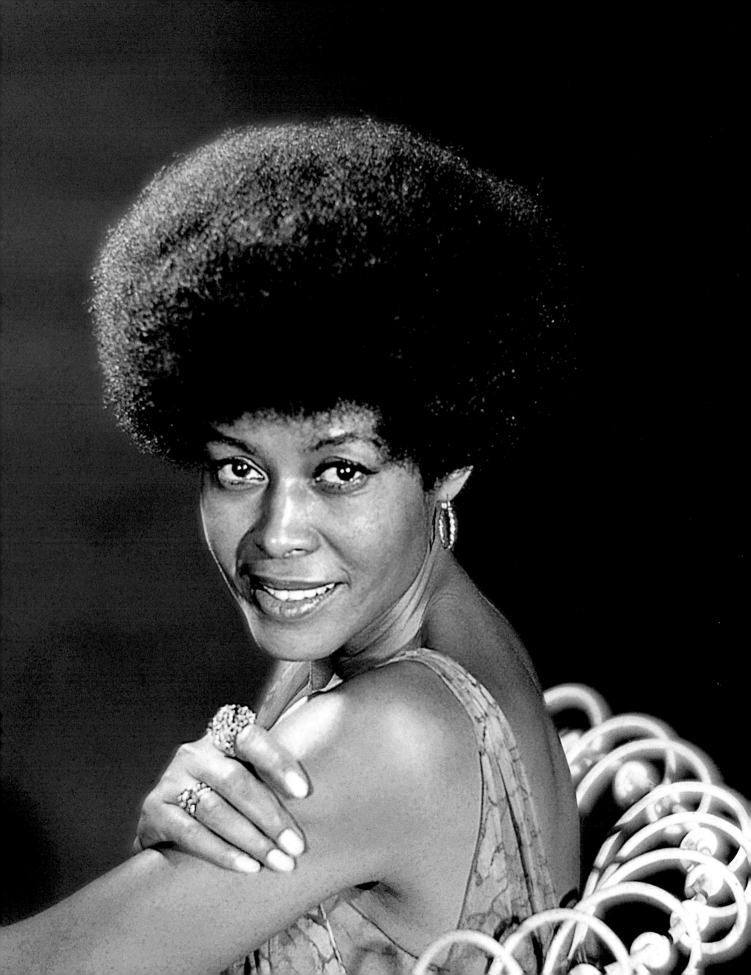

modern era, this has extended to what we now call "media," where conceptions of beauty are reflected, reshaped, idealized, deconstructed, reconstructed, and concretized. The "Black is Beautiful" campaign of the 1960s, for example, linked black power and black feminism and offered new representations of femininity. Prominent black women like singer Abbey Lincoln and South African singer Miriam Makeba made the Afro a symbol of black female empowerment. Natural hair became a way to represent freedom from white standards of beauty seen on television screens and in glossy magazines around the world. In 1978, the U.K. writer Susie Orbach declared that the societal preference for slenderness was oppressive. Her book *Fat Is a Feminist Issue* argued that women's bodies carry symbolic value as sexual and emotional resources for others, with the result that women either starve themselves to make their bodies "look right" or stuff themselves to fill the emptiness of not being seen. Orbach lamented her book's continued relevance in a 2018 article published in *The Guardian*. Naomi Wolf, in her bestselling book, *The Beauty Myth* (1991), examined the insidious imposition of unrealistic and oppressive ideals of beauty, particularly as they pertained to weight, that put many women in warfare against their bodies. "When you see the way a woman's curves swell at the hips and again at the thighs, you could claim that that is an abnormal deformity," Wolf wrote, "or you could tell the truth: 75 percent of women are shaped like that, and soft, rounded hips and thighs and bellies were perceived

as desirable and sensual without question until women got the vote."

To understand the social meaning of beauty, one can turn to fine art—the images of women in museums and in the canon of art history. Historically, male artists have created the majority of these portrayals, which does not mean that they have represented women in any uniform or universal way. Rather, this work was created in a societal structure that by and large prohibited the training and employment of women as artists, and that prescribed certain roles for them. Most frequently, women were expected to be submissive, passive, and were placed in positions of secondary importance. Since artists' patrons were generally royalty, aristocrats, and the church—those who could afford patronage—it's perhaps unsurprising that artists created works that were consistent with the values of those paying their bills. In the eighteenth and nineteenth centuries, as the nature of patronage in the art world evolved and expanded along with the fortunes of the upper classes, the exclusion of female artists largely continued unabated (with notable exceptions) and persisted well into the twentieth century. This created a situation where men's artistic vision of not only landscape, sculpture, and portraiture, but of women and ideal womanhood, were the only representations to be seen.

One of the manifestations of male dominance in art was the depiction of women from a male, heterosexual point of view, a phenomenon dubbed

"the male gaze" by the film critic Laura Mulvey in 1975. Predicated on the superior social and political position of men, the male gaze typically presents women as objects of sexual desire. The oppression of this kind of depiction in "high" art came under scrutiny in the U.S. in the early 1970s, before Mulvey even coined the term, by groups of women artists in Southern California and New York City who pointed out a set of interrelated issues. Even though women made up the majority of art school graduates, female artists produced only one percent of the art on display in the nation's most prestigious museums. Nearly 90 percent of art journalism was about men, and nearly the same percentage of funding went to supporting male artists. The feminist art movement emerged in response to this gender inequality. Dominant on the West and East Coasts, the movement spread to nearly all major cities where women artists developed feminist art programs, opened women-operated galleries, and launched newsletters and journals dedicated to the review of art made by women.

Feminist art historians started raising critical questions about how gender impacted an artist's success. Linda Nochlin's groundbreaking essay "Why Have There Been No Great Women Artists?" (1971) documented the ways women were systematically cut off from opportunities for education and careers in the arts, their creative talents channeled into socially acceptable "domestic" crafts such as weaving instead. Nochlin wondered, "What if Picasso had been born a girl," and proceeded to

illustrate the extreme unlikelihood that "Pablita," however gifted, would have had the same opportunities as her male sibling, Pablo, who went on to become the great Picasso. Nochlin echoed Virginia Woolf, who described the equally thwarted career of Shakespeare's imaginary sister. "The fault," Nochlin wrote, "lies not in our stars, our hormones, our menstrual cycles, or our empty internal spaces, but in our institutions and our education."

Nochlin's essay was part of a wave of feminist writing in art history, one that exposed and examined assumptions underlying the canon of Western art. What had been considered universal truths about what constituted art were in fact socially constructed truths that both reflected and reinforced the prevailing male-dominated culture, and *white* male culture most pervasively. The Black Arts movement and the Chicano Arts Movement of the 1960s and 1970s brought artists, art critics, and communities together to demand that museums exhibit art made by people and women of color. Together, these activist artists and art critics ushered in a period of transformation in the country's art world, and they inspired growing interest in representing America's racial and gender diversity in its museums and institutions. Over time, this movement has met with some success: increasing numbers of museums and galleries are exhibiting the work of minority and women artists. In 2018, the Baltimore Museum of Art auctioned off seven well-known works by white male artists, including Robert Rauschenberg and Andy Warhol, to finance the purchase of works by

United States, 1973

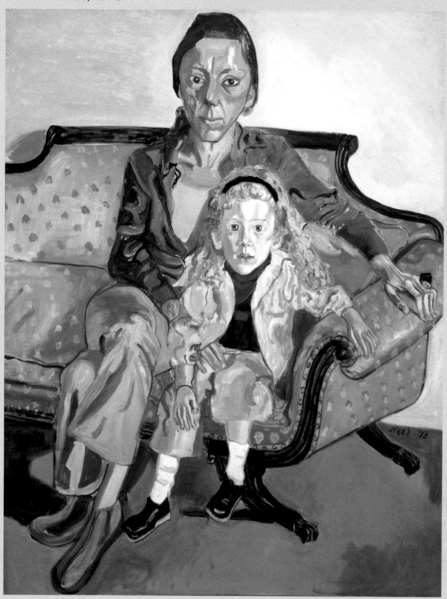

ABOVE The painter Alice Neel (1900–84) was a hero to the generation of women artists who came of age in the 1960s and 1970s, in part because she overcame a tumultuous personal life and considerable financial hardship to establish an important and respected body of work. Neel was known for her revealing, sometimes unflattering portraits of friends and acquaintances—in this case, the groundbreaking feminist art historian Linda Nochlin (1931–2017) and her daughter Daisy. Neel's affection for Nochlin and her respect for Nochlin's intelligence and stature are apparent.

RIGHT Visual artist Zanele Muholi uses self-portraiture to reimagine black identity and to challenge the oppressive standards of beauty that often ignore people of color. This portrait references her late mother, Bester Muholi, whose work as a domestic is represented by clothespins. Muholi, who eschews gender-specific pronouns, is co-founder of the Forum for the Empowerment of Women, an organization that advocates for the rights of black lesbians in South Africa, and Inkanyiso, a collective for queer activism and visual media.

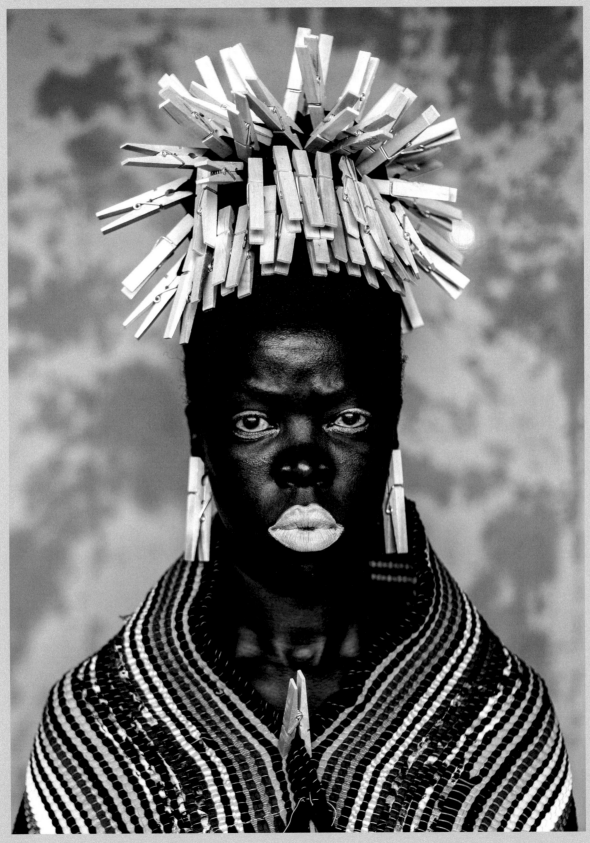

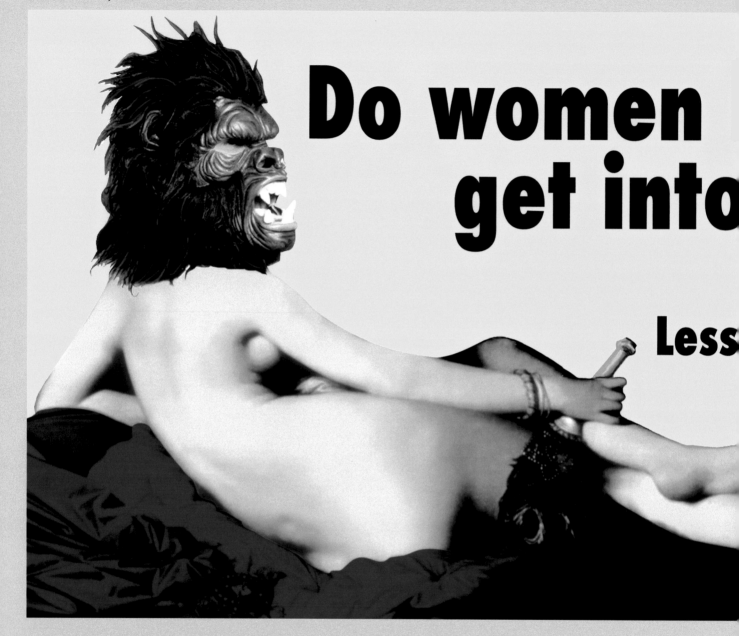

ve to be naked to
he Met. Museum?

n 5% of the artists in the Modern Art sections are women, but 85% of the nudes are female

Statistics from the Metropolitan Museum of Art, New York City, 1989

GUERRILLA GIRLS CONSCIENCE OF THE ART WORLD

Guerrilla Girls, a group of feminist artists creating awareness about racism and sexism in the art world, has been active since 1985. The impetus for Guerrilla Girls originated with the Metropolitan Museum of Art's 1984 exhibition "An International Survey of Recent Painting and Sculpture." The exhibition featured 165 artists, only thirteen of whom were women. Members generally wear gorilla masks in public in order to maintain their anonymity, and they use pseudonyms that reference dead female artists. As a member named GG1 stated in a 1995 interview, "We wanted the focus to be on the issues, not on our personalities or our own work." Guerrilla Girls uses culture jamming tactics in the form of performances, billboards, books, and posters, like the one shown here.

Grande Odalisque, 1814. Oil on canvas, 91 x 162 cm. Musée du Louvre, Paris

Woman World (Ingres #2) Betty Tompkins ©2018 79

LEFT Betty Tompkins based the series of paintings entitled "Women Words" on thousands of submissions from people around the world of words used to describe women. The original series, to which the artist keeps adding, layers words on women's forms in great paintings such as those by Caravaggio, Lucas Cranach the Elder, and Artemisia Gentileschi. Here, the artist layers over an odalisque by Jean-Auguste-Dominique Ingres. Tompkins is considered a pioneer of feminist art.

ABOVE Visual artist Marilyn Minter first began to take photographs under the guidance of Diane Arbus. In the 1980s she began to incorporate imagery borrowed from advertising and pornography into her art. She sought to create imagery for women to enjoy by reclaiming images from these male-dominated and often abusive industries, while simultaneously raising the question of whether the meaning of the image might be changed if used by a woman. In 2005, Minter had a solo exhibition at the San Francisco Museum of Modern Art focused on hyper-realistic close-ups of adorned lips, eyes, and toes, like the later work shown here.

Laurie Simmons (1949–) is a photographer and filmmaker known for using dolls and miniature objects to create staged domestic scenes. Simmons is part of the Pictures Generation group of artists who explored the perception of images in numerous contexts. In the 1970s, she began photographing dolls and dollhouses as a way of examining traditional gender roles and domesticity. In this piece, "New Bathroom/Woman Kneeling/First View," Simmons depicts a doll kneeling next to a bathtub wearing a dress and high heels. Dolls were often criticized by second-wave feminists who viewed them as a way of indoctrinating young girls to follow particular social expectations. In a 2014 interview, Simmons said, "When I picked up a camera with a group of other women, I'm not going to say it was a radical act, but we were certainly doing it in some sort of defiance of, or reaction to, a male-dominated world of painting."

women and minority artists including the South African photographer Zanele Muholi.

Artists and art historians have shifted the cultural conversation about women's beauty and appearance as surely as early suffragists jolted their contemporaries into considering the possibility of women's political rights. Where women once had little voice or agency in shaping cultural consensus about beauty and sexuality, feminist artists and writers have represented aspects of women's experience in their art and criticism that both challenge traditional notions of beauty and suggest new ones. Artists like Judy Chicago, Yayoi Kusama, Carolee Schneemann, Nancy Spero, Renate Eisenegger, Ewa Partum, and Anita Steckel have drawn on their personal experiences and turned themselves into subject matter, challenging viewers' assumptions about beauty and sexual attractiveness by calling attention to aspects of women's lives that traditionally have been ignored or stigmatized. Women's bodies, menstruation, pregnancy, and birth would no longer be cordoned off as inappropriate subjects of art. Unlike forebears such as Georgia O'Keeffe, this new generation of feminist artists eschews the suggestive beauty of vagina-like flowers to confront viewers with the less "pretty" aspects of femininity—the bodily fluids, the unseemly bulges. Some artists, such as Kiki Smith, have deliberately tried to provoke disgust in the viewer. Smith and other artists represent or allude to menstrual blood, feces, and internal organs in their work, overturning conventional ideas of femininity, and thus perceptions of female beauty.

In recent years, artists such as Marilyn Minter, Cindy Sherman, and others have created works that play with the idea of women being packaged for consumption by both artists and the mass media, which have long served to amplify, refine, and weaponize the imagery of desire. These images, often eroticized, highlight the artifice used by the beauty industry to set standards that are beyond what is attainable for most women. Sherman's photographs use familiar poses, lighting, and other techniques of Hollywood films and glossy magazines—invariably using herself as a model—to peel away, reflect, and distort the tricks of composition, costume, makeup, and other effects used to package and commodify women.

The deliberate use of erotic imagery by artists like Minter, Judith Bernstein, Betty Tompkins, Juanita McNeely, Joan Semmel, and others has the effect of short-circuiting the viewer's expectation of what can be considered "feminine" art and his or her own libidinal reaction. For these artists, creating challenging imagery is itself an act of gender rebellion. In some cases, these artists freely depict or evoke female desire, again subverting traditional conceptions of demure femininity. Female artists have also challenged conventional depictions of race. Artists like Faith Ringgold, Lorna Simpson, Carrie Mae Weems, Adrian Piper, Mickalene Thomas, and Kara Walker have woven memories and experiences of the Middle Passage and Jim Crow into their work, for instance, throwing conceptions about the presumed egalitarianism of American culture into

LEFT Kiki Smith, American, has been fascinated with the body and its fluids in her provocative multimedia work. Blood, sperm, and the messy details of embodiment figure prominently in her work. "I think the whole mystery of the world is in your body," Smith has said. The work here, on display at the Pulitzer Foundation for the Arts in St. Louis, linked femininity with all that is abject, or outside of representation, raising new questions about the boundaries of gender and animality.

ABOVE Artist Yayoi Kusama attends the opening ceremony of the Yayoi Kusama Museum on September 26, 2017, in Tokyo, Japan. Kusama participated in the pop art scene in New York City in the late 1960s, and organized performance pieces in conspicuous public spaces such as Central Park and the Brooklyn Bridge. These pieces involved nudity and were designed to protest America's involvement with Vietnam. She also wrote an open letter to President Richard Nixon offering to have sex with him if he ended the war.

Cindy Sherman's *Untitled Film Stills* comprises seventy black-and-white photographs of the artist dressed as various generic female film characters, such as the ingénue, working girl, vamp, and lonely housewife. Sherman uses these multimedia references to explore the often stilted, confining, and mass-produced experiences of gender inequity.

Nan Goldin's "Ballad of Sexual Dependency" comprises 700 portraits of love and loss paired with a musical soundtrack that together capture the experience of the artist in Boston, New York and Berlin during the 1970s and 1980s. The images explore themes of domestic violence, drug use, and AIDS, keeping the ideals of romance and domesticity at bay. In the words of Goldin, "'The Ballad of Sexual Dependency' is the diary I let people read."

ABOVE *It is So* (2014), with its lush colors and gender play, has made artist Nicole Eisenman a favorite of the LGBTQ and feminist communities. Representations of sexual pleasure that escape the traps of objectification and heteronormativity like this stand as important accomplishments in the history of art activism. Eisenman received a MacArthur genius grant in 2015.

RIGHT June Quick-to-See Smith is part of a generation of Native American artists re-imagining how the brutalities of the past and the riches of native cultures figure into their work and worldviews. The artist grew up on the Flathead Reservation in Montana and traveled with her father, who traded horses, throughout the Pacific Northwest and California before attending the University of New Mexico.

LEFT In 2018, Lorna Simpson released *Lorna Simpson Collages*, a collection of her collages of black women, focusing on an essential and protean component of their appearance—their hair. Simpson used vintage advertising photographs of black women (and some men) from archival issues of *Ebony* and *Jet* magazines as the foundational images for her collages, building on them with ink washes, illustrations from old textbooks, and other unexpected, sometimes whimsical, forms and objects, exploring the visual language of African American hair.

ABOVE Tschabalala Self (1990–) creates mixed media art that primarily addresses and subverts images of black women, here in a work entitled *Loosie in the Park*. Born in Harlem, Self creates images of black female figures, which she refers to as "avatars," in different settings. Self has stated that she seeks to "create alternative narratives around the black body" with her work, using a range of printed, sewn, and painted materials. This unique combination of materials is one of her trademarks. As Self explained in an interview, she makes "… round, multidimensional characters with complicated desires, inner dialogues, and psychology," and she challenges racism and sexism "by trying to show a real spectrum of human emotion."

RIGHT AND ABOVE Kara Walker's *A Subtlety, or the Marvelous Sugar Baby* went on display at the Domino Sugar factory in Brooklyn, New York, in 2014. Walker created the sphinx-sized figure (right) to pay homage to the unpaid and overworked women who refine sugar from sugar cane, a comment the reliance of the sugar industry on the slave labor of women. "Mammy sphinx" is composed of thirty tons of sugar and is naked except for the head scarf. The approach to the sphinx is dotted by thirteen molasses-colored boys (above) made of cast resin or cast sugar, each carrying baskets or bunches of bananas.

Amy Sherald's portrait of First Lady Michelle Obama stylizes her
subject's skin in shades of gray, a color with ambiguous racial
associations, and her body to a geometric form silhouetted against
a single color. Amy Sherald and Kehinde Wiley, the artist who painted
President Barack Obama's portrait, are the first black artists to be
commissioned by the National Portrait Gallery.

question. Other artists have similarly commented directly on contemporary attitudes toward race. The African American artist Howardena Pindell, who was also a curator at the Museum of Modern Art, is uniquely attuned to the ways in which black artists and black subjects have been underserved both in the museum world and in the world at large. In her video piece *Free, White and 21* (1980), she appears both as a black narrator, relating one racist experience after another, and as a white character, who casually dismisses each experience in succession.

Feminist artists have continued to push the envelope on gender performativity by producing art that challenges binary definitions of gender and the cultural acceptance of non-binary people. Frida Kahlo explored gender fluidity as early as the 1930s, both in her work and personal life, and yet art representing non-binary subjects was largely unknown by mainstream audiences until the twenty-first century. Today, it is common to see images that subvert traditional notions of masculinity and femininity, as artists depict visions of humanity that are genderqueer. Wu Tsang, a Chinese-Swedish-American filmmaker, video artist, and performance artist, combines community organizing, activism, and gender fluidity in films like *Duilian* (2016), which illuminates the surprising queer history of the nineteenth-century Chinese feminist and revolutionary Qiu Jin (see p. 195). In her photographs and installations, the British-Israeli artist Yishay Garbasz documented her transition from male to female

and the experience of trauma and post-traumatic memory-making. Her identity as a trans woman deeply informs her political sensibility.

Beyond the world of fine arts, images made to sell goods have tremendous power to define our standards of beauty. Present-day images of women in popular culture, unlike the fine art world, tend to have universal elements. The female form is firm but soft, toned but not cut, tall, girlishly small-nosed, frequently light-skinned, and always delighted in herself. This Anglo-American standard of beauty has never been static, however. In the flapper age of the 1920s, for instance, a boyish flat chest, sharply cut sleek hair, and angular limbs were wildly popular, displacing the ideal of the "Gibson Girl" of the 1890s with her blousy shirtwaist and tower of soft hair. Similarly, the wildly popular Virginia Slims cigarette ad of the 1970s showed a woman smoking a slim cigarette under the banner, "You've come a long way, baby," a slogan of the "superwoman" of second-wave feminism, who supposedly wanted to do things the way men did them. The Virginia Slims woman came in all skin tones and was always stylishly dressed for work or a hot date, capturing the ethos of women's liberation.

Today's #MeToo movement has also brought its own imagery of female empowerment. Differently shaped and sized bodies, across the spectrum of racial and sexual identities, find greater representation in ad campaigns. The fat acceptance and body positivity movements have helped bring about

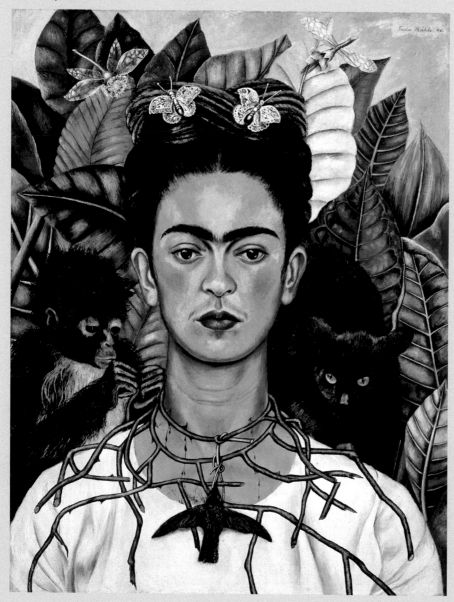

ABOVE Frida Kahlo combined indigenous Mexican culture with a decisively modern point of view in her self-portraits like "Self Portrait with Thorn Necklace and Hummingbird." Kahlo, who suffered from polio as a child, was in a streetcar accident that left her with multiple spine fractures and broken ribs. The artist was rarely free of physical pain. Of her 143 paintings, 55 are self-portraits, many of which capture the emotional legacy of injury and challenge assumptions about gender identity. Kahlo was married to the Mexican muralist Diego Rivera. She rejected the label of surrealist, preferring instead to describe herself as realist.

RIGHT Catherine Opie began to make studio portraits of gay, lesbian, and transgendered men and women associated with the sadomasochist leather subculture in Southern California in the 1990s, many featuring sadomasochistic cutting and piercing. Opie emphasizes sexual identity and landscape in her photography, striking an explicit and implicit relationship between self and place.

United States, 1993

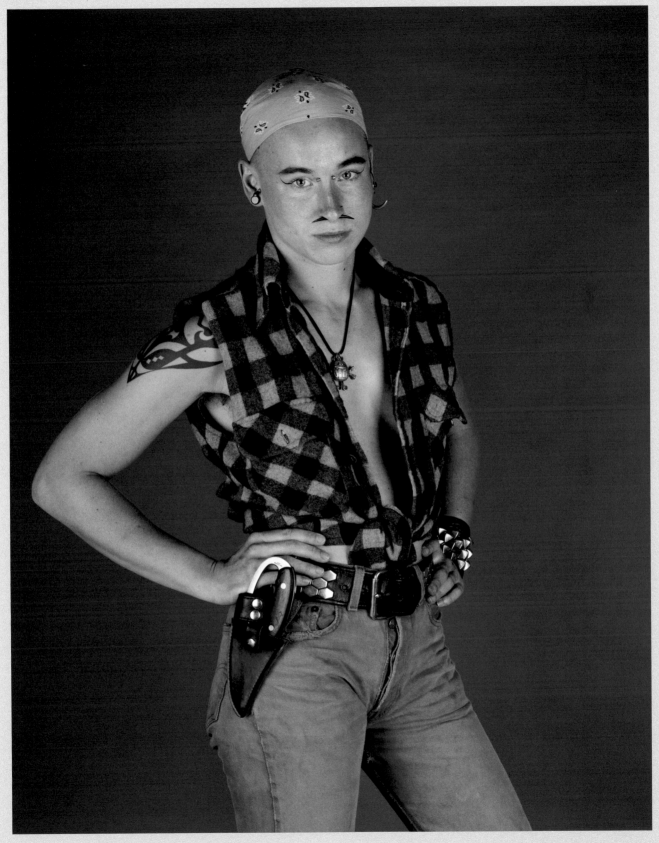

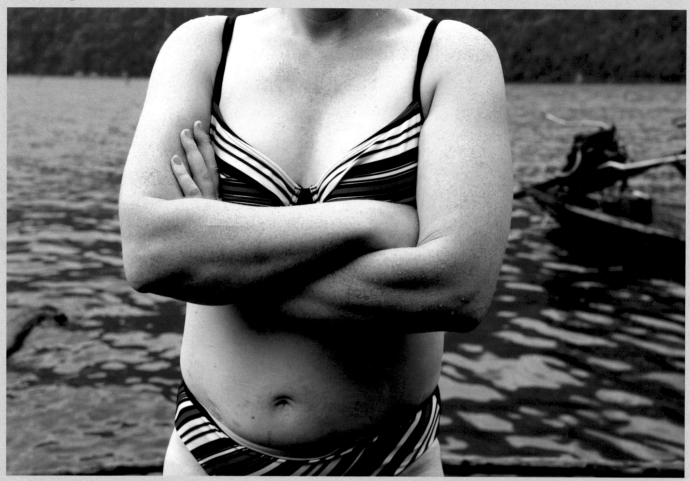

United Kingdom, 2011

British-Israeli artist Yishay Garbasz's *Bikini, Khao Sok, Day 22, 2011*, is part of a series entitled "The Number Project" dealing with the traumatic inheritance of her mother's Holocaust experience through the branding of her mothers tattooed Auschwitz number. The photos demand the viewer to contemplate what is lost when connections between people and the past are severed. Garbasz's work explores trauma and post-traumatic memory in her photographs, including her mother's Holocaust experience, her own sexual affirmation surgery, as well as the use of the "other" for political control by severing connections between people with borders and fear.

the increased visibility of people who don't necessarily fit traditional ideals of beauty into the media mainstream. Dove soap's "Real Beauty" campaign, for instance, celebrates a range of ideals about female beauty by featuring women of differing races, sizes, and ages in their ads and by sponsoring storytelling and education initiatives that teach tolerance and build self-esteem. In 2019, a host of advertisers promoted messages emphasizing the positive aspects of diversity and inclusion regarding race, age, body type, and gender fluidity, or were at least being more inclusive in the models they chose to pitch their products.

And yet, beauty and sexual desirability are still conflated in mass culture in ways that thwart women's efforts to be liberated in the modern age. While consumers understand that images in ads are altered to "fit" the contours of conventional beauty—curves flattened, necks elongated, lips plumped, eyes rounded—women still embrace these standards. Editing tools have migrated to "selfies" on social media platforms, enabling consumers to play with remaking their faces and forms to fit the ideal, pushing the ethical dilemmas of commercial artists onto the home user. At times, mainstream commercial imagery seems indistinguishable from that of its reprobate cousin, the pornography industry. Many consumers see Victoria's Secret ad campaigns as soft porn, while others view it as innocuous advertising. Most feminists would argue, however, that these images have the effect of normalizing the objectification of women and of pushing them into unrealistic and unhealthy expectations of what their bodies should look like.

The pursuit of feminine beauty has also resulted in frequently risky practices of body modification by women, ranging from diet regimens, to corset wearing, to surgery. In pre-modern China, elites and the upper classes bound their daughters' feet to enhance their physical desirability. Aesthetic standards held that large feet were ugly, bound feet (or "lotus feet"), delicate. Upper-class Chinese society idealized the graceful sway of a woman perched on tiny feet. And thus older women in the household would fold a girl's toes underneath the soles, breaking the bones of the toes and foot, and tightly wrapping them in bandages which remolded the foot over time. The practice spread such that by the nineteenth century, nearly half of all Chinese women had bound feet, including nearly 100 percent of women from elite families, suggesting that this physical modification was a sign of status as much as beauty. Qiu Jin, a revolutionary feminist activist at the turn of the twentieth century (the subject of Wu Tsang's 2016 film; see p. 191), wrote a manifesto outlining the problems caused by bound feet and arranged marriages. In an attempt to modernize, the government of the new Republic of China banned foot binding in 1912, calling it a backward custom. Over time, the practice was completely abandoned.

In the West, great numbers of women altered their bodies using corsets, beginning in the sixteenth century and peaking in the Victorian era. Typically stiffened with whalebone or wood, corsets narrowed

the waist, raised the bust, and straightened the back, often rearranging or damaging internal organs and even reshaping ribs in the process. In *Femininity* (1984), Susan Brownmiller speculated that Catherine de Medici and Elizabeth I of England wanted their womanliness "ceremoniously displayed by that excessively small and breathless feminine bodice," and hence contributed to the corset's popularity among the aristocracy. Unfortunately, corsets made even the simplest movements more difficult, and so like bound feet in China, they remained the province of the well-to-do or those who wished to project an image of idle wealth. By World War I, the need to repurpose metal for munitions and the increasing use of the bra and girdle brought an end to corset use, which was already in decline.

Historically, notions of feminine beauty have in many cultures been tied to beliefs about sexual purity. Often, these convictions are rooted in religious beliefs. The idea that sexual experience and overt expressions of desire diminished both a woman's physical attractiveness and her value as a spouse gave rise to the practice of female genital circumcision (FGC) or mutilation (FGM). FGC and FGM are currently most widely practiced in central Africa, the Middle East, and South Asian countries, but are present throughout the world in spite of legislation banning the practices in many of the countries where it is most prominent. Today, there are more than 200 million women alive who have undergone FGC or FGM worldwide primarily in central Africa, Iraqi Kurdistan, and Yemen. Its exact historical origins are unknown, but the practice is believed to date back at least to the fifth century B.C.E., possibly to ancient Egypt, and likely spread by the slave trade across the western shore of the Red Sea to southern and western Africa. A variety of procedures constitute FGC, including the trimming of genital skin, the removing of the clitoris and "infibulation," sewing shut the labia. Generations of women have been subject to these procedures as a way of ensuring their sexual purity, desirability, and marriageability. The procedures pose health risks and diminished sexual pleasure for many women who undergo them, and yet they remain integral to ensuring good marriages and family honor. Instead of men or doctors, it is mothers and grandmothers who perform the procedure on young girls in the belief that they are ensuring a good future for them.

By the 1970s, FGC became an issue for the global women's health movement and NGOs hoping to establish more robust discussion of women's human rights. The debate has been complex. Many feminists argue that the procedure mutilates women, while some from the regions where the practice remains prevalent, such as Sierra Leone-born Fuambai Ahmadu, insist that FGM is a traditional, non-Western expression of femininity. Groups like Maendelaeo Ya Wanawake in Kenya, NOW in Nigeria, and 28 Too Many in Egypt, and elsewhere in Africa, now include the elimination of female circumcision among their goals. The practice is nonetheless in decline and tracks along lines of class and education, suggesting that the cultural spectrum

China, circa 1890

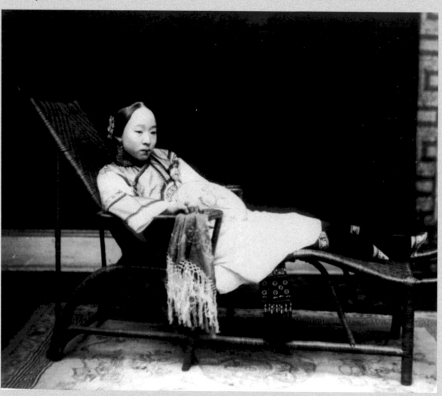

Uganda, 2018

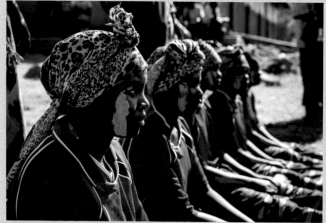

ABOVE, RIGHT A Chinese woman with bound feet reclines on a chaise. Foot binding likely started before the Song Dynasty in the tenth century, and for many centuries, the practice was considered to be both a sign of beauty and a status symbol in China. The result was painful and had a major impact on women's mobility, making it extremely difficult to walk. However, women with bound feet were considered more desirable to men and were more likely to make a good marriage. Binding made the foot much smaller and women with bound feet wore special shoes. Many feminists have argued that foot binding was a form of violence against women and an oppressive practice.

RIGHT Female genital mutilation (FGM) remains a major issue in Uganda. The practice was made illegal in 2010, but it is still performed in some areas of the country. This photo shows girls from the Sebei tribe in Kapchorwa, northeast Uganda, reenacting a ceremony that is held prior to female genital mutilation involving elders smearing mud on the girls' faces. In 2019, the U.N. began investigating the growing number of women and girls undergoing FGM in Uganda. A study showed that FGM is increasingly performed on married women who are shunned because they have not undergone the procedure.

Jonathan Yeo's "Surgery Series" interrogates the trend for cosmetic
surgery with its attendant goal of physical perfection. The paintings
in the series lift the curtain that veils the procedures from sight and
in so doing, force the viewer to reckon with the lengths people will go
to capture or maintain a view of themselves. In this unglamorized,
clinical painting, the skin appears to be as pliable as fabric and the
needle, held by the unseen hand of the surgeon, briefly turns the face
it is transforming into a mask.

in Africa, the Middle East, and South Asia is shifting toward a more global view of women's rights and citizenship.

Cosmetic surgeries, including breast and vaginal reductions, facelifts, nose modifications, augmentations, and liposuction, have fallen prey to similarly contentious debates. Societies with strict ideas about the female form have long modified the body through surgery. In South Korea, for example, one in five women has had cosmetic surgery, mostly to achieve the rounded eyes and larger breasts of popular idols. In Brazil, women across the economic spectrum routinely get "butt lifts" and tummy tucks. The United States led the world in the number of cosmetic procedures in 2018, according to a report by the International Association of Aesthetic Plastic Surgery, followed closely by Brazil. Japan, Mexico, Italy, Germany, Colombia, and Thailand rounded out the top eight. Breast augmentation has been the most popular procedure in the U.S., and 7.2 million injections of "facial rejuvenation procedures," or Botox, were sold in 2018. In the U.S. alone, nearly eighteen million cosmetic procedures were performed in 2018. All of this makes the debate over women's appearance in modern life quite contested. Can it be considered a "feminist" act for a woman to augment her breasts if she makes the choice of her own free will and it increases her confidence in the world? Or does breast augmentation (and similar interventions) merely reinforce unrealistic images of the female form in ways that perpetuate women's objectification and dissatisfaction with their own bodies?

In "Appearance as a Feminist Issue" (2016, Vol. 69 SMU Law Review 697), the Stanford law professor Deborah Rhode sums it up:

In today's universe of escalating opportunities for cosmetic enhancement, the issues surrounding beauty have posed increasingly complex challenges. Some women find the cultural preoccupation with appearance a source of wasted effort and expense, a threat to physical and psychological well-being, and a trigger for workplace discrimination. Yet others see the pursuit of beauty as a source of pleasure and agency, and a showcase for cultural identity. The question for the women's movement is whether it is possible to find some common ground, and to develop a concept of beauty that is a source of pleasure rather than shame, and that enhances, rather than dictates self-worth."

Artists and feminists have led the way in challenging and redefining inherited ideas about beauty and sexuality, reflecting back to us our preconceptions and cultural biases, and showing us the possibilities for a more egalitarian, inclusive—and perhaps beautiful—future.

Constructing Roberta Breitmore *Lynn Hershman 1975*
① Lighten with Dior eyestick light. ② "Peach Blush" Cheekcolor by Revlon. ③ Brown contour makeup by Coty. ④ Shape lips with brush, fill in with "Date Mate" scarlet. 5. Blond wig ⑥ Ultra Blue eye-shadow by Max Factor. ⑦ Maybelline black liner top and bottom. ⑧ $7.98 three piece dress. ⑨ Creme Beige liquid makeup by Artmatic.

ABOVE Lynn Hershman Leeson is a filmmaker and media artist whose work in the 1970s anticipates the impact of technology, surveillance, and censorship on identity. Here, the artist renders the face of her alter ego, Roberta Breitmore, in whose name she signed a lease, obtained credit cards, and posted personal ads in San Francisco papers. Hershman Leeson was among the first feminist artists to explore identity and preconceptions of female roles in society, here literally providing the instructions for obtaining the appearance of the fictitious Roberta Breitmore.

RIGHT Hannah Wilke was best known for performances, photographs, sculpture, and works on paper that use her body as a canvas. Here, the artist is shown in a photograph from the *SOS Starification Object Series* (1974–1979) for which she had herself photographed wearing chewing gum sculptures she had made and placed on her body. She also did public performances where she passed out chewing gum and molded the softened product into vulva-like sculptures that she then placed on paper and hung on the wall. When asked, the artist said: "I chose gum because it is the perfect metaphor for the American woman—chew her up, get what you want out of her, throw her out and pop in a new piece."

Iran, 1996

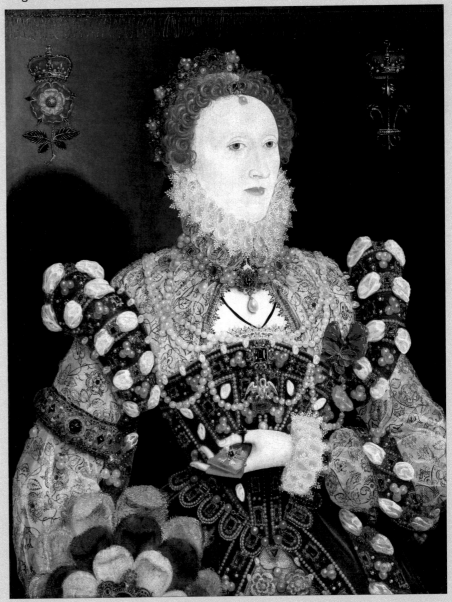

LEFT Shirin Neshat has been recognized for her work on the contrast between the West and Islam, and the set of binaries that the opposition calls forth: masculinity and femininity, public life and private life, modernity and antiquity. This photograph, part of the "Women of Allah" series, subtly subverts Western preconceptions about submissive Muslim women, overlaying poetry by contemporary Iranian writers in traditional calligraphy on portraits of women. Neshat was first introduced to western feminism and its ethno-centrism at a Catholic boarding school in Tehran, and later at the University of California, Berkeley. Her work creates the opportunity for different feminist histories and points of view to meet.

ABOVE Queen Elizabeth's highly constricted bodice helped to popularize the corset, and along with it, the desirability of a tiny waist and hourglass figure for women. Like all aristocratic Elizabethan women, the Queen would typically wear a corset stiffened with whalebone under her petticoat when in public.

Black women have had to develop a larger vision of our society than perhaps any other group. They have had to understand white men, white women, and black men. And they have had to understand themselves. When black women win victories, it is a boost for virtually every segment of society.

Angela Davis

The Expanding Circle of Citizenship

The U.S. provides a historically significant case study on the role of race and racism in the women's rights movement, one that has been watched, amended, and embraced around the world. Woman suffragism and abolitionism for African American slaves were movements linked from the beginning in their quest for greater citizenship for all Americans. But racism in the suffrage movement left fault lines of distrust between black and white women that have been hard to overcome, and as such, become a critical window into the fraught dynamics of coalition-building for all social justice movements. Women of color, whose voices and concerns had been systematically dismissed by white women's groups in the fight for suffrage, organized for their rights in separate groups or caucuses, in which they articulated their own goals and developed their own leadership networks and political courses. This strategy of selective separatism within coalitions shaped twentieth and twenty-first century women's activism, starting with the Civil Rights movement of the 1950s and '60s and second-wave feminism of the 1970s.

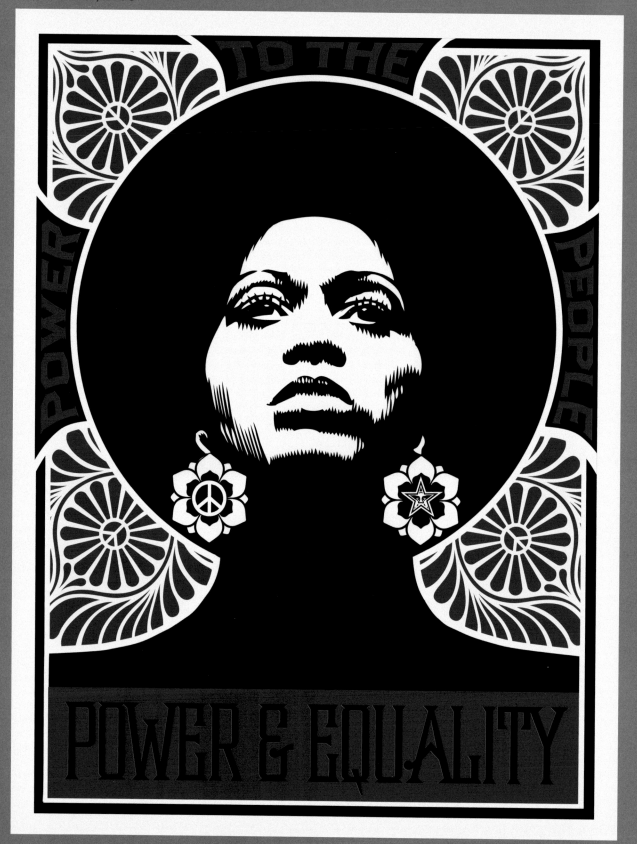

That is not to say that cross-pollination between movements, between men and women, and between white and minority activists did not happen. The Civil Rights movement and feminism—together and separately—generated a tremendous outpouring of hope and activism that profoundly altered the boundaries and meaning of citizenship. By century's end, sexual minorities and gender non-conforming people would likewise step into the circle of expanded rights. Intersectionality, an approach that examines race, class, gender, and sexuality simultaneously in social relations, has become one of America's most important exports.

In America, longstanding frustration and rising resentment at the reluctance to end racial discrimination reached a critical point after World War II, when returning black soldiers, having risked life and limb to defend the United States, were still treated as second-class citizens by a seemingly indifferent nation. The popular "Double V" Campaign, calling for victory over fascism abroad and racism at home, mobilized Americans and perfectly captured the opportunity for democratic renewal that the war represented. Yet peace did not bring comprehensive solutions to the problem of structural and institutional racism in the United States in areas such as education, housing, and health. When high-paying jobs went back to returning white male soldiers, and not to black men or to women who manned wartime industries, a new generation of Americans began to put pressure on the government to ensure equality for all people. Jim Crow segregation in public settings reinforced racism by establishing whites-only food counters, whites-only bathrooms, and whites-only stores, in addition to whites-only hospitals and schools. This put issues that affected peoples' daily lives on the front lines of the fight to end legal racial discrimination.

Figures like Rosa Parks, canonized for her refusal to move to the back of the bus in 1955, were part of a network of politically aware women committed to ending segregation. Another activist, Pauli Murray, became a major figure in both the Civil Rights and feminist movements, and made eradicating racism and sexism her life's work. Murray referred to the sexism she faced as "Jane Crow," a direct nod to the "Jim Crow" state laws that oppressed African Americans on account of race and to which she added the experience of gender. Murray understood what it felt like to simultaneously bear the brunt of racism and sexism. At the same time, she also considered herself an "invert," or what we today might call a transgender person. She felt that she responded to women as a man would, and thus that she had the "inverted" desire of a heterosexual man in a female body. She kept her relationships with women hidden for most of her life.

In 1950, Murray published a book that Thurgood Marshall, then the head of the NAACP, called the "bible" of the Civil Rights movement. *States' Laws on Race and Color* challenged the constitutionality of state segregation laws. President John F. Kennedy appointed Murray to the Presidential Commission on the Status of Women in 1961, and on

United States, 1978

United States, 1960

PAGE 206 After Emma Goldman, Angela Davis might be the most well-known American female member of the Communist Party. In the 1960s she joined the party and emerged as a prominent activist within the Black Panther and black feminist movements. She was catapulted into notoriety in 1970 when her name was added to the FBI's Ten Most Wanted List for kidnapping, murder, and inter-state flight. She was denied bail for sixteen months and charged with a crime whose perpetrators were either in prison or dead. Davis's release from prison became a cause célèbre. Hundreds of local committees in the U.S. and abroad agitated for her freedom, expressing their support via countless posters and flyers. Crowned by a halo of hair, Angela, as the world soon came to know her, was frequently depicted holding a microphone, unflinchingly speaking truth to power.

LEFT, TOP In 1977, Pauli Murray added yet another "first" designation to her extraordinary biography when she became the first African American woman to become an Episcopal priest. In the early 1950s, like many of her peers in the Civil Rights movement, Murray suffered from McCarthyism, the burst of virulent anti-communism that swept America during the Cold War. In 1952, she lost a post at Cornell University because the people who had supplied her references—Eleanor Roosevelt, Thurgood Marshall, and A. Phillip Randolph—were considered to be too radical. In the early 1960s, she grew critical of the way men dominated the leadership of the Civil Rights movement. In a 1963 letter, she wrote that she had become "increasingly perturbed over the blatant disparity between the major role which Negro women have played and are playing in the crucial grass-roots level of our struggle and the minor role of leadership they have been assigned in the national policy-making decisions."

LEFT Betty Friedan found a national voice with the publication of her best-selling book *The Feminine Mystique* in 1963. But she was no "mere" homemaker prior to that. She had a ten-year career covering labor unionism and working-class activism. It was in that capacity that she first encountered working women's oppression and exclusion. Ironically, she was fired from her job in 1952 because she was pregnant with her second child. Five years later, Friedan conducted interviews with her classmates at her Smith College reunion, focusing on their education and their sense of satisfaction. These interviews became the germ for "the problem with no name," the malaise associated with domesticity and an important catch phrase for a new feminist awakening.

that commission, she prepared a memo that argued that the Fourteenth Amendment forbade sex and race discrimination. Her argument was a cornerstone of second-wave feminism. Murray became a co-founder of the National Organization for Women (NOW) in 1966, which she hoped would act like the National Association for the Advancement of Colored People (NAACP) for women's rights. Murray's race, along with her gender and sexual identities, combined to give her special legal insights into the nature of oppression that others did not have.

In 1966, a group of activists including Betty Friedan, Pauli Murray, labor organizer Aileen Hernandez, and New York State Assemblywoman Shirley Chisholm formed the National Organization for Women (NOW) in response to what they saw as the government's slowness to enforce the 1964 Equal Employment Opportunity Commission. Women workers, from secretaries to nurses to factory operators, needed equal pay and an end to workplace harassment immediately, not in some distant future. NOW's 1968 "Bill of Rights" (adopted at the 1967 national conference) reflected this attention to women's work and professional lives as a measure of their equality. It called for the passage of the Equal Rights Amendment, enforcement of Title VII, maternity-leave rights, childcare centers accessible to people of all income levels, and reproductive freedom. NOW articulated a pragmatic political agenda to improve the lives of all women, and the media essentially anointed its leaders the figureheads of the new feminist movement.

Yet for many, Friedan and the leadership of NOW did not do enough to shed the organization's orientation toward white, educated women. Many younger women of color felt that the leaders dismissed their demand to address racism as a women's issue. They did not share the claim of most of NOW's white leadership that the organization sufficiently addressed the needs of women of all races. They viewed NOW as putting minority women in the uncomfortable position of having to educate white women on the realities of racism. NOW was also not responsive to the needs of lesbians and gender non-conforming people. Friedan initially viewed the presence of lesbians in the women's movement as a distraction from its primary objectives—she described them as the "lavender menace." She later revised her position, but the damage had been done. By the early 1970s, young and more radical white women and most women of color viewed NOW as part of the problem, vowing that their feminist organizations would be different.

And they were. A new generation of women formed their own groups to fight for women's rights in ways that accounted for racial difference and discrimination. The bipartisan National Women's Political Caucus formed in 1971 to promote women's entry into politics. Black women formed the National Black Feminist Organization in 1973, and Puerto Rican women formed the National Conference of Puerto Rican Women in 1972. Chicana feminists

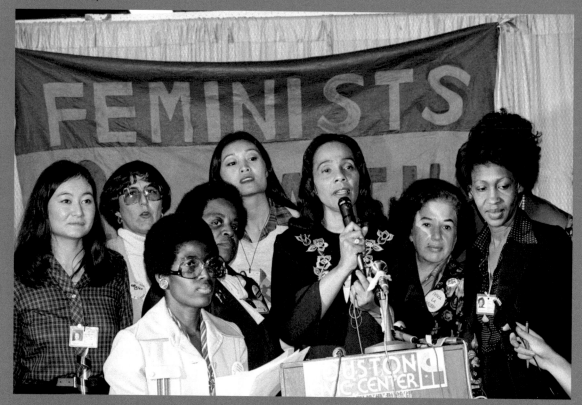

ABOVE Coretta Scott King, the widow of the slain Civil Rights leader Martin Luther King, Jr., speaks about the resolution on minority women's rights that won the support of the National Women's Conference in 1977, surrounded by a group of the resolution's supporters. Proposed by caucuses representing African Americans, Latinas, Asian Americans, American Indians, and Pacific Islanders, the resolution added a plank addressing the double discrimination of sexism and racism to the organization's National Plan of Action. On its passage, King declared, "There is a new force, a new understanding, a new sisterhood against injustice that has been born here. We will not be divided and defeated again."

RIGHT (United States, 1971) This portrait of Gloria Steinem (1934–) and Dorothy Pitman Hughes (1938–) was taken by photographer Dan Wynn in 1971. Published in *Esquire* magazine, it shows Steinem and Hughes with their fists raised, a symbol of solidarity that was also known at the time as the Black Power salute. Hughes wears her hair in an Afro. In 1969, pioneering feminist Gloria Steinem published an article in *New York* magazine entitled "After Black Power, Women's Liberation," in which she acknowledged links between the two radical movements. She joined ranks with Dorothy Pitman Hughes, a black feminist activist and childcare advocate, to found *Ms.* magazine in 1972. Hughes and Steinem also toured the United States in the 1970s, speaking about discrimination and issues related to gender, race, and class.

NEXT SPREAD (United States, 2017) President Donald Trump's anti-Muslim views have led some Muslim American women to speak out against his discriminatory rhetoric. Since the attacks on September 11, 2001, American Muslims have often found themselves to be marginalized and racially profiled, especially women who wear the hijab. Trump's inauguration in 2017 drew thousands of women to Washington D.C. to protest a man accused of sexual misconduct and assault. The new president's antipathy for Muslims and immigrants had been on full display during his run up to the White House, a reality that sent feminists of all religious backgrounds and ethnicities to join the protest. This photo of a Muslim American woman protesting at the 2017 Women's March signals the complex, sometimes paradoxical relationship between religious belief, feminism, and individual liberty.

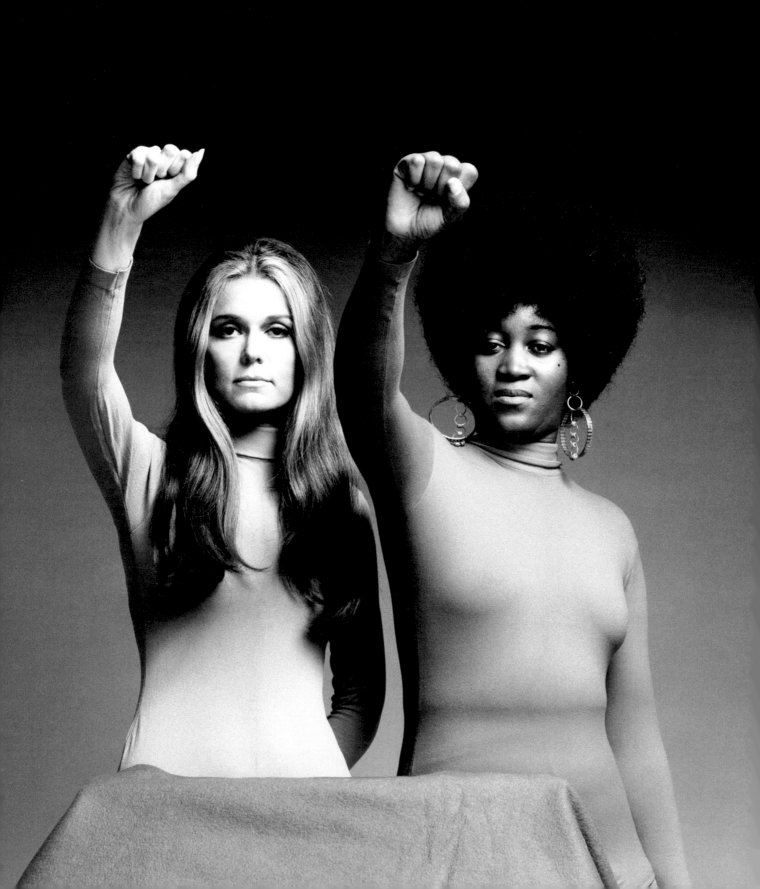

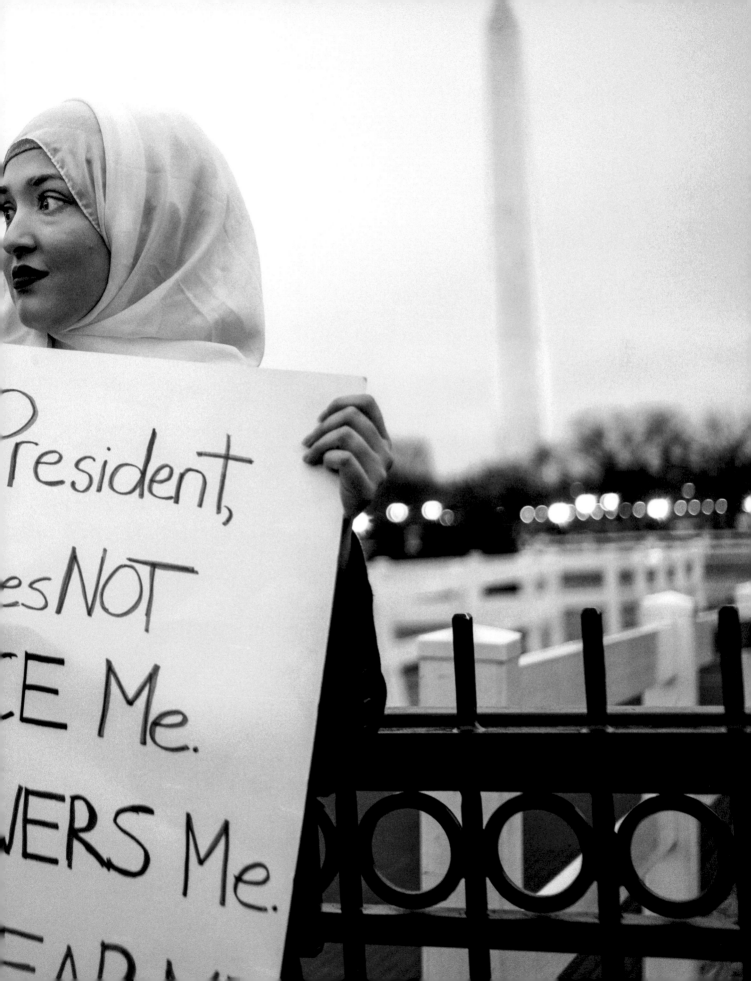

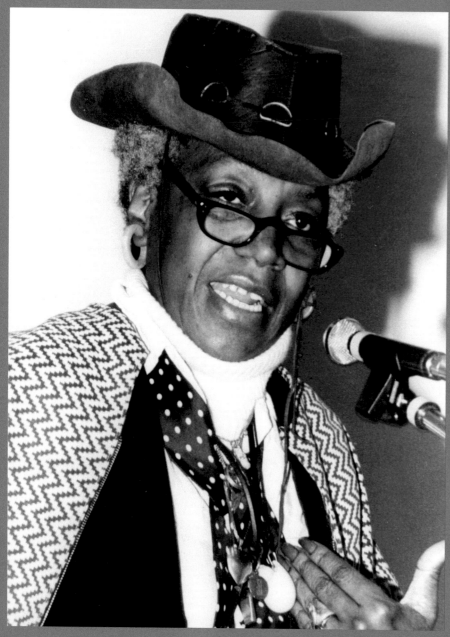

Lawyer Florynce Kennedy was nothing if not iconoclastic. Known for her flair, she wore long, fake eyelashes and dressed like a cowboy. Kennedy's feminist activism began with the 1968 Miss America Pageant Protest in Atlantic City, where she helped to both formulate the action and later served as the lawyer for activists who had been arrested. In the 1970s, Kennedy traveled with writer Gloria Steinem and the two became staunch allies. Kennedy was an early member of the National Organization for Women, but left in 1971 to start the Feminist Party, which nominated Shirley Chisholm for president. She went on to organize the National Women's Political Caucus, an organization that advocated for women of color. For her seventieth birthday in 1986, Kennedy hosted a party for herself at the New York City Playboy Club.

United States, 2017

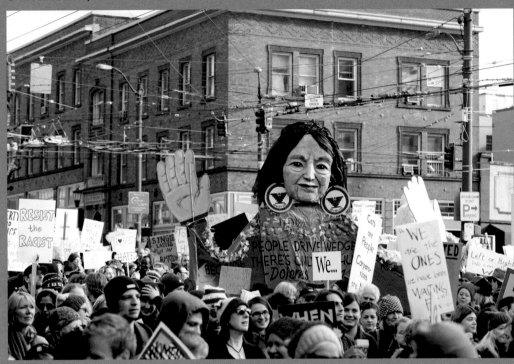

United States, 1965

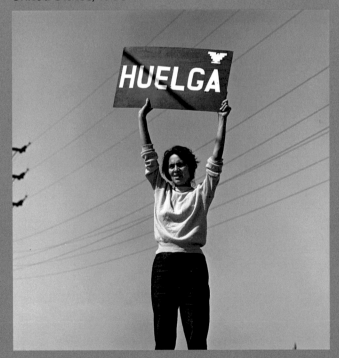

ABOVE A Dolores Huerta puppet appears in the Womxn's March on Seattle in solidarity with the national Women's March on January 21, 2017. Local media outlets reported that it was the largest protest march in Seattle history, with between 120,000 and 170,000 participants. Organizers used the term "womxn" to promote intersectionality and solidarity with the transgender community, and they requested for the march to be silent in homage to silent civil rights protests. The tribute to Dolores Huerta demonstrates her ongoing legacy in the twenty-first century. The float features grape vines and the quote on the front reads, "We can't let people drive wedges between us … because there's only one human race."

RIGHT Dolores Clara Fernandez Huerta is one of the most influential labor activists of the twentieth century and a leader of the Chicano civil rights movement. Huerta began her career as an activist in 1955 when she co-founded the Stockton, California chapter of the Community Service Organization, which led voter registration drives and fought for economic improvements for Hispanics. In 1962, Huerta and Cesar Chávez founded the National Farm Workers Association, the predecessor of the United Farm Workers' Union (UFW), which formed three year later. Huerta served as UFW vice president until 1999. Huerta was the driving force behind the nationwide table grape boycotts in the late 1960s that led to a successful union contract by 1970. In 1973, Huerta led another consumer boycott of grapes that resulted in the groundbreaking California Agricultural Labor Relations Act of 1975, which allowed farm workers to form unions and bargain for better wages and conditions.

organized within El Movimiento, the Mexican American civil rights movement that had roots in the United Farm Workers organization. This labor union, formed by Cesar Chávez and Dolores Huerta, fought for the rights of Mexican Americans working in agriculture. In the 1960s, Asian American women, predominantly Chinese and Japanese Americans, likewise saw parallels between their class and race position in the United States and the liberation struggles in the Third World, imbuing their feminism with an anti-imperialist, transnational outlook.

A group of feminists including Gloria Steinem, Brenda Feigen, and Dorothy Pitman Hughes responded to the need to include multiple perspectives and agendas in feminism by forming the Women's Action Alliance (WAA) in 1971. The WAA dedicated itself to supporting grassroots initiatives promoting feminist legislation and gender equality, prioritizing groups that were outside of the mainstream. Steinem, who had made her reputation as a journalist (perhaps most famously for taking a job as a scantily clad waitress, or "bunny," in order to write an exposé of the Playboy Club in New York City), co-founded *Ms.* magazine in 1972 with Dorothy Pitman Hughes. Hughes, an African American feminist and activist, had operated childcare centers in Harlem through the 1960s. Steinem's partnership with Hughes reflected the recognition by both women that representing a multiplicity of viewpoints was where feminism's future lay, and *Ms.* provided them with the outlet to help bring that about.

In 1982, Alice Walker emerged as a major new voice for black feminism. Her novel, *The Color Purple*, became an immediate classic and was translated into numerous languages and sold worldwide. But more broadly, Walker also became the best-known voice of womanism, a powerful approach to thinking about multiple forms of identity and oppression. Womanism claimed that a woman's blackness was not a component of her feminism but rather a lens through which she understood her own and others' femininity. Other feminists, including Boston-based Combahee River Collective, sociologist Patricia Hill Collins and Nigerian literary critic Chikwenye Okonjo Ogunyemi, further developed and disseminated the ideas of a feminism informed by a distinctive African and African American gender analysis.

By the 1990s, understanding the intersection of race and gender in women's lives became the hallmark of a new era in feminist activism. American legal scholar Kimberlé Crenshaw was the first feminist to use the word "intersectionality," arguing that the experiences of being black and a woman cannot be considered independently—the interactions between the two categories must be accounted for.

The theory of intersectionality, the outgrowth of Black and minority American feminists' long engagement with race and racism in the women's movement, marks an important moment in the history of women's activism. While women around

the world have experienced prejudice because of ethnicity, race, class, sexuality, and gender in their daily lives, feminist approaches that show a path to social justice for all women are only now catching up. American feminist debates, forged in the aftermath of slavery and ongoing segregation, took the lead in developing a language for theorizing the role of race and racism in social movements. The transnational struggle for gender equality takes place in communities and states, each uniquely shaped by ethnicity, religion, and national histories.

The reach of intersectionality, whether approached as a theory, heuristic device, or basis for activism, has been such that many disciplinary fields in Germany—including sociology, cultural studies, ethnology, history, law, philosophy, psychology, migration studies, public policy, and of course, gender studies—have been touched by it. For example, German scholars have noted that the issues faced by first-, second-, and third-generation Turkish women in Germany can be compared to the discrimination black women experience in America. Yet, according to some German feminists, the use of the category "race" in the European context is met with reluctance. The lack of consensus on the relevance of race in most European countries implies an erasure of race in intersectionality theory as it travels from the U.S. Discussions of intersectionality in Europe revolve around gender, ethnicity, and class. This erasure of race also means that the experiences of black women and other women of color no longer occupy a critical space in these discussions.

Intersectionality as a method exposes the debilitating interrelationships between poverty, racism, and sexism. Nothing demonstrates the need for an approach that captures the multiplicity of factors shaping women's lives more powerfully than rates of maternal mortality, which are unacceptably high. About 830 women die from pregnancy- or childbirth-related complications around the world every day. In Guatemala, as of 2011, seventy maternal deaths were reported in childbirth per one hundred thousand live births for non-indigenous women, while for indigenous women, the rate was 210. In Panama, the national rate for indigenous women was seven hundred maternal deaths, whereas for non-indigenous women, the number was seventy deaths for every one hundred thousand live births. Women in developing countries have, on average, many more pregnancies than women in developed countries, and their lifetime risk of death due to pregnancy is higher. But developed countries are not exempt from these racial and ethnic disparities. In the U.S., white and Latina maternal mortality is ten per one hundred thousand, black mothers thirty-four, Native American seventeen, and Asian/Pacific Islanders eleven. England has similar race-based differences: twenty-seven for mothers of African descent, twenty-one for Indian, nineteen for Caribbean, and nine for mothers of Anglo descent. Most maternal deaths are preventable. All women need access to prenatal care in pregnancy, skilled care during childbirth, and care and support in the weeks after childbirth. During the United Nations General

United States, 2005

United States, 2018

LEFT Alice Walker set the terms of "womanism" in the 1980s
with her personal essays and creative prose that embraced a black
feminist heritage in African American writers such as Zora Neale
Hurston and Nella Larson. Her best-selling *The Color Purple* won the
Pulitzer Prize for Fiction and the National Book Award in 1983. It
was later adapted into a film and a musical.

LEFT, BELOW Kimberlé Crenshaw (1959–) is a scholar, activist, and
lawyer who developed the theory of intersectionality as a way to
understand the oppression of black women in the U.S. Crenshaw is
also a co-founder of the field of critical race theory. She first used the
term "intersectionality" in a 1989 paper entitled "Demarginalizing
the Intersection of Race and Sex: A Black Feminist Critique of
Antidiscrimination Doctrine, Feminist Theory and Antiracist
Politics." In this paper, Crenshaw argued that to understand the
experience of black women, one must acknowledge the importance
of both racism and sexism.

RIGHT (United States, circa 1970) Audre Lorde (1934–1992) was
a feminist, writer, and civil rights activist. She described herself
as "black, lesbian, mother, warrior, poet." Lorde's parents were
Caribbean immigrants who settled in Harlem. A prolific poet and
essayist, Lorde published her first poem in *Seventeen* magazine while
she was still in high school. During the 1970s, she published a number
of books of poetry and taught as a poet-in-residence at Tougaloo
College. Lorde is remembered as a powerful activist in the realm of
black lesbian feminism. Her work is known for its radical vision and
transparency regarding black queer experience. In the 1980s, she
co-founded Kitchen Table: Women of Color Press, which published
the work of feminist writers of color. Lorde was named Poet Laureate
of New York in 1991. She died of cancer a year later while living on the
Caribbean island of St. Croix with her partner, Gloria I. Joseph.

Sierra Leone, 2010

Sierra Leone, 2010

LEFT, TOP AND BOTTOM The Masuba School of Midwifery in Makeni, Sierra Leone provides skills-based education and training for midwives. The School of Midwifery in Makeni (SOMM) is the second midwifery school in Sierra Leone; the first was established in Freetown in 1945. Since it was founded in 2010, SOMM has enrolled 712 students, 467 of whom have graduated as state-certified midwives. A new skills lab facility was announced in May 2019. According to UNICEF, Sierra Leone has the highest maternal mortality rate in the world, with one in seventeen mothers at risk for death in child-birth. The main goal of midwife training is to reduce infant and maternal mortality.

ABOVE Police escort a Turkish woman during a demonstration of right-wing Neo-Nazi party "Die Rechte" in Essen, Germany. Turks in Germany have been victims of neo-Nazi violence on several occasions, dating back to the early 1990s. Arson attacks on Turkish households and other ethnic minorities by skinheads led to riots and counter-protests over who can call Germany home.

Assembly in New York in 2015, UN Secretary-General Ban Ki-moon launched the Global Strategy for Women's, Children's, and Adolescents' Health, 2016-2030. The strategy seeks to end all preventable deaths of women, children, and adolescents, and create an environment in which these groups not only survive, but thrive, and see their environments, health, and well-being transformed.

The fight for gay, lesbian, and transgender rights has exploded as an important social justice movement on a transnational scale. Sexual minorities have been a part of all reform and protest movements, but most have remained closeted or have kept their sexual orientations private. The social and political climate in much of the world was outright hostile to them until the end of the twentieth century, and there is still more work to be done to create tolerance and equality. A society that has criminalized homosexual acts and been riddled with unexamined homophobia has made "coming out" as gay, lesbian, or bisexual dangerous. And thus most sexual minorities have, until recently, chosen not to come out, preferring to congregate in bars, clubs, and private organizations where they could be themselves in relative safety.

In America, the first gay or "homophile" organizations began in the early 1950s, the most famous being the Mattachine Society in Los Angeles and the Daughters of Bilitis in San Francisco. These groups began the process of normalizing and then politicizing homosexual identities, eventually taking back the word "queer" as a label of strength and resiliency.

Transgender people, often the most visible to outsiders as drag queens, led the first protests in the United States. In August 1966, a group of transgender women and drag queens resisted police harassment at Compton's Cafeteria in San Francisco's Tenderloin district. Compton's was one of the few places where trans women—some of whom spent their evenings hustling—could congregate publicly, since they were unwanted in gay bars. The riot at Compton's Cafeteria was the first recorded LGBTQ-related riot in the United States.

The more historically famous uprising came three years later at the Stonewall Inn in New York City's Greenwich Village. The Stonewall Inn was a favorite place for drag queens, transgender people, gay men, butch and femme lesbians, male prostitutes, and homeless youth. Police raids of gay-friendly establishments led to complicated relations between Stonewall's patrons and the police, who alternately extorted them and raided them. On the night of June 28, 1969, a crowd of patrons resisted an unscheduled police raid, and the situation escalated to a street riot during which angry rioters shouted "gay power!" perhaps for the first time. Resistance and protest around the inn went on for four days. The first Gay Pride marches were held on June 28, 1970 to commemorate the Stonewall riots. Gay Pride parades brought together diverse communities of gay men, lesbian women, transgender people, and self-defined queer or non-binary people, who together formed a loose and at times uncomfortable coalition to bring about greater acceptance.

United States, 1969

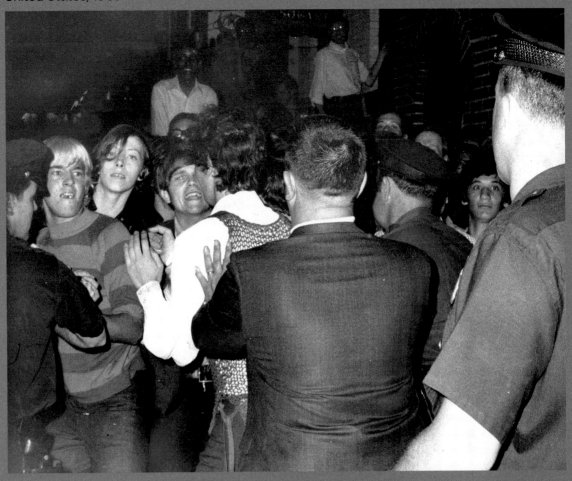

ABOVE The Stonewall riots began on June 28, 1969, when police raided a gay bar in New York City called the Stonewall Inn. The bar was located on Christopher Street in Greenwich Village, which was one of several neighborhoods in Manhattan with a significant LGBTQ population. The riot came as a response to harassment and monthly raids on gay bars by the police department. After nine police officers arrived and arrested several employees and patrons, the hostility escalated, and a crowd of mostly gay, lesbian, and transgender patrons outside the bar overturned police vehicles. They threw garbage cans, bottles, and rocks, and eventually set the bar on fire. Riots and protests continued for several days. In this photograph, a group of young people celebrates outside the boarded-up Stonewall Inn after the riots. The Stonewall uprising is often seen as one of the early catalysts for the modern gay rights movement.

NEXT SPREAD (United States, circa 1979) In the early 1970s, lesbian activism became a powerful social force as women drew strength from both the gay rights and feminist movements. Throughout the next four decades, lesbian and queer activists tackled a broad range of issues: sexual identity and sex itself, pop culture, race, class, violence, and many others. From early activists who advocated complete lesbian separatism to modern queer organizers who work in partnership with multiple identity groups, the "lesbian activist" movement has generated a huge variety of social activism and a rich body of political thought.

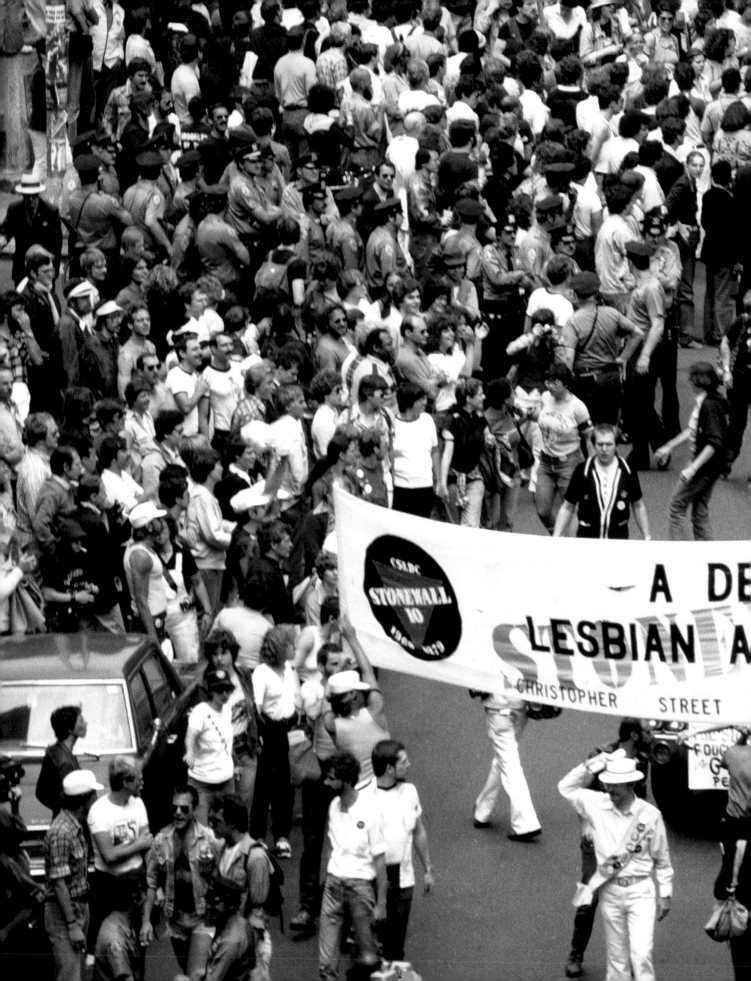

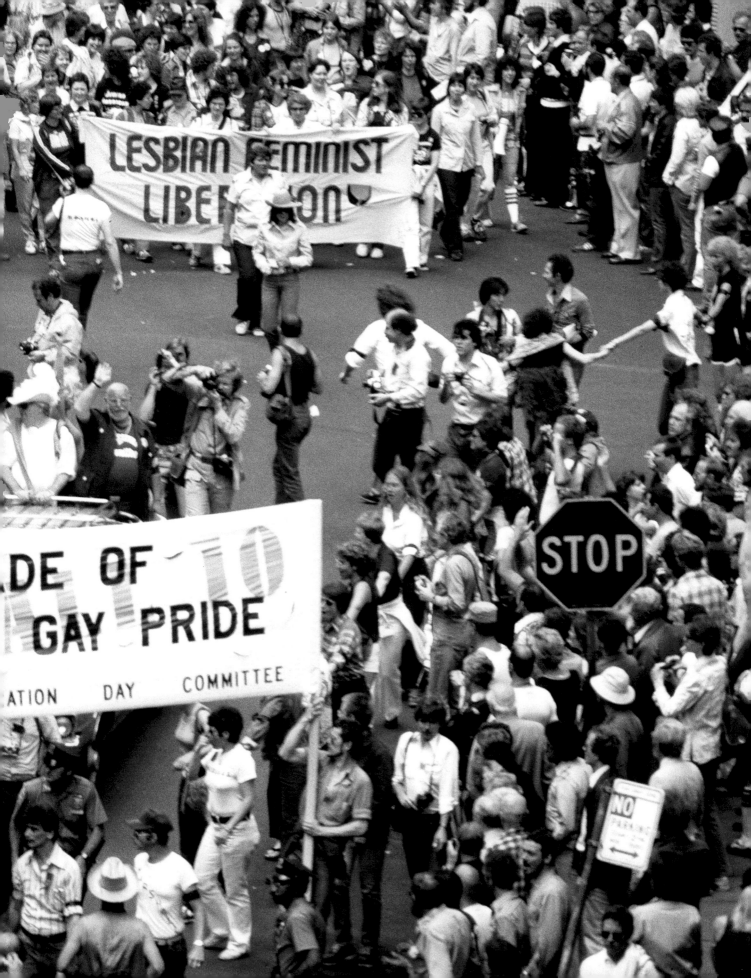

United States, 1989

ABOVE Keith Haring (1958–1990) was an American artist and activist known for his unique pop art style. Haring's work depicted outlines of cartoon-like figures, and he often created art in public places—first in the New York City subway system—using chalk. Haring was openly gay, and he used queer sexual imagery in his work. He was diagnosed with AIDS in 1988. With posters like this one, he sought to raise awareness about the AIDS epidemic and the stigma surrounding the disease. Titled *Ignorance=Fear/Silence=Death*, this poster was one of Haring's most socially engaged pieces. The poster uses the AIDS Coalition to Unleash Power (ACT UP) motto "silence=death" as well as the symbol of the pink triangle on the bottom right. Haring died of AIDS-related complications on February 16, 1990, and he was commemorated in the NAMES Project AIDS Memorial Quilt, a piece that currently memorializes the lives of ninety-four thousand people who have died of AIDS.

RIGHT (United States, 1988) Members of ACT UP (AIDS Coalition to Unleash Power) hold signs and placards during the Gay and Lesbian Pride March in New York City in 1988. ACT UP is an international grassroots political group that works to end the AIDS pandemic. Formed in 1987 in New York, the group devoted itself to radical, direct action to bring government attention to the crisis. Their inaugural action took place on Wall Street to protest the profiteering of pharmaceutical companies on AIDS drugs and a demand for a coordinated national policy to fight the disease. In 2012, nearly one thousand AIDS activists from around the world marched to the UN to demand world leaders renew their commitments to AIDS treatment and prevention.

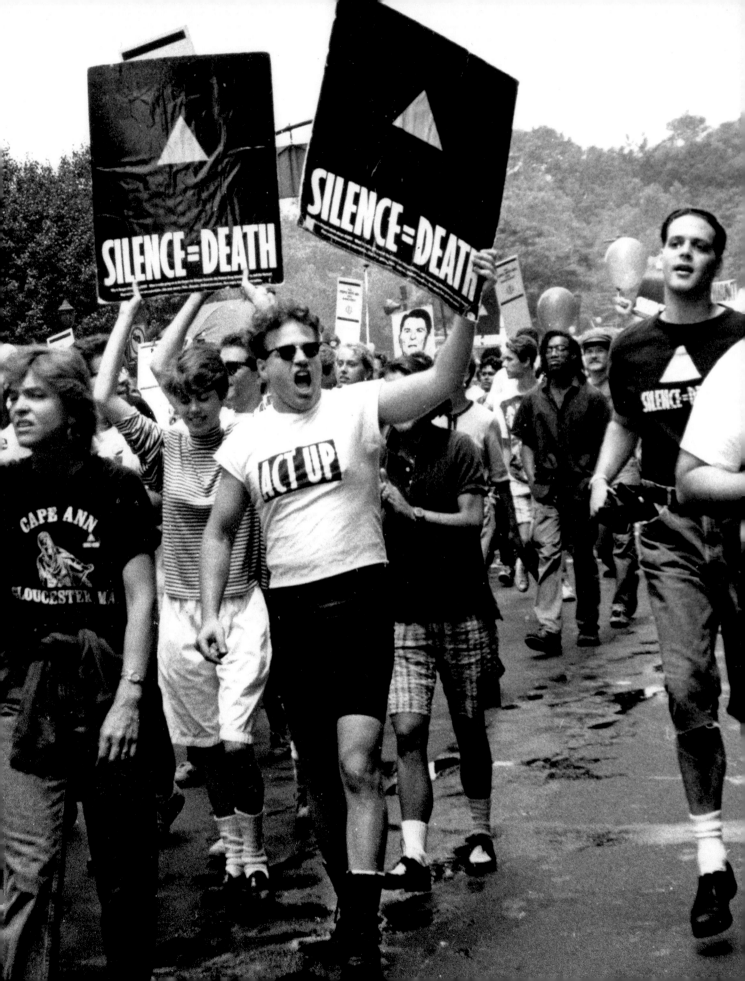

Brazil, 2014

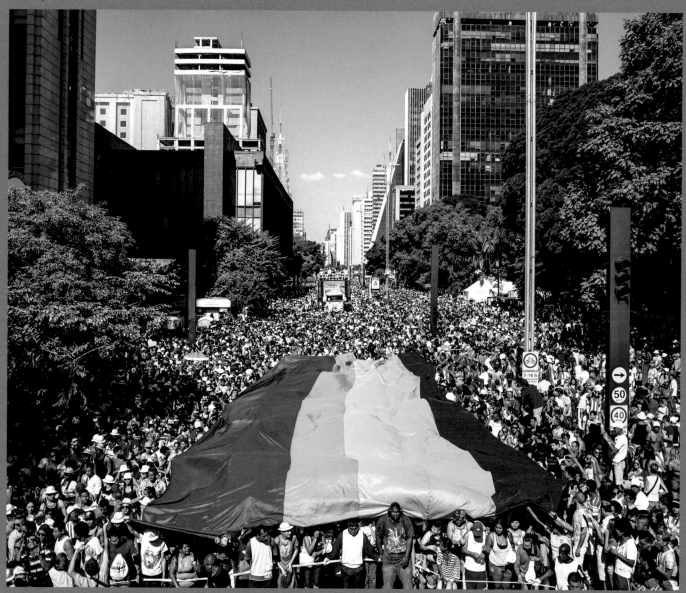

ABOVE São Paulo hosted the world's largest gay pride parade in 2014 with an estimated 2.5 million participants. This was Brazil's eighteenth Gay Pride Parade. Demonstrators carried signs demanding the prosecution of anti-gay and anti-lesbian hate crimes and the protection of human rights for transsexuals in Brazil. The first pride march took place in 1970 in Chicago and was organized by the Chicago Gay Liberation group to commemorate the 1969 Stonewall riots. The next year, Gay Pride marches took place in Boston, Dallas, London, Paris, West Berlin, and Stockholm.

NEXT SPREAD (United States, 2015) The supporters of same-sex marriage rallying in front of the United States Supreme Court on June 26, 2015, the day the *Obergefell v. Hodges* decision was announced, would not disappointed. "It would misunderstand these men and women to say they disrespect the idea of marriage," Justice Anthony Kennedy wrote in his majority opinion. "Their plea is that they do respect it, respect it so deeply that they seek to find its fulfillment for themselves. Their hope is not to be condemned to live in loneliness, excluded from one of civilization's oldest institutions. They ask for equal dignity in the eyes of the law. The Constitution grants them that right."

The tragedy of the AIDS crisis, which began in the early 1980s, decimated the leadership of gay advocacy groups, but it had the effect of galvanizing LGBTQ activism around the world. Direct action groups like the AIDS Coalition to Unleash Power (ACT UP) responded by coordinating and leading protests in cities across the globe, demanding that governments stop criminalizing gay and lesbian citizens and begin devoting resources to fighting the disease. In 1984, activist groups including the International Lesbian and Gay Alliance (ILGA), succeeded in getting the European Parliament to adopt the Squarcialupi Report, named for a famed fifteenth-century Italian musician, its first statement in support of LGBTQ rights. In 1995, the ILGA conference in Rio led to the first pride march in Brazil, which now rivals New York's as among the largest in the world. In 2003, the Brazilian delegation the United Nations Council on Human Rights proposed a resolution formally recognizing sexual orientation as a human rights issue. The interrelated threads of race and gender discrimination were brought together on a global scale at the 2001 UN-sponsored Worldwide Conference Against Racism, Racial Discrimination, Xenophobia, and Related Intolerance in Durban, South Africa—a significant affirmation of the efficacy of intersectionality. The following year, a Latin America and Caribbean regional unit of the ILGA was formed, followed by the Pan Africa group in 2007. Today, there are LGBTQ advocacy groups in every region of the planet. Yet in 2018, institutionalized discrimination based on sexual orientation and gender identity remains a powerful force throughout much of the world, particularly in Southeast Asia, much of the Middle East, and North Africa, according to Human Rights Watch.

One of the most prominent issues within the LGBTQ movement since the 1990s has been marriage rights. Marriages confer many rights and privileges to a couple, including joint ownership of property, access to a partner's health care and health insurance, and next of kin status for hospitals, among others. In the twenty-first century, public opinion on same-sex marriage has shifted rapidly in the United States, reaching 50 percent favorability in 2011. In 2015 the Supreme Court ruled in *Obergefell v. Hodges* that same-sex couples have the same fundamental rights and responsibilities as opposite-sex couples, thus legalizing marriage equality for all Americans.

With the rising visibility and activism around LGBTQ causes, the United Nations High Commissioner for Human Rights has called for the inclusion of sexuality and gender identity in its definition of human rights. In 2011, the UN issued its first report on the human rights of lesbian, gay, bisexual, and transgender people, detailing how people are killed or suffer violence, torture, detention, criminalization, and discrimination because of their "real or perceived sexual orientation or gender identity." Governments have overlooked such violence and discrimination for too long. The report conveys that LGBTQ people are often the targets of

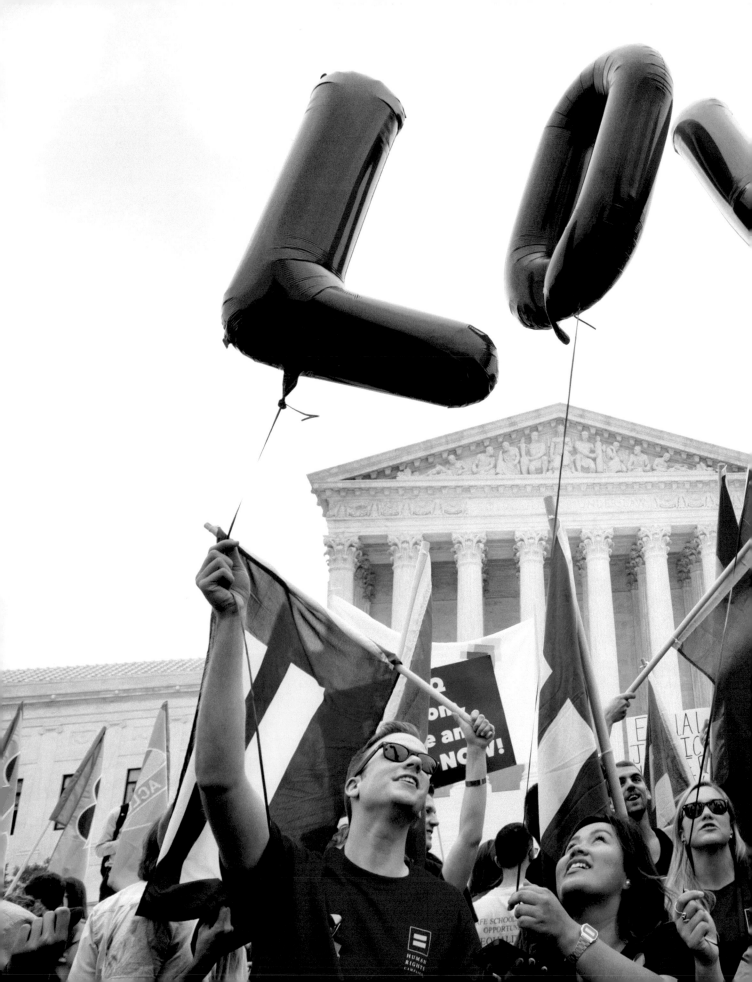

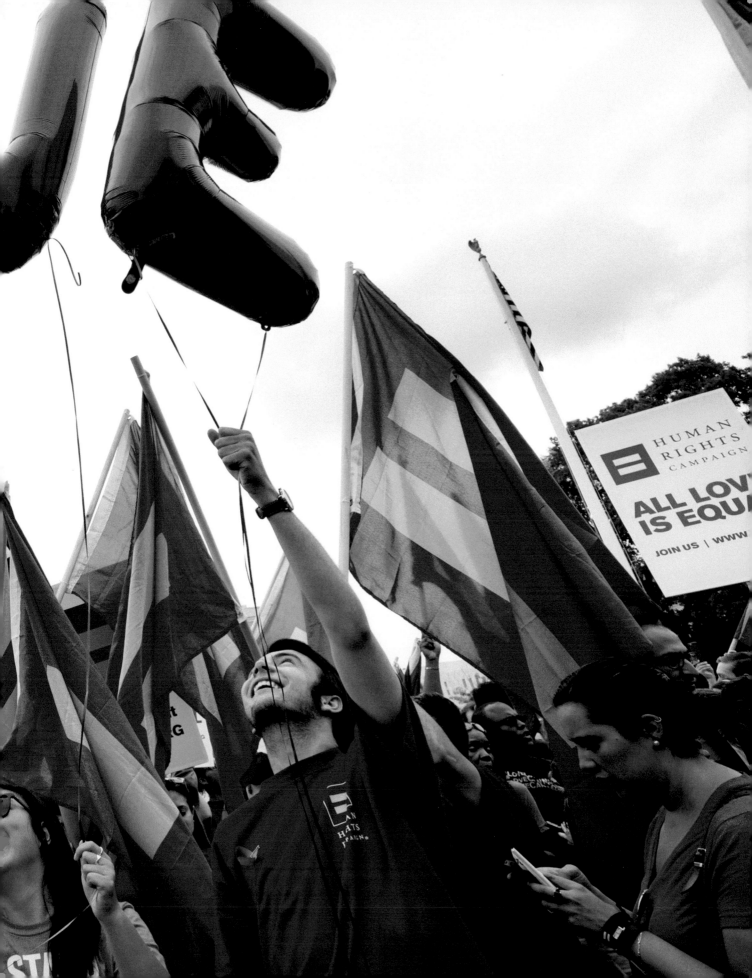

religious extremists and paramilitary groups, as well as their own communities and families. Same-sex behavior is illegal in seventy-six countries, and in five countries could lead to the death penalty. LGBTQ people often do not report crimes because they do not trust the police to protect or defend them. In this context, NGOs have stepped in to provide support, with mixed results. Public information campaigns in schools and police forces may help to educate people, but they also invite suspicion of imposing Western values on cultures where they are not welcome, tainting the efforts of indigenous LBGTQ activists with the stain of imperialism.

Social acceptance of LGBTQ people varies across the globe. In Africa, with the exception of South Africa and Cape Verde, LGBTQ rights are limited. Homosexuality is outlawed in thirty-four of the fifty-four countries on the continent, and many have intensified their sanctions in response to international pressure. In Sudan, southern Somalia, Mauritania, and northern Nigeria, homosexual acts are punishable by death. In Uganda, Tanzania, and Sierra Leone, same-sex acts may result in life imprisonment. Nigeria has passed laws that would make it illegal for family members to financially support a homosexual relative.

In the Americas, same-sex marriages have been legal in Canada since 2005, in Argentina since 2010, Brazil and Uruguay since 2013, and the United States since 2015. In Mexico, same sex unions are recognized nationally but marriage is legal in only twelve states. In January 2018, the Inter-American Court of Human Rights recognized same-sex marriage, making its acceptance mandatory in nations under its jurisdiction. The outliers in the Americas are the island countries of the British West Indies (which include Jamaica, Dominica, Barbados, St. Lucia, Antigua and Barbuda among others), where homosexual acts are still criminalized. Europe is much closer to the Americas in its extension of marriage rights: fourteen countries have legalized same sex marriage and fifteen have legalized civil unions for same-sex couples. The constitutions of Armenia, Bulgaria, Croatia, Georgia, Hungary, Latvia, Moldova, Montenegro, Serbia, Slovakia and Ukraine recognize marriage as a union of one man and one woman, thus banning same-sex marriage.

Transgender people have become more visible and integrated in the twenty-first century, thanks in part to improvements in medical technology, health resources, and a greater awareness of the complexities of gender. In 2004, South Africa passed legislation that allows transgender people to change their legally recognized sex. In 2011, the Parliament of Canada amended the Canadian Human Rights Act to include gender identity and gender expression as categories of protected status. As of 2008, Iran has carried out more sex reassignment surgeries than any other country but Thailand. The Iranian government pays for half of one's medical costs, and the sex change is recognized on one's birth certificate. In 2017, Denmark became the first country to delete transgender identification from its official list of mental health disorders.

This portrait from the *Being* series by queer, non-binary artist
Zanele Muholi depicts the wedding day of a lesbian couple in
South Africa. Muholi explores themes of love and intimacy in
South African same-sex relationships, affirming the value of these
relationships in a society where same-sex relationships are techni-
cally legal, but in which homophobia remains a powerful force.

Pakistan, 2019

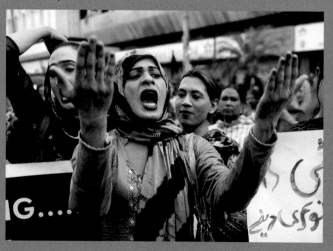

Japan, 2019

LEFT, TOP Pakistani transgender women protest in Karachi, calling for increased rights for transgender people. Pakistani culture has long recognized a third gender, neither male nor female, now called *khwaja sara* in Urdu. The presence of *khwaja sara* has meant that there is a unique perspective on gender in Pakistani culture. A 2018 law guaranteed protections for transgender citizens, meaning that they no longer have to appear before a medical panel to confirm their gender. And in 2019, a transgender woman was appointed to the Ministry of Human Rights for the first time. In practice, however, transgender people still encounter violence and discrimination in jobs, housing, and education.

LEFT While most political parties in Japan support LGBTQ rights, same-sex marriage is not recognized. Since 2002, Japanese transgender people have been required to undergo procedures including sex reassignment surgery and sterilization before being allowed to change their gender on legal documents. In this photo, American transgender woman Elin McCready (right) sits with her wife of nineteen years Midori (left) and their son, Tyler, at their home in Tokyo. McCready was successfully able to change her name and gender status on her Japanese foreign residence card after updating her U.S. passport, but the couple's marriage status may now be revoked.

RIGHT (India, 2019) West Bengal Forum for Gender and Sexual Minority Rights organized the Rainbow Carnival in 2019 in the city of Kolkata to promote acceptance of the LGBTQ community. The Carnival aimed to "sensitize people about differences among people and embracing them." Here, Indian activists enjoy the mobile selfie booth. The event was a response to the 2018 Supreme Court's repeal of Section 377 of India Penal Code, a British-era law that banned consensual gay sex. The historic judgment, cheered by millions, acknowledged the painful struggle for equality. "Respect for individual choice is the essence of individual liberty. LGBT community possesses equal rights under the constitution."

PAGE 236 In documenting lesbian and other fringe communities in South Africa, the photographer Zanele Muholi makes visible and asserts their existence. This image, *Zinzi and Tozama I, Mowbray* depicts the unselfconscious, joyful love of a lesbian couple.

The rise of LGBTQ rights, victories in the arenas of marriage and military service, and greater visibility of LGBTQ people across the arts, movies and television, have produced outcomes that were unimaginable at the start of the century. Sexual orientation and gender identity are increasingly seen by social scientists, biologists, and the general public as fluid aspects of personhood and thus as ones that should not be pathologized in ways that lead to discrimination and abuse. As U.S. Secretary of State Hillary Rodham Clinton stated in 2011, one of the remaining human rights challenges facing the world is guaranteeing the equality and dignity of people in the LGBTQ community. She referred to this community as an "invisible minority," whose human rights remain in jeopardy throughout the world. Clinton went on to say that respect for cultural and religious traditions should not supersede human rights, and thus must not serve as a pretext for denying rights to citizens based on their sexual orientation or gender identity. International consensus is slowly building. In 2012, Ban Ki-moon, Secretary General of the United Nations, spoke directly to "those who are lesbian, gay, bisexual or transgender, let me say: You are not alone ... Today I stand with you, and call upon all countries and people to stand with you, too."

The quest for full citizenship rights has expanded over the last century in impressive and surprising ways, moving from women's rights to minority rights to LGBTQ rights. In fits and starts, through moments of intense activism and competing periods of conservative political retrenchment, more people around the world now enjoy rights and responsibilities as full political participants in their societies. This is the dream Sojourner Truth had in 1851, as the abolitionist movement reached maturity and the long battle for suffrage was in its infancy. She stood as a former slave but more importantly spoke as a person who represented all of us when she demanded the right to be herself and to enjoy autonomy and the fruits of her own labor. "I have heard much about the sexes being equal; I can carry as much as any man, and can eat as much too, if I can get it. ... As for intellect, all I can say is, if woman have a pint, and a man a quart—why can't she have her little pint full? You need not be afraid to give us our rights for fear we will take too much—for we can't take more than our pint'll hold."

Suggested Reading

CHAPTER ONE

Adams, Jad, *Women and the Vote: A World History* (New York: Oxford University, 2014)

Cott, Nancy F., editor, *No Small Courage: A History of Women in the United States* (Oxford University Press, 2000)

Daley, Caroline and Melanie Nolan, eds., *Suffrage and Beyond: International Feminist Perspectives* (New York: New York University Press, 1994)

DuBois, Ellen C., *Feminism and Suffrage: The Emergence of an Independent Movement, 1848-1869* (Ithaca, NY: Cornell University Press, 1979)

Franceschet, Susan, Mona Lena Krook, Netina Tan, *The Palgrave Handbook of Women's Political Rights* (London: Palgrave, 2019)

McConnaughy, Corrine M., *The Woman Suffrage Movement in America: A Reassessment* (New York: Cambridge University Press, 2013)

Wagner, Sally Roesch, *Sisters in Spirit: Haudenosaunee (Iroquois) Influence on Early American Feminists* (Summertown, TN: Native Voices Book Publishing Company, 2001)

Weiss, Elaine, *The Woman's Hour: The Great Fight to Win the Vote* (New York: Penguin, 2018)

CHAPTER TWO

Bakhru, Tanya Saroj, ed., *Reproductive Justice and Sexual Rights: Transnational Perspectives* (New York: Routledge, 2019)

Bourbonnais, Nicole C., *Birth Control in the Decolonizing Caribbean: Reproductive Politics and Practice on Four Islands, 1930-1970* (New York: Cambridge University Press, 2016)

Craven, Christa, *Pushing for Midwives: Homebirth Mothers and the Reproductive Rights Movement* (Philadelphia: Temple University Press, 2010)

Ehrenreich, Nancy, ed., *The Reproductive Rights Reader: Law, Medicine, and the Construction of Motherhood* (New York: New York University Press, 2008)

Gordon, Linda, *The Moral Property of Women: A History of Birth Control Politics in America* (Chicago: University of Illinois Press, 2002)

Hagel, Alisa Von and Daniela Mansbach, *Reproductive Rights in the Age of Human Rights: Pro-Life Politics from Roe to Hobby Lobby* (New York: Palgrave Macmillan, 2016)

Klausen, Susanne Maria, *Abortion Under Apartheid: Nationalism, Sexuality, and Women's Reproductive Rights in South Africa* (London: Oxford University Press, 2015)

Knudsen, Lara M., *Reproductive Rights in a Global Context: South Africa, Uganda, Peru, Denmark, United States, Vietnam, Jordan* (Nashville, TN: Vanderbilt University Press, 2006)

Lopez, Iris, *Matters of Choice: Puerto Rican Women's Struggle for Reproductive Freedom* (New Brunswick, NJ: Rutgers University Press, 2008)

Nelson, Jennifer, *Women of Color and the Reproductive Rights Movement* (New York: New York University Press, 2003)

Ross, Loretta, Lynn Roberts, Erika Derkas, Whitney Peoples and Pamela Bridgewater, eds., *Radical Reproductive Justice: Foundations-Theory-Practice-Critique* (New York: The Feminist Press, 2017)

Sasser, Jade S., *On Infertile Ground: Population Control and Women's Rights in the Era of Climate Change* (New York: New York University Press, 2018)

Tsui, Amy O., Judith N. Wasserheit, and John Haaga, eds., *Reproductive Health in Developing Countries: Expanding Dimensions, Building Solutions* (Washington, D.C.: National Academy Press, 1997)

Wittenstein, Vicki Oransky, *Reproductive Rights: Who Decides?* (Minneapolis, MN: Twenty-First Century Books, 2016)

CHAPTER THREE

Abbott, Elizabeth, *A History of Marriage from Same Sex Unions to Private Vows and Common Law, the Surprising Diversity of a Tradition* (New York: Penguin, 2010)

Ali, Kecia, *Marriage and Slavery in Early Islam* (Cambridge, MA: Harvard University Press, 2010)

Celello, Kristin, *Making Marriage Work: A History of Marriage and Divorce in the Twentieth Century United States* (Chapel Hill, NC: University of North Carolina Press, 2009)

Chauncey, George: *Why Marriage: The History Shaping Today's Debate over Gay Equality* (New York: Basic Books, 2004)

Coontz, Stephanie, *Marriage, A History: From Obedience to Intimacy or How Love Conquered Marriage* (New York: Viking, 2005)

Cott, Nancy, *Public Vows: A History of Marriage and the Nation* (Cambridge, MA: Harvard University Press, 2000)

Corvino, John and Maggie Gallagher, *Debating Same-Sex Marriage* (New York: Oxford University Press, 2012)

Doumani, Beshara, ed., *Family History in the Middle East: Household, Property, and Gender* (Albany, NY: State University of New York Press, 2003)

Esteve, Albert and Ron J. Lesthaeghe, eds., *Cohabitation and Marriage in the Americas: Geo-historical Legacies and New Trends* (Springer International Publishing, 2016)

Hunter, Tera W., *Bound in Wedlock: Slave and Free Black Marriages in the Nineteenth Century* (Cambridge, MA: The Belknap Press of Harvard University, 2017)

Lefkovitz, Alison, *Strange Bedfellows: Marriage in the Age of Women's Liberation* (Philadelphia, PA: University of Pennsylvania Press, 2018)

Menchi, Silvana Seidel, ed., *Marriage in Europe 1400-1800* (Toronto: University of Toronto Press, 2016)

Rydstrom, Jens, *Odd Couples: A History of Gay Marriage in Scandinavia* (Aksant Academic Publishers, 2011)

Spruill, Marjorie, *Divided We Stand: The Battle Over Women's Rights and Family Values that Polarized American Politics* (Bloomsbury USA, 2017)

Tucker, William, *Marriage and Civilization: How Monogamy Made Us Human* (Washington, D.C.: Regnery Publishing 2014)

Watson, Rubie S. and Patricia Buckley Ebrey, eds., *Marriage and Inequality in Chinese Society* (Berkeley, CA: University of California Press, 1991)

CHAPTER FOUR

Barber, Elizabeth Wayland, *Women's Work, The First 20,000 Years: Women, Cloth, and Society in Early Times* (New York: Norton, 1994)

Bardsley, Sandy, *Women's Roles in the Middle Ages* (Westport, CT: Greenwood Press, 2007)

Bennett, Judith M., *Ale, Beer, and Brewsters in England: Women's Work in a Changing World, 1300-1600* (New York: Oxford University Press 1996)

Braybon, **Gail**, *Women Workers in the First World War* (New York: Routledge, 2013)

Coontz, Stephanie and Peta Henderson, eds., *Women's Work, Men's Property: The Origins of Gender and Class* (London: Verso, 1986)

Holloway, Gerry, *Women and Work in Britain since 1840* (New York: Routledge, 2005)

Kessler-Harris, Alice, *Out to Work: A History of Wage-Earning in the United States* (New York: Oxford University Press, 2003)

Lane, Penelope, Neil Raven and K.D.M. Snell, eds., *Women, Work and Wages in England, 1600-1850* (Rochester, NY: The Boydell Press, 2004)

Madden, Kirsten and Robert W. Dimand, eds., *The Routledge Handbook of the History of Women's Economic Thought* (New York: Routledge, 2019)

McCallum, Mary Jane Logan, *Indigenous Women, Work and History, 1940-1980* (Winnipeg, Manitoba: University of Manitoba Press, 2014)

Milkman, Ruth, ed., *Women, Work and Protest: A Century of US Women's Labor History* (New York: Routledge, 1985, 2013)

Poya, Maryam, *Women, Work and Islamism: Ideology and Resistance in Iran* (London: Zed Books, 1999)

Sharpless, Rebecca, *Cooking in Other Women's Kitchens: Domestic Workers in the South, 1865-1960* (Chapel Hill, NC: The University of North Carolina Press, 2010)

Simonton, Deborah, *A History of European Women's Work, 1700 to the Present* (New York: Routledge, 1998)

Wiesner-Hanks, Merry E., *Gender in History: Global Perspectives* (Maldon, MA: Wiley-Blackwell, 2011)

CHAPTER FIVE

Berger, John, *Ways of Seeing* (New York: Penguin, 1972)

Broude, Norma and Mary D. Garrard, eds., *The Power of Feminist Art* (New York: Harry N. Abrams, 1996)

Butler, Cornelia, *WACK!: Art and the Feminist Revolution* (Los Angeles, CA: Museum of Contemporary Art, 2007)

Dekel, Tal, *Gendered: Art and Feminist Theory* (London: Cambridge Scholars Publishing, 2013)

Eco, Umberto, *History of Beauty* (Rizzoli International Publications, 2010)

Langa, Helen and Paula Wisotzki, eds., *American Women Artists, 1935-1970* (New York: Routledge, 2016)

Gill, Tiffany M. *Beauty Shop Politics: African American Women's Activism in the Beauty Industry* (Urbana, IL: University of Illinois Press, 2010)

Glenn, Evelyn Nakano, ed., *Shades of Difference: Why Skin Color Matters* (Stanford, CA: Stanford University Press, 2009)

Gosling, Lucinda, Hilary Robinson, and Amy Tobin, *The Art of Feminism: Images that Shaped the Fight for Equality, 1857-2017* (New York: Routledge, 2017)

Ioannou, Maria and Maria Kyriakidou, eds., *Female Beauty in Art: History, Feminism, Women Artists* (Newcastle: Cambridge Scholars Publishing, 2014)

Jones, Geoffrey, *Beauty Imagined: A History of the Global Beauty Industry* (New York: Oxford University Press, 2010)

Lippard, Lucy, *The Pink Glass Swan: Selected Feminist Essays on Art* (New York: New Press, 1995)

Riordan, Teresa, *Inventing Beauty: A History of the Innovations That Have Made Us Beautiful* (New York: Broadway Books, 2004)

Slatkin, Wendy, *Women Artists in History: From Antiquity to the Present* (New York: Prentice Hall, 2001)

Stearns, Peter N., *Fat History: Bodies and Beauty in the Modern West* (New York: New York University Press, 2002)

CHAPTER SIX

Ayoub, Phillip M., *When States Come Out: Europe's Sexual Minorities and the Politics of Visibility* (New York: Cambridge University Press, 2016)

Ayoub, Phillip M. and David Paternotte, *LGBT Activism and the Making of Europe: A Rainbow Europe?* (New York: Palgrave Macmillian, 2014)

Ball, Carlos, ed., *After Marriage Equality: The Future of LGBT Rights* (New York: New York University Press, 2016)

Collins, Patricia Hill, *Black Feminist Thought: Knowledge, Consciousness, and the Politics of Empowerment* (New York: Routledge, 2000)

Chin, Rita, *The Crisis of Multiculturalism in Europe: A History* (Princeton, NJ: Princeton University Press, 2017)

Evans, Sara, *Tidal Wave: How Women Changed America at Century's End* (New York: Free Press, 2004)

Molony, Barbara and Jennifer Nelson, eds., *Women's Activism and "Second Wave" Feminism: Transnational Histories* (New York: Bloomsbury Academic, 2017)

Nash, Jennifer, *Black Feminism Reimagined after Intersectionality* (Durham, NC: Duke University Press, 2019)

Nicol, Nancy, et al, eds., *Envisioning Global LGBT Human Rights: (Neo)Colonialism, Neoliberalism, Resistance and Hope* (Institute of Commonwealth Studies, 2018)

O'Dwyer, Conor, *Coming Out of Communism: The Emergence of LGBT Activism in Eastern Europe* (New York: New York University Press, 2018)

Roth, Benita, *Separate Roads to Feminism: Black, Chicana and White Feminist Movements in America's Second Wave* (New York: Cambridge University Press, 2004)

Swinth, Kirsten, *Feminism's Forgotten Fight: The Unfinished Struggle for Work and Family* (Cambridge, MA: Harvard University Press, 2018)

Takaki, Ronald, *A Different Mirror: A History of Multicultural America* (Boston: Little, Brown and Company, 2008)

Thoreson, Ryan R., *Transnational LGBT Activism: Working for Sexual Rights Worldwide* (Minneapolis, MN: University of Minnesota Press, 2014)

BOOKS FOR KIDS

Barcella, Laura, *Fight Like a Girl: 50 Feminists Who Changed the World* (San Francisco: Zest Books, 2016)

Schatz, Kate, *Rad American Women A to Z* (San Francisco: City Lights Books, 2015)

Zimet, Susan and Todd Hasak-Lowy, *Roses and Radicals: The Epic Story of How American Women Won the Right to Vote* (New York: Penguin, 2018)

Acknowledgments

The editors would like to acknowledge, first and foremost, the activists who have pressed for citizenship in its fullest sense for women throughout time and across the globe, in ways large and small. Our hope is that this book is a worthy tribute to their efforts, and that it inspires others to understand and carry them forward.

We would like to thank Holly La Due, our astute and sensitive editor at Prestel for her unwavering commitment to the project; the rest of her team at Prestel, including Ayesha Wadhawan and Anjali Pala for their unfailing professionalism; and Sarah Gephart and Ian Keliher at MGMT. design for the powerful and dynamic design of the book you're holding in your hands.

Thanks also to Julia DeVarti for her tireless photo research, (and to Linda Liang for her helpful advice), to Julie Des Jardins for her whip-smart editorial guidance, and to Meghan Drury, who made everything sound better.

Photo Credits

Marilyn Minter, *Blue Poles*, 2007, Enamel on metal, 60 x 72 inches (152.4 x 182.9 cm), © Marilyn Minter, Courtesy Regen Projects, Los Angeles and Salon 94, New York: 175

Mirrorpix/Getty Images: 148

MPI/Getty Images: 106-107

Monica Schipper/Stringer/Getty Images: 218 bottom

© Museum of London: 127 bottom

Museum of London/Heritage Images/Getty Images: 163 bottom

Courtesy of Zanele Muholi, Yancey Richardson, New York, and Stevenson Cape Town / Johannesburg. *Bester I, Mayotte*, 2015. Gelatin silver print. © Zanele Muholi: 171

Courtesy of Zanele Muholi, Yancey Richardson, New York, and Stevenson Cape Town / Johannesburg. Ayanda & Nhlanhla Moremi's Wedding, Kwanele Park, Katlehong, 9 November, 2013. © Zanele Muholi: 233

Courtesy of Zanele Muholi, Yancey Richardson, New York, and Stevenson Cape Town / Johannesburg. *Zinzi and Tozama I, Mowbray, Cape Town*, 2010. © Zanele Muholi: 237

NARINDER NANU/AFP/Getty Images: 91

National Archives (165-WW-(600A)16): 31 top

National Motor Museum/Heritage Images/Getty Images: 145

Alice Neel, *Linda Nochlin and Daisy*, 1973, Oil on canvas, 55 1/2 x 44 inches, 141 x 111.8 cm, © The Estate of Alice Neel, Courtesy The Estate of Alice Neel and David Zwirner: 170

Shirin Neshat, *Untitled, 1996*, RC print & ink (photo taken by Larry Barns), 67 1/8 x 48 1/4 inches (170.5 x 122.6 cm), Copyright Shirin Neshat, Courtesy the artist and Gladstone Gallery, New York and Brussels: 202

New York Daily News Archive/Getty Images: 223

New York Historical Society, Button, ca. 1900, Metal, plastic, 1/2 in. (1.3 cm), INV.2460: 25 left

New York Historical Society, Chichester's English Diamond Brand Pennyroyal Pills, PR 031, Bella C. Landauer Collection of Business and Advertising Ephemera, ID 96537d: 60 bottom

Catherine Opie, *Idexa*, 1993, Chromogenic print, 20 x 16 inches (50.8 x 40.6 cm), © Catherine Opie, Courtesy Regen Projects, Los Angeles and Lehmann Maupin, New York, Hong Kong, and Seoul: 193

Orjan Ellingvag/Alamy Stock Photo: 156

OSCAR DEL POZO/AFP/Getty Images: 158-159

Paul Gordon/Alamy Live News: 215 top

Pictorial Press Ltd/Alamy Stock Photo: 13, 139, 164 bottom

Rico D'Rozario/Redferns/Getty Images: 112 top

RIZWAN TABASSUM/AFP/Getty Images: 234 top

Sally Hayden/SOPA Images/LightRocket/Getty Images: 197 bottom

Schlesinger Library, Radcliffe Institute, Harvard University: 110 (photo by Bettye Lane), 208 top, 214 (photo by Bettye Lane), 224-225 (photo by Bettye Lane)

Science & Society Picture Library/Getty Images: 131

Science History Images/Alamy Stock Photo: 27 left, 132, 146-147

Tschabalala Self, *Loosie in the Park*, Flashe, acrylic, fabric and painted canvas on canvas, 8⬚ (H) × 7⬚ (W), 2019, Photo: Joshua White / JWPictures.com: 187

Amy Sherald, *Michelle LaVaughn Robinson Obama*, Oil on linen, 2018, National Portrait Gallery, Smithsonian Institution; gift of Kate Capshaw and Steven Spielberg; Judith Kern and Kent Whealy; Tommie L. Pegues and Donald A. Capoccia; Clarence, DeLoise, and Brenda Gaines; Jonathan and Nancy Lee Kemper; The Stoneridge Fund of Amy and Marc Meadows; Robert E. Meyerhoff and Rheda Becker; Catherine and Michael Podell; Mark and Cindy Aron; Lyndon J. Barrois and Janine Sherman Barrois; The Honorable John and Louise Bryson; Paul and Rose Carter; Bob and Jane Clark; Lisa R. Davis; Shirley Ross Davis and Family; Alan and Lois Fern; Conrad and Constance Hipkins; Sharon and John Hoffman; Audrey M. Irmas; John Legend and Chrissy Teigen; Eileen Harris Norton; Helen Hilton Raiser; Philip and Elizabeth Ryan; Roselyne Chroman Swig; Josef Vascovitz and Lisa Goodman; Eileen Baird; Dennis and Joyce Black Family Charitable Foundation; Shelley Brazier; Aryn Drake-Lee; Andy and Teri Goodman; Randi Charno Levine and Jeffrey E. Levine; Fred M. Levin and Nancy Livingston, The Shenson Foundation; Monique Meloche Gallery, Chicago; Arthur Lewis and Hau Nguyen; Sara and John Schram; Alyssa Taubman and Robert Rothman: 190

Cindy Sherman, *Untitled Film Still #48, 1979*, Gelatin silver print, 8 x 10 inches, 20.3 x 25.4 cm, Courtesy of the artist and Metro Pictures, New York: 180-181

© 2019 Laurie Simmons, Courtesy of the artist and Salon 94, New York: 176

Lorna Simpson, *A Friend*, 2012, Collage and ink on paper, 11 3/16 x 8 11/16 in (28.4 x 22.1 cm), © Lorna Simpson. Courtesy the artist and Hauser & Wirth: 186

Sarin Images/GRANGER — All rights reserved. Sarin Images 25 Chapel Street Brooklyn: 123 bottom

Sipa USA via AP Images: 92 bottom

Jaune Quick-to-See Smith, *Fear*, 2005, Mixed media on canvas, 72 x 48 inches, 182.9 x 121.9 cm, Signed and dated, verso, (INV# QTSPT146), Courtesy the artist and

Garth Greenan Gallery, New York: 185

Smith Collection/Gado/Getty Images: 25 right

Sueddeutsche Zeitung Photo/Alamy Stock Photo: 38 top

© Susan Meiselas/Magnum Photos: 92 top

Sylvain Gaboury/FilmMagic/Getty Images: 218 top

Thomas Imo/Photothek via Getty Images: 150 bottom

TOBIAS SCHWARZ/AFP/Getty Images: 117

Betty Tompkins, *Women Words (Ingres #2)*, 2018 acrylic on book page, 9 3/8 x 7 3/8 ins. 23.9 x 18.8 cm, Courtesy of Betty Tompkins and P•P•O•W, New York: 174

Universal History Archive/Universal Images Group/Getty Images: 32-33, 90

View Pictures/Universal Images Group via Getty Images: 178

Victor Moriyama/Getty Images: 228

Voice of America: front cover

Wellcome Collection, A pregnant woman receives an abortifacient draught from a peasant "wise woman"; she falls ill but the physician cannot save her life; her funeral is attended by her family and neighbours. Colour lithograph by S. Iaguzhinskii, 1925: 73 bottom

Wikimedia Commons, Nicholas Hilliard, Portrait of Queen Elizabeth I, c.1575: 203

Hannah Wilke, S.O.S. Starification Object Series, 1975 (Guns), Hannah Wilke Collection & Archive, Los Angeles, Copyright Marsie, Emanuelle, Damon, and Andrew Scharlatt/VAGA at ARS, New York: 201

World History Archive/Alamy Stock Photo: 17 left, 35, 73 top

Jonathan Yeo, *Extended SMAS (Superficial Muscular-Aponeurotic System) Facelift*, 2011, oil on canvas 45 x 35cm, ©2019, Jonathan Yeo Studio. Courtesy of the Artist: 198

Index

Never doubt that
a small group of
thoughtful, committed
citizens can change the
world. Indeed, it's the
only thing that ever has.

Margaret Mead